LET'S

GET

LOST

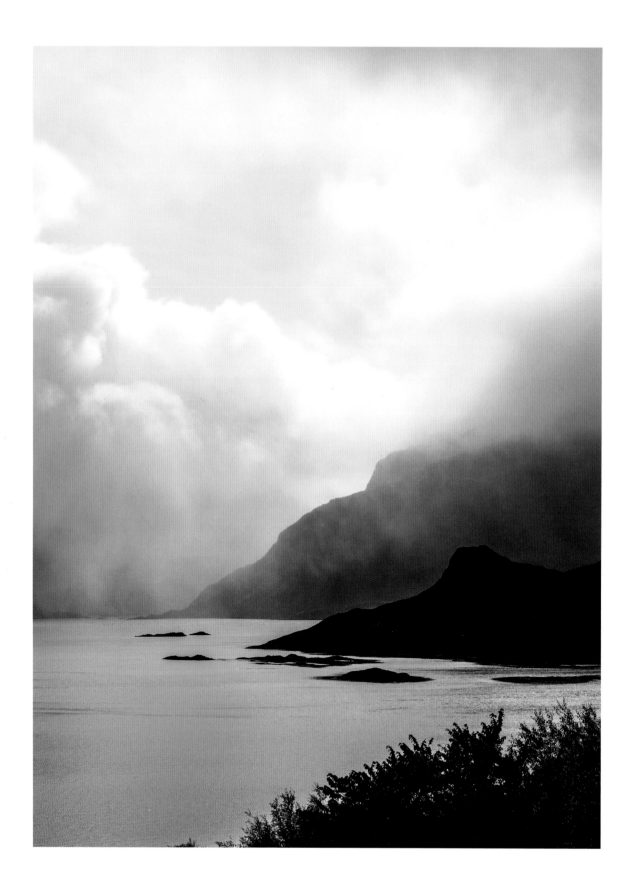

LET'S

GET

LOST

the world's most stunning remote locations

curated by

FINN BEALES

WHITE LION PUBLISHING

CONTENTS

LET'S GET LOST

INTRODUCTION

We can travel the world in the blink of an eye today. Image-sharing platforms offer up mesmeric views of the world that we can journey to in our minds, but why do photographs of far-off places capture our imagination so vividly?

Perhaps we are simply seeking an escape from the rigours of everyday life, but I think it's more than that. Our curiosity to explore runs deep; it's hardwired. Exploring improves our understanding of new places and can also lead to a more profound perception of ourselves. Unfortunately, however, I'm not sure the algorithmic funnel that is social media is of that much value. Our engagement is reduced to the double-tap, the hurried comment – 'Wow!' – before we scroll down and teleport elsewhere. How trivialized the privilege of journey-making has become, and how marked was that full stop called Covid-19?

The global pandemic gave me time to ponder. Perhaps getting lost is the privilege today. I mean, it's virtually impossible to do! Global positioning systems, mapping, photo sharing, 24-hour news channels… the list goes on. Our awareness of the world has never been greater, but how deep does that awareness run and what happened to our ability to wonder? Getting lost forces us to consider our situation and become more aware of our surroundings – which is no bad thing. Getting lost is part of a process: it helps us determine that which we find of value. And, when we find what we are looking for, it can be the most rewarding form of discovery.

I think photographers are good at getting lost. We feel the need to immerse ourselves in our surroundings when making work. We need to 'feel' a place, and that means relying on all the senses to explore somewhere properly. Only by letting go and simply connecting with space and time can we find the pictures we're looking for.

This book opens the door to a number of the world's most remote places, as seen through the eyes of some superb photographers. It is a place where they can tell their stories unhindered by character counts or algorithms, and gives space for their photographs to breathe.

Split across six distinct environments – Mountains, Wilderness, Coast, Ice & Snow, Lakes & Rivers and Forests – each entry showcases a remarkable part of the world. And each of the photographers I have chosen details their journeys and experiences, and how they set about capturing them on camera, before kindly offering up some tips for improving your photography along the way. In pursuit of these images, their experiences range from flying over frozen monuments (pre-drones!) to hiking up erupting volcanoes or photographing magical glaciers after dark. Many of the locations featured are tricky to reach, so I hope you will experience them through the incredible photographs and the first-hand accounts of those who have made them.

Life is a homecoming, so enjoy the journey and remember it's ok to to get a little bit lost along the way.

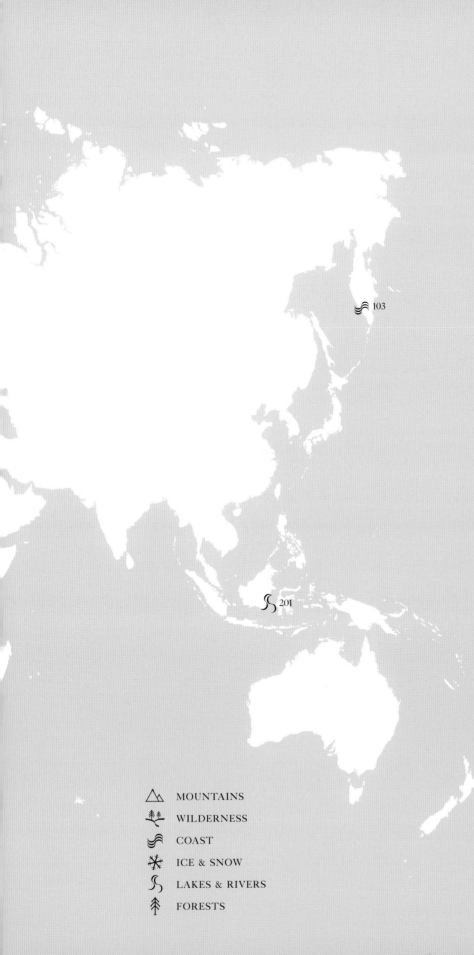

△ MOUNTAINS

WILDERNESS

COAST

ICE & SNOW

LAKES & RIVERS

FORESTS

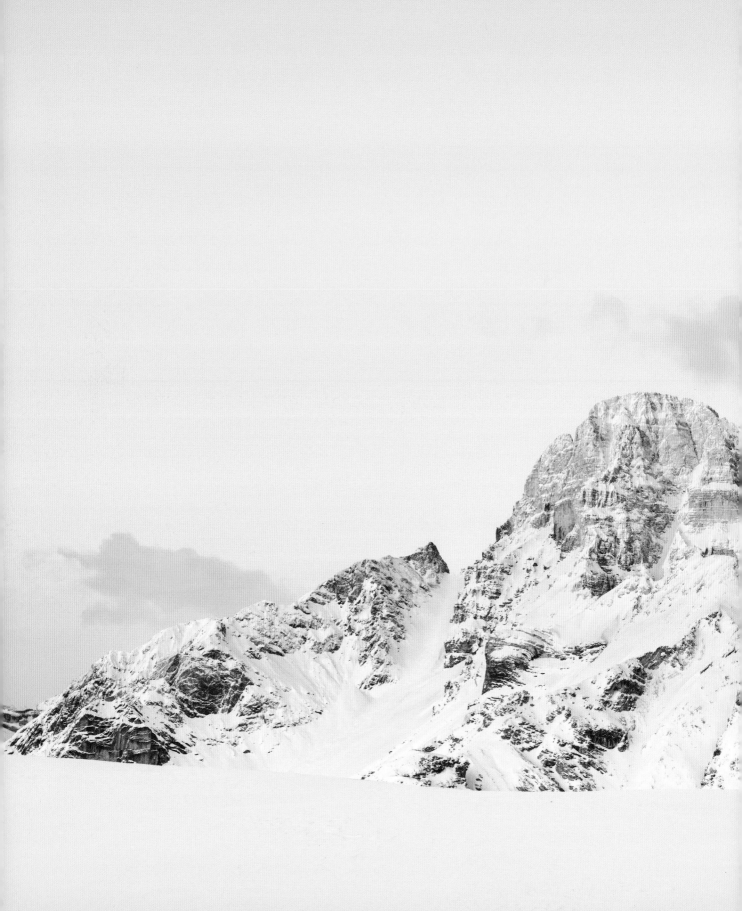

MOUNTAINS

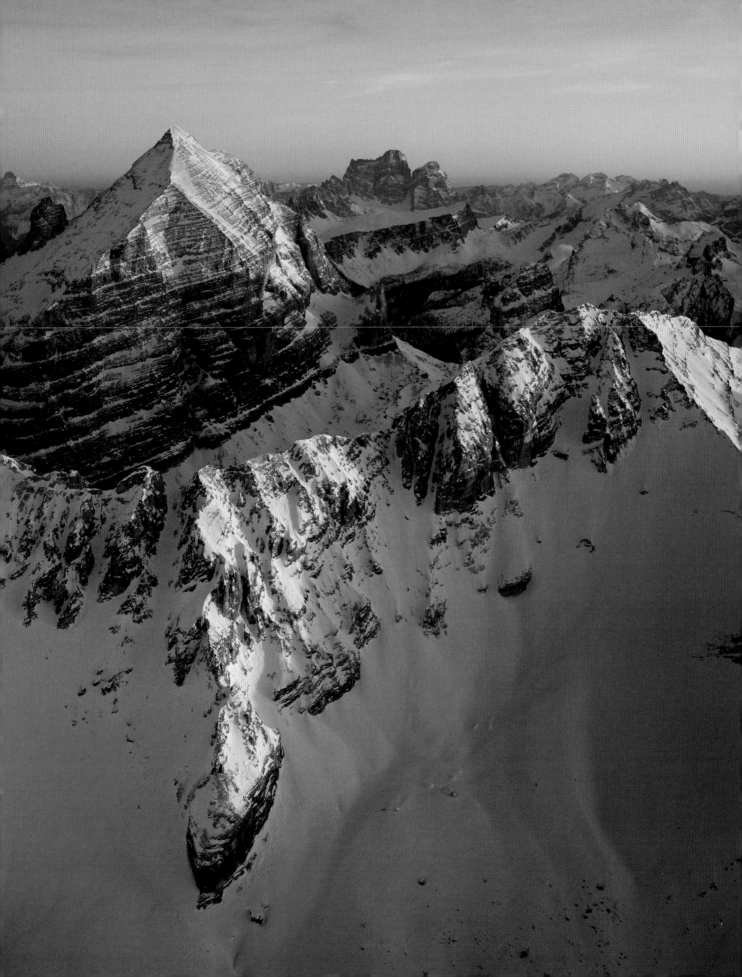

JONATHAN GREGSON
THE DOLOMITES, ITALY

coordinates
46.5981°N, 11.7242°E

The Dolomites were formed around 250 million years ago during the Triassic period, resulting from the collision between Africa and Europe's tectonic plates. The monumental force of the impact pushed the bedrock skyward, creating the breathtaking mountain range we see today. In 2009, the Dolomites became a designated UNESCO World Heritage Site, reflecting the mountains' extraordinary beauty and their geological significance. In summer, the valleys are home to meadows and wildflowers akin to a scene from *The Sound of Music*, perfect for mountain biking, nature walks, climbing and Alpine hikes. In winter, snow blankets the landscape, offering up skiing, snowboarding and hiking opportunities. Photographically, the stunning vistas and incredible sunrises and sunsets deliver all year round.

EACH MONOLITHIC TURRET OF ROCK ERUPTS FROM THE LANDSCAPE IN AN IMPRESSIVE DISPLAY OF DEFIANCE.

Located in northeastern Italy along the Austrian border, it would be hard to visit the Dolomites and feel you have seen even a fraction of the region: the mountain range alone covers 141,903 hectares (330,650 acres). There are various peaks with visual prominence, including Seceda – a beautiful mountain to visit for early evening light and views over the range – and the Kronplatz, whose challenging steep slopes demand technical expertise from world-class skiers and provide dramatic landscapes for photographers. Alpe di Suisi is another location with visual appeal. It is the largest Alpine meadow in Europe and is offset by the Langkofel Group massif. Alpine huts are dotted around the undulating landscape, providing picture-perfect foreground detail to counter the dramatic mountain ridges beyond.

It was late January when I arrived in Dobbiaco, a small town located in the Puster Valley, that provided the perfect base for my chosen subject: the Three Peaks. Each monolithic turret of rock erupts from the landscape in an impressive display of defiance. They are an iconic feature of the range in this location, and I wanted to try to photograph them in optimal dawn light. I would have to leave at 4.30am the next morning to reach my desired vista in good time for this brief, mercurial light.

The journey to the Mount Strudelkopf viewpoint with kit weighing 20kg (44lb) upon my back made for arduous trekking. A guide directed the two-hour hike through several feet of freshly fallen snow and total darkness, each of us armed only with a head torch to illuminate hazardous pitfalls. There was no moon in the clear, velvet black sky, but the stars were out in their millions to

⌄ Looking west over the Dolomites from the summit of the Kronplatz.

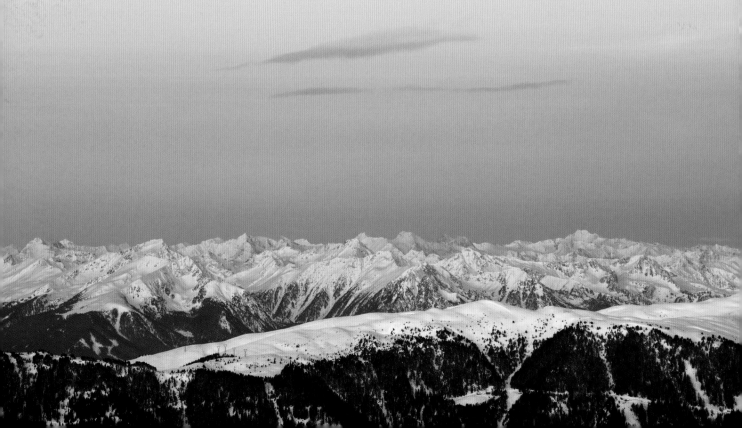

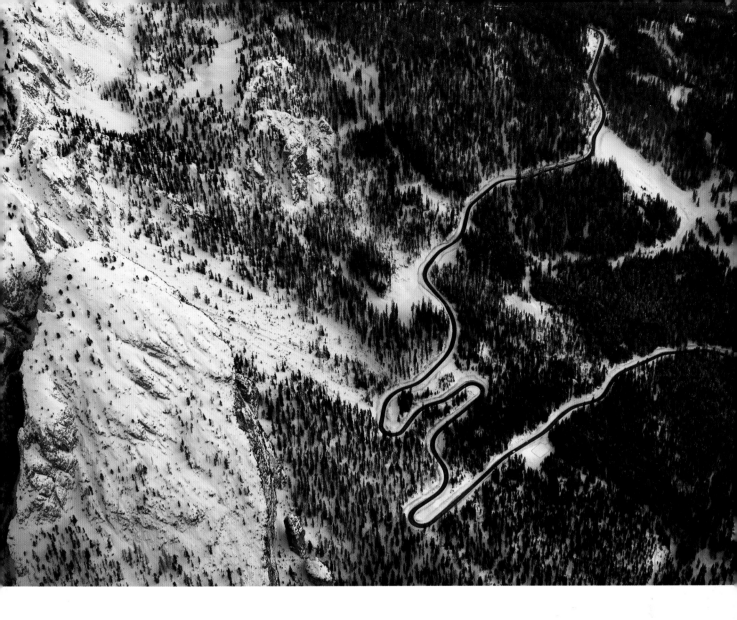

watch us plough through the snow up the slopes. The crisp, icy night air filled my lungs as I craned my neck in an attempt to take in the impossible expanse of the universe above me. All I could hear was the gentle sound of fresh powder compressing underfoot as my boots pushed through the snow.

Gradually, an inky blue light swathed the snow in all directions, filling the vacuum left by the fast-departing night. Dawn was stirring, but sunrise was still a way off. As we picked up the pace to get in position for the vista I had visualized, the sun quickly and unexpectedly broke on the summit of one of the peaks.

From a photographer's perspective, the window of opportunity at sunrise is drastically narrower than at sunset. For a sunset shot, you can arrive early, scope out the best angles for capturing the light and then wait. As the sun diminishes in the sky, the light gets better

and then continues improving. Generally, as you take more images, each new shot usurps the last. You can simply keep shooting until the light is no longer as good as it was in the previous frame, and then accept that you 'have it in the bag'. Sunrises are much less forgiving. There is generally a race to get in position, choose a lens and form a composition before the sun goes from a soft whisper to a full-volume roar. Like an unripe pear, if you take your eye off it for even a second, it is suddenly spoiled and brown in the bowl. It's the same with a sunrise, so this was the challenge I faced on this day.

There was still 800 metres (2,625 feet) or so to go before I could get to a clear, uninterrupted view of the Three Peaks, but to my left the sunrise began catching on the lesser peaks with outstanding brilliance. Soft pink tones bathed the mountaintops in a light I had genuinely never experienced before. I had a choice to make: attempt

⌃ A mountain pass winds its way through the
mountain range – photographed from a helicopter.

MOUNTAINS

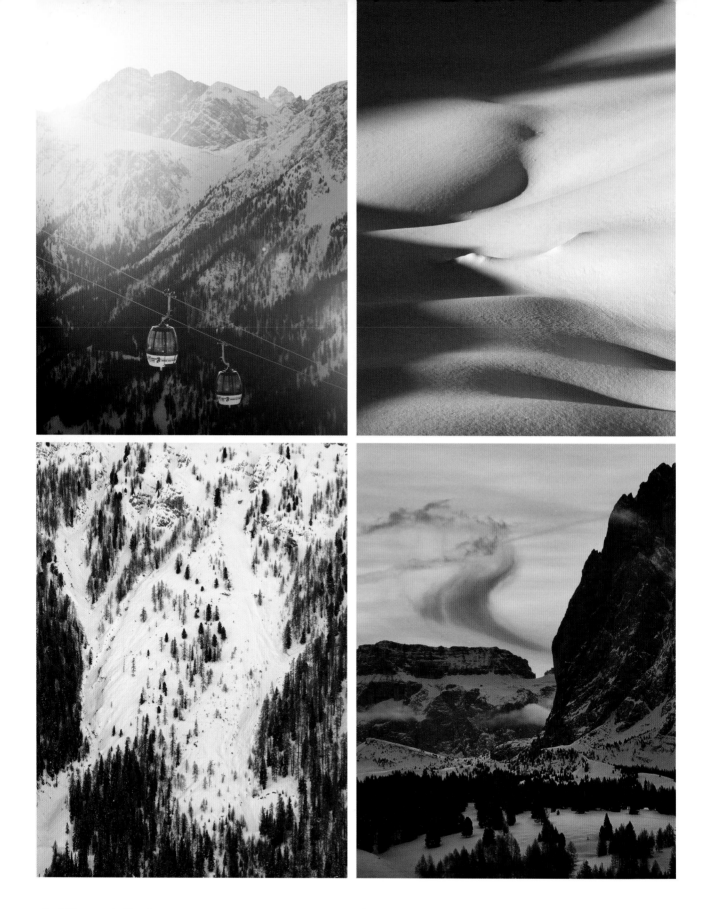

⌃ Cablecars on the Kronplatz.

⌃ Pine forest on mountain slopes.

⌃ Early morning light on a snowdrift.

⌃ Sunset at Alpe Di Siusi.

to trudge through the fresh snow to the viewpoint before the light matured into full daylight or stop where I was and quickly assemble the camera to catch the amazing light on a lesser mountain. My guide was in disbelief when I stopped and took off my backpack. He pointed frantically in protest to the distant viewpoint, but I was already shooting.

The incredible light I was witnessing is a phenomenon called *enrosadira*. This term literally translates as 'turning pink' from Ladin, the ancient language of the Dolomites' inhabitants. The spectacle, whereby many of the Dolomites' peaks glow a fiery red and pink at dawn and dusk, is due to the geological makeup of the mountains. The colour spectrum of morning and evening light is transformed by the calcium carbonate and magnesium carbonate in the rock, resulting in breathtaking natural hues. Muted blues and turquoises in the shadows were perfectly countered by the soft flamingo pinks of the sunlit peaks. Within a minute or two, the sun had crept over the distant ridge, and the balance was lost.

Had I persisted to the viewpoint, I would have caught neither the *enrosadira* nor captured the Three Peaks in the warm glow of sunrise. The resulting image from the hike turned out to be one of my favourites from the whole shoot (seen on pages 10–11). It wasn't of the mountain I was there to photograph, but it revealed more about the location's magic than if I had taken the intended image.

BEHIND THE LENS

I am frequently the last photographer left in a location when the light has 'gone' and others have packed up. But the light following the golden hour is unrivalled. There's tranquillity to be found in the voids either side of a highly saturated orange sunset. I will often wait until it is dark and then let the shutter stay open for seemingly unending exposures. That is when I find the most delicate of colours: beautiful blues and purples that drape the landscape in soft hues, transforming a scene with an otherworldly colour palette. Some photographers refer to this period as the blue hour, but I feel it doesn't quite capture the gradual shifts in hue and tone as dusk approaches, going from indigo to violet to blue as time passes.

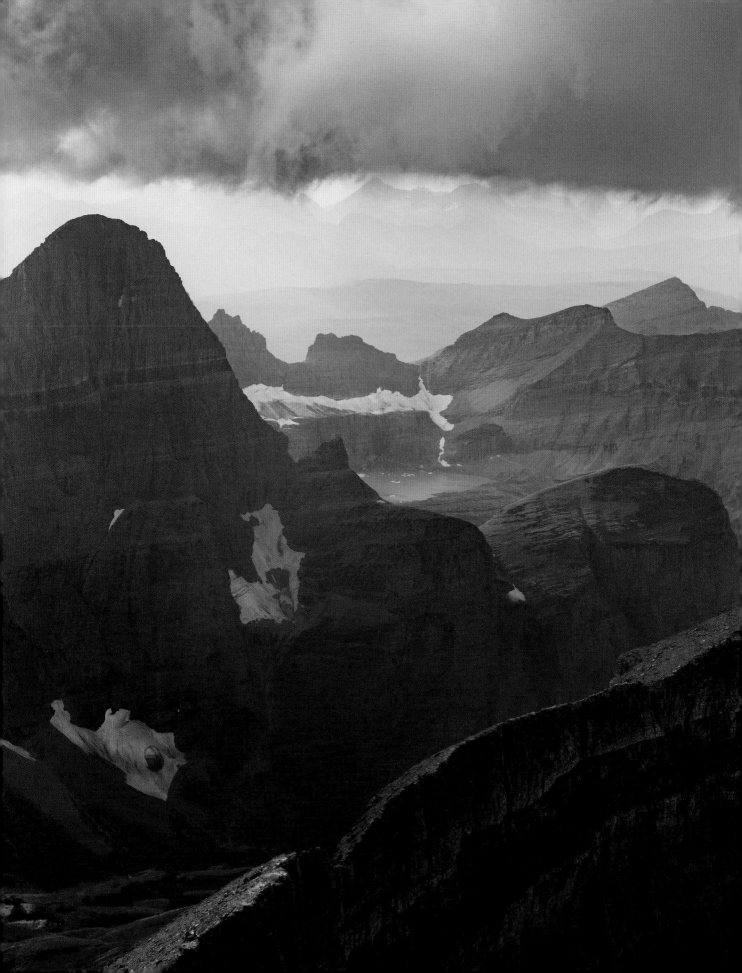

ALEX STROHL

THE LIVINGSTONE RANGE, MONTANA, USA

coordinates
48.7285°N, 113.6508°W

The Livingston Range is a rugged mountain range located in the US state of Montana near the Canadian border. Much of the range covers the western half of the Glacier National Park, a designated World Heritage site. Several peaks exceed 2,700 metres (9,000 feet), with the tallest being Kintla Peak. While these aren't exceptionally high for North America, the elevation gain from the surrounding flat-bottomed valleys makes them appear particularly dramatic on the horizon. Montana is home to several wilderness areas that make up approximately 14,000 square kilometres (5,400 square miles) of the state. These areas are thankfully shielded from industry, protecting them for generations.

❮ Looking over Upper Grinnell Lake and what
remains of the Salamander Glacier.

THE MOUNTAINS IN GLACIER PARK ARE SO HIGH AND DENSE THAT THEY CREATE THEIR OWN WEATHER PATTERNS...

I first saw these mountains in 2009, on a mad coast-to-coast road trip. As we approached from the east, the surrounding cornfields slowly transformed from plains of sweet grass to rolling hills, before eventually morphing into the extensive formations of limestone that climb high into the western sky and make up the Livingstone Range. I had never seen any landforms quite so dramatic, and that first glance of them through the windshield of my rusty Subaru will stay imprinted in my mind forever. Five years later, I was back – this time with my girlfriend and all of our belongings in tow, with plans to stay indefinitely.

Montana is one of the few areas where humans and the natural world exist in relative harmony, and I think that is what I find most appealing about life here. I love pure, unaltered places, and my passion for exploring the wilderness areas of Montana is always rewarded photographically.

The guidebook on Mount Siyeh reads, 'Don't go on a windy day, the summit towers shake like a bridge when a semi (lorry) passes over.' With that valuable nugget of advice in mind, my climbing partner, Isaac Johnston, and I picked a 'not too windy' day to climb the fifth-biggest peak in Glacier National Park. Or, at least, we thought we had. Through my experiences in the backcountry, I've learned that if you can hear the wind in the trees as you approach a climb, it's going to be very gusty at the top. This day was no different.

As we made our way through the larch forest, we could hear the sway in the canopy above. We knew we were going to be in for

⌄ Isaac walking towards Lake McDonald from Grinnell Glacier overlook.

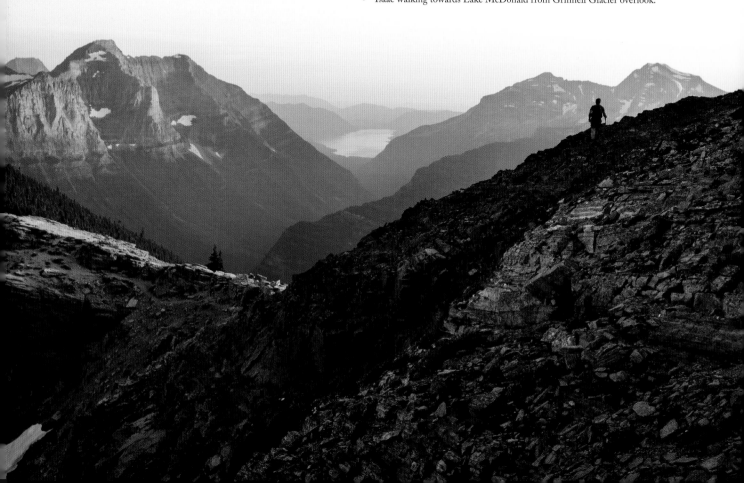

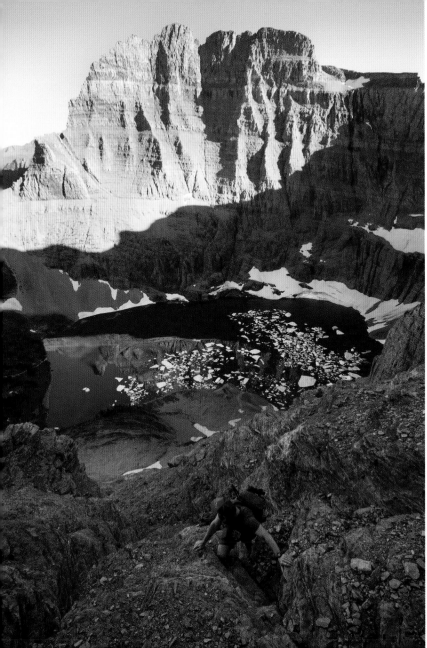

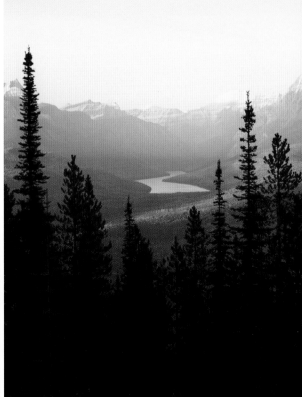

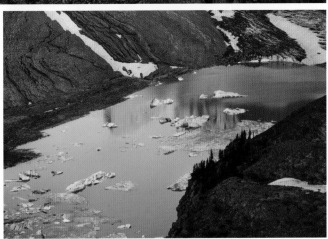

⌐ Isaac above Iceberg Lake on the Iceberg Notch scramble.

⌃ Bowman Lake seen from Cyclone lookout on an early autmn day.

⌃ Anchoring myself to the summit of Mount Siyeh on a 50mph wind day. Photo by Isaac Johnston.

‹ Blocks of ice from the Grinnell Glacier drifting on Upper Grinnell Lake.

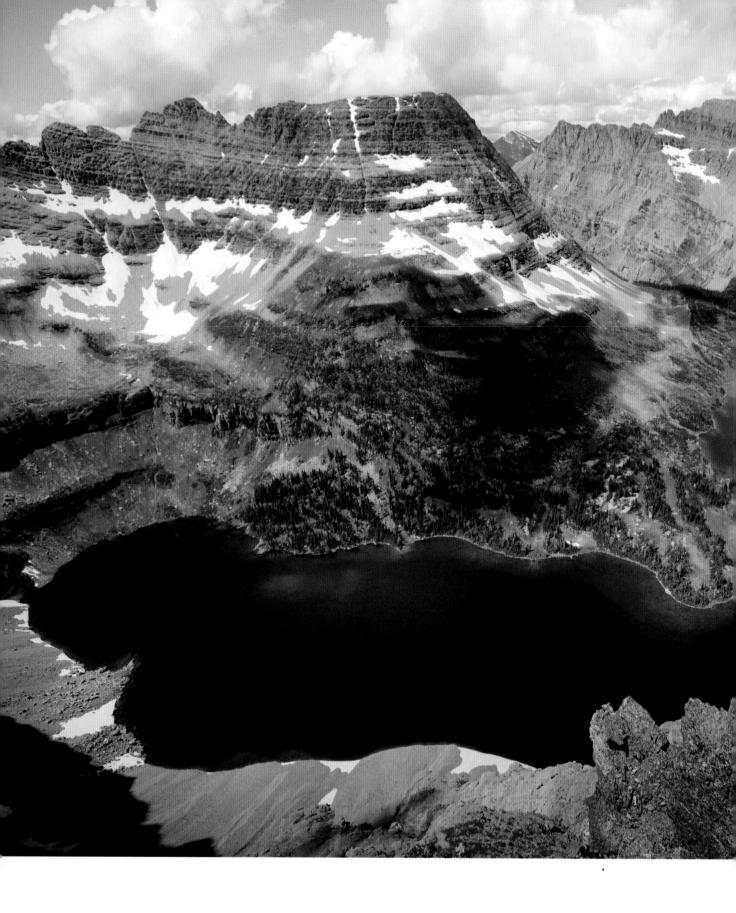

∧ Hidden Lake seen from a neighbouring ridgeline.

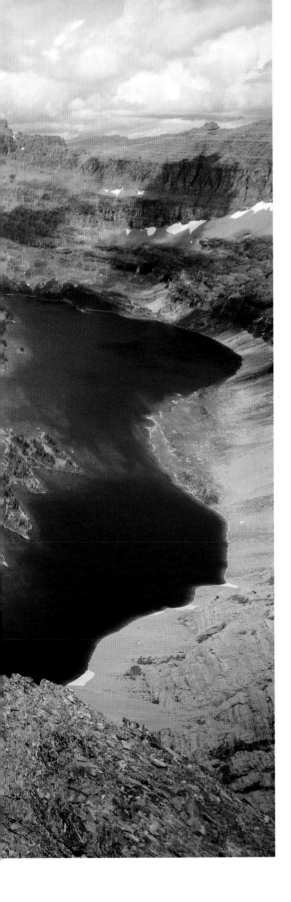

IT IS NOT THE WORLD OF HUMANS, AND THE ELEMENTS ENSURE IT STAYS THAT WAY.

a treat. The mountains in Glacier Park are so high and dense that they create their own weather patterns, yet because so few people live here, no one bothers forecasting it! Generally, the wind blows west to east, but we were conveniently sheltered from it because we were making our way up the south slope. As far as a northwestern Montana summer day goes, it was a good one. We were in our T-shirts, and the sun was warming our backs.

As we climbed, we passed a young man making a hasty descent. He had turned around on the ridge before the summit because the wind 'almost blew me off the mountain'. We thanked him for the warning and carried on. We didn't need to discuss this much, as we knew what the other was thinking. After an hour of scrambling up a scree field, we approached the arête, the sharp ridge before the peak, and the tremor of the wind became more apparent. Until that point, we had been living in a fantasy world where all was well.

We took to our knees as we peered over the top; the wind was so strong that we couldn't hear each other only a metre (3.2 feet) apart. We retreated to put on our shells and have 'the talk'. We had been in much more challenging situations before, and both have an intuitive feel for when we're pushing too far, so over a couple of energy bars we discussed a plan. Since we were about 600 metres (1,970 feet) shy of the summit, we would walk as far as possible from the 300-metre (1,000-foot) drop off to our left. If the air started shaking us, we would lie on our chests and wait for the gust to end.

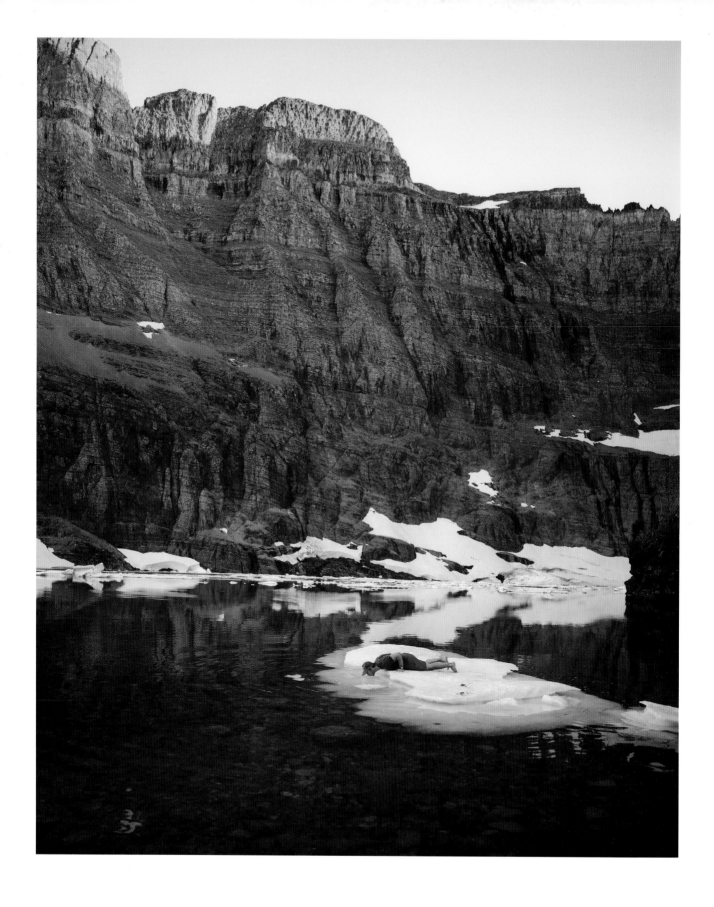

∧ Isaac takes a sip from Iceberg Lake upon return of the Iceberg Notch.

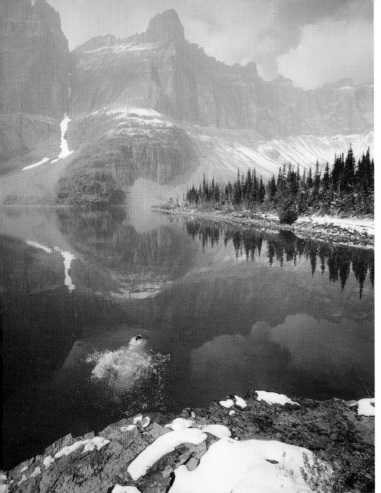

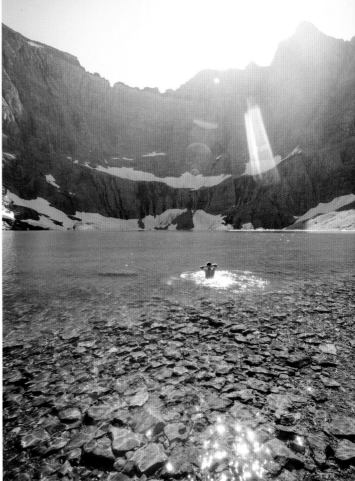

BEHIND THE LENS

I like using a polarizer filter when photographing glacial lakes, as it allows me to see what is under the surface of the water. Polarizers cut the reflection from the sun and reveal the hidden treasures below – which is mostly interesting-looking rocks. It's a relatively cheap trick that can make all the difference to your photographs.

⌃ Noah Couser goes for an early fall freezing dip into Iceberg Lake.

⌐ Tucker taking in the hot summer sun in Iceberg Lake.

Having formulated a (loose) plan, we pushed on towards the summit. Despite the frigid gusts, we neared the top towers with relative ease, but that's when things got a little more real. A screaming blast dropped us both to the ground. We waited for it to pass, but it took a solid 30 seconds, which feels like an age when you're being pinned to the ground by a gale. Once it felt safe, we gingerly stood up and started taking pictures of Cracker Lake, a stunning saucer of emerald blue 1,200 metres (4,000 feet) below.

Moments later another gust dropped us to our knees. We waited it out and stood again. In total, we must have only stayed about 4–5 minutes on the summit, and half that time we were either on our knees or bellies. The guidebook was correct: we were perched on a massive rock, precariously balanced over the towers below – it looked like a giant Lego set – and we could feel the ground tilting in the wind, ever so slightly, from one side to the other. It was awesome.

We were happy we persevered; we had the summit to ourselves, took some epic photos, and the wind certainly added to the adventure. It served as a reminder that these places are here for us only to pass through. It is not the world of humans, and the elements ensure it stays that way.

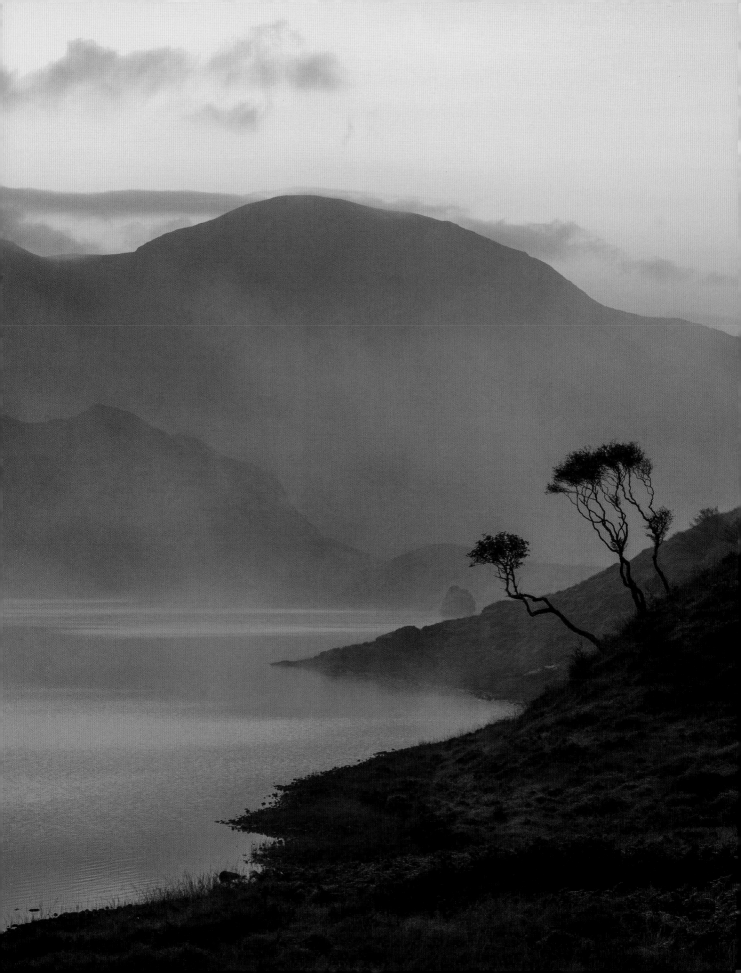

RICHARD GASTON

THE CAPE WRATH TRAIL, SCOTLAND

coordinates
START: CAMUSNAGAUL 56.8277°N, 5.1238°W
END: CAPE WRATH 58.6252°N, 4.9988°W

The Cape Wrath Trail is an unmarked walk 386 kilometres (240 miles) long through Scotland's most spectacular and demanding landscapes. The adventure takes two-and-a-half weeks to complete and runs from Fort William to the northwesternmost point of mainland Britain, Cape Wrath. The route ventures through Scotland's wildest regions, encountering the country's grandest mountains, sleepiest glens, highest waterfalls and most remote beaches. It is regarded as one of the UK's most challenging long-distance routes, and only a handful complete it annually. Only possible through the use of bothies and wild camping for accommodation, it is the very essence of Scottish outdoor culture.

⟨ The penultimate day. We were gifted with a beautiful crisp morning in the far north of Sutherland, Loch Stack. Only 30 miles to go.

THE ROUTE
VENTURES
THROUGH
SCOTLAND'S
WILDEST REGIONS...
THE COUNTRY'S
GRANDEST
MOUNTAINS,
SLEEPIEST
GLENS, HIGHEST
WATERFALLS, AND
MOST REMOTE
BEACHES.

I had always wanted to complete the Cape Wrath Trail. My love of the Highlands runs deep, and the idea of pushing north until you can't physically go any further was appealing. After the first Covid-19 lockdown came to an end, it seemed the perfect time to undertake such a challenge.

I was to travel with my old friend David Cooper. We chose to visit in September, mainly to avoid midges (they die out around the end of August). At this time of year, the days are still long, relatively dry (or so we thought) and moderate in temperature. And, of course, it's the beginning of beautiful autumnal conditions. We packed lightly – only essential, functional items; a nod to sustainable living and consuming less – and set out for the north.

Day one served up a yellow weather warning for rain – an excellent introduction to the cape. We grew accustomed to it after the first eight hours of persistent rainfall, though wading through a river in a full downpour at the end of the day sapped of energy nearly broke me.

We soon formed a routine, walking around 24 kilometres (15 miles) each day before searching for somewhere to sleep at night. Boggy moorland, lush glens, winding rivers, mountain passes, rugged coasts, lochs, waterfalls, white sand beaches and tarmac roads – the latter being the most taxing – made for tough going. Our mood would visibly diminish during the final few miles until a campsite was declared. We ate meals from packets and hoped for a good night's rest, conscious of what the following morning would bring.

⌄ Fog rolling in over the hills and hovering above Loch Stack.

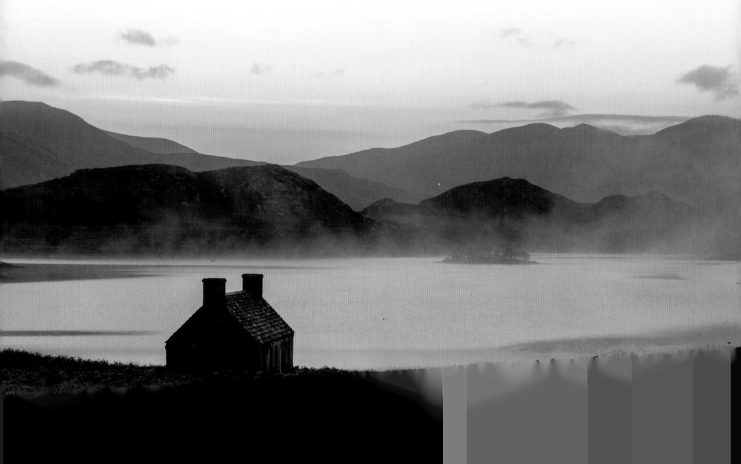

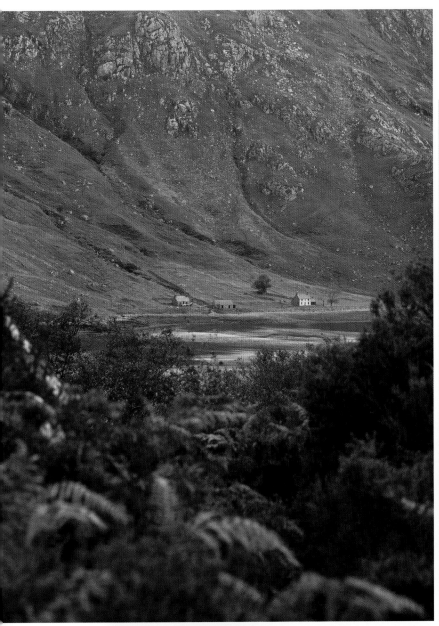

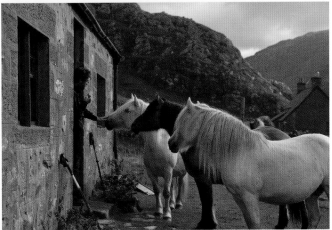

┌ Bashing though the bracken, I was greeted with a peak of Glendhu.

∧ Approaching the Am Bealach of Ben More Assynt.

⟨ Confident, curious, playful, bold and boisterous are the words to describe these horses as they barged their way into the bothy.

THE LIGHT, WHEN IT BROKE THROUGH THE BLUE-GREY SKIES IN A GREAT BEAM, WAS GOLDEN AND LIT UP THE LANDSCAPE, BURNISHING IT ORANGE.

Each day brought a new challenge as we negotiated the landscape. Ascending bealachs (narrow mountain paths) and bashing through wet bogs became major mental hurdles to overcome, at points making us doubt our ability to complete the route. We found it easier to follow meandering rivers, which led to yet more unspecified glens. Each bealach led us over the shoulder of a mountain and down into a different loch, the occasional abandoned house the only interruption to the endless wilderness.

The further north we travelled, the more rugged the land became. It was barren, sparse and forever wet underfoot. There was no escaping the rain, and the weather determined everything: our mood, where we would set up camp, how far we could walk in a day and where and when we could eat.

We encountered a few others along the route: some older lads drinking beer as they took a pit stop, a couple who had just finished university and a lone girl attempting the route barefoot. She had very little equipment; a black bin bag for a bivvy (small tent) and a bag of carrots for dinner. So much for us packing lightly!

It was autumn and deer rutting season. The rut echoed in the glens day and night and became our soundtrack for 17 days straight – the silence in between broken only by the tinkle of streams, birds trilling and the endless buffet of the wind. The light, when it broke through the blue-grey skies in a great beam, was golden and lit up the landscape, burnishing it orange. Early morning mists, shifted pink by the breaking dawn, gave way to the warmth of the day, providing some comfort until it was robbed again by the night.

Despite the ardour, it was worth it, from the Eas a' Chual Aluinn waterfall glowing in the morning sun and a wash of rain to the enchanting Glendhu Bothy, where wild horses ran from the hill to greet us. Not to mention the gift of a beautifully crisp morning over

∧ The morning light catching Glencoul Bothy and Britain's highest waterfall, Eas a' Chual Aluinn, in the background.

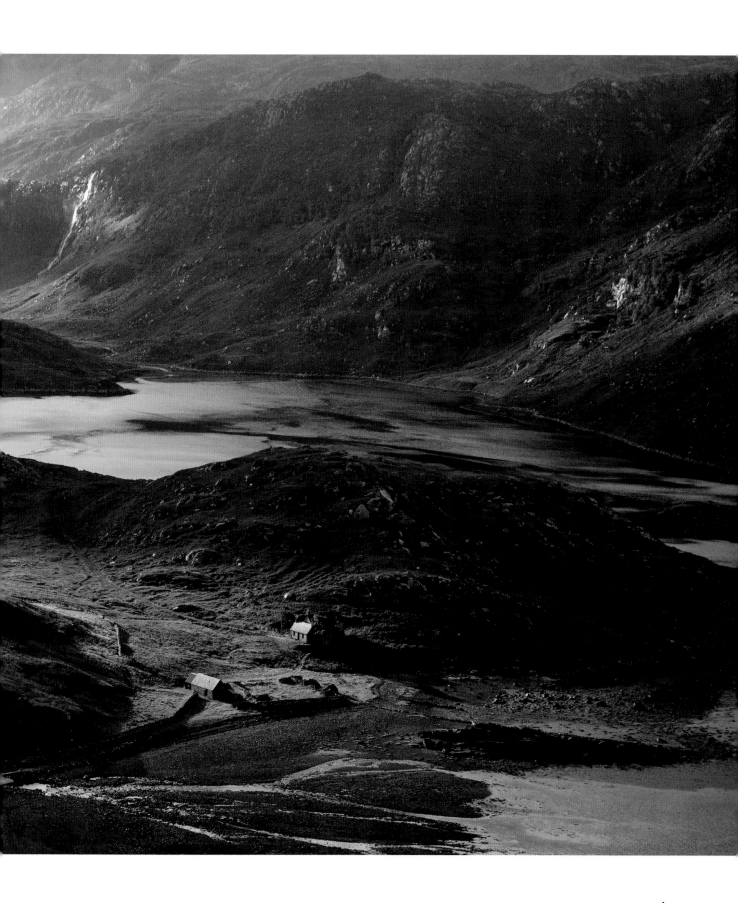

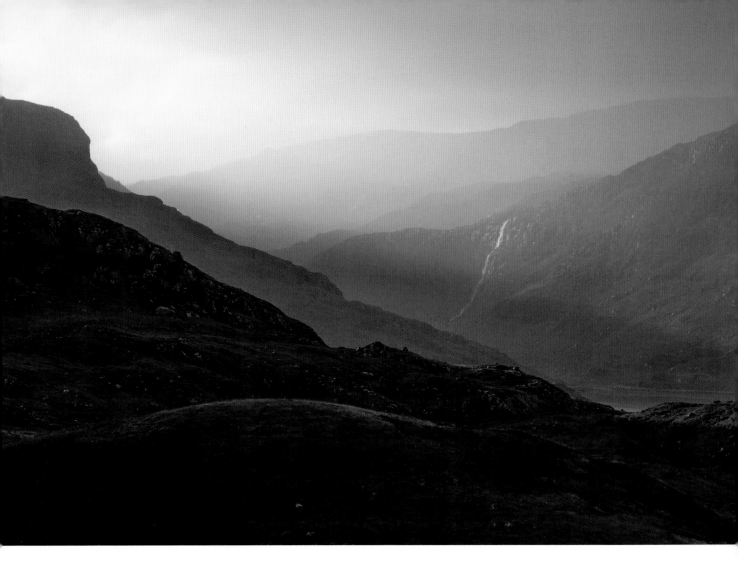

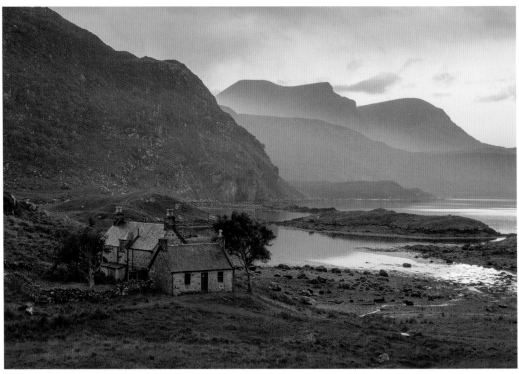

∧ My favourite moment from the trip; Eas a' Chual Aluinn waterfall glowing in the morning sun and a wash of rain.

〉 Morning at Glencoul and the hills of Quinag.

∨ From the Am Bealach of Ben More Assynt, looking down to Loch Assynt where the sun emerged through the rain clouds, illuminating a beautifully situated house.

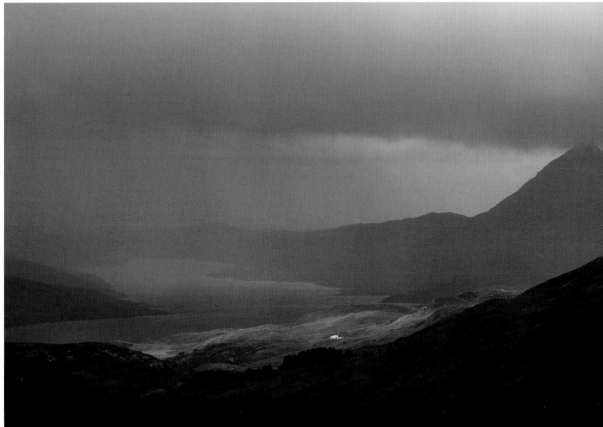

BEHIND THE LENS

The weather moves fast in the Highlands, so you need to be ready for picture opportunities. Have your camera accessible, i.e. not at the bottom of a bag. A clip that attaches to your shoulder or waist strap is ideal. I usually shoot with a long lens but I found myself using a wider focal length on this trail, since most subjects are within close proximity. A blessing really, as every ounce you carry needs consideration – cutting down on weight where possible is essential.

Loch Stack, and a hazy evening at Loch Clair as the sun set behind Liathach. Cape Wrath offers a bleak yet captivating landscape. It is rare in features, but rich in atmosphere. It's a stark contrast to where we come from.

'Character building' is a phrase often used to describe the experience of time in the wild. It's a battle of patience and determination, which does wonders for your resilience and ability to manage life. Ultimately, I was left itching for more time in the rugged beauty of the Scottish Highlands. The Cape Wrath Trail comprises 277 square kilometres (107 square miles) of moorland wilderness which separates it from the mainland, unconnected by road. You can travel from Glasgow to Fort William by bus or train and then take a short ferry from Loch Linnhe to Camusnagaul, where the walking begins. Iain Harper's guidebook, *Walking the Cape Wrath Trail,* will provide you with a recommended route with many alternative options. I found the west coast the most beautiful, and suggest steering in that direction. Ultimately, there is no designated route; you choose your own way, and that's the beauty of the Cape Wrath. There is no fixed path, much like life. It is what you make it.

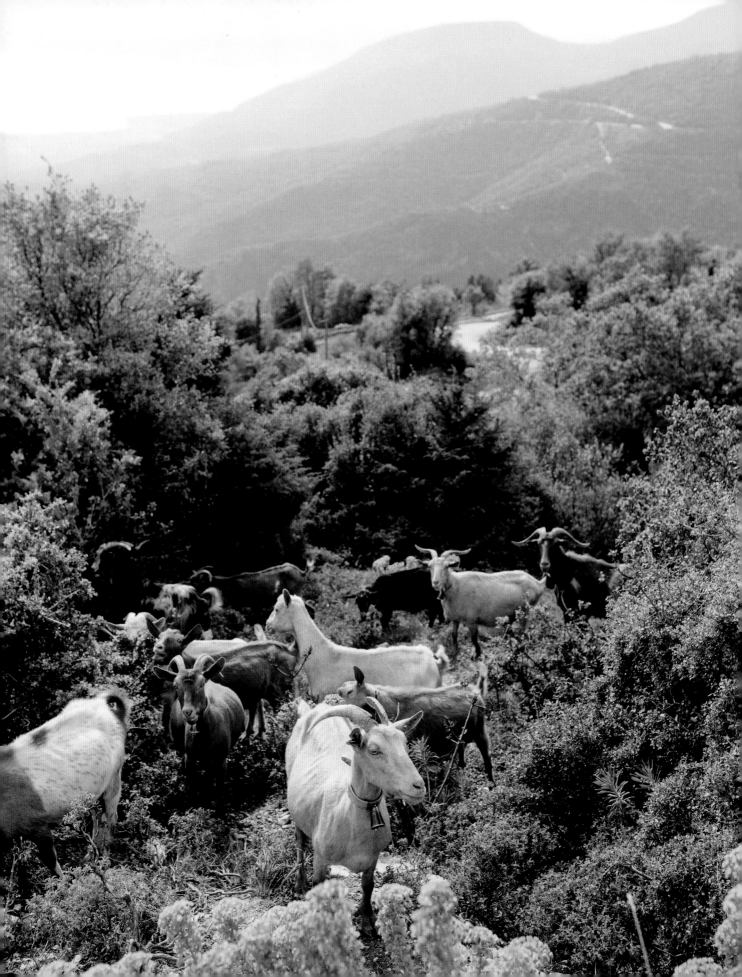

FINN BEALES
PELION, GREECE

coordinates
39.4383°N, 23.0475°E

What springs to mind when you think of Greece?
One of the 6,000 islands scattered throughout the
Aegean and Ionian Seas? Beautiful for sure, but if that
is where your knowledge stops, you're missing a trick.
Hiding in plain sight, halfway between Athens and
Thessaloniki on the Greek mainland, you will find
Pelion. A fascinating, time-locked part of the world
where the mountains meet the sea, Greek Gods come
to holiday, and the mythological centaur originates.

〈 The sound of goat bells ring in the morning air, as their
shepherds herd them over the foothills of the mountain.

LIGHT SPARKLES AND DANCES ON THE SEA BELOW AND THE SMELL OF PINE COMPLETES THE ENSEMBLE.

Mount Pelion forms a peninsula running south between the Pagasetic Gulf and the Aegean towards the island of Skiathos. Stone villages with pretty cobblestone streets hug its slopes, and the sound of distant goat bells fill the air. Light sparkles and dances on the sea below and the sweet smell of pine completes the ensemble.

There is a deep sense of harmony here, a balance between the modest needs and traditional working methods of the locals. Sustainability isn't a buzzword, it's a given. It feels a little like time has passed it by, along with the cheap flights and package holidays that have impacted its neighbours – a survivor perhaps. In days past it was used as a peaceful retreat for Christian Monks during the crusades, and all these years later, Pelion still remains a perfect place to escape.

Like most, I hadn't heard of Pelion before a random message from one of my workshop students arrived via Instagram. A simple invite to make photographs of a beekeeper, shepherd and fisherman led me to a mountain thick with the long-forgotten past. A place of pine tree forests, olive groves and fresh springs that wound through quaint villages steeped in stories. All the ingredients were present. It was my kind of place.

A warm wind greeted our first morning there and carrying with it, the sound of goat bells – an early introduction to Kostas, the shepherd who walked his herd in front of our house. He stopped long enough for me to photograph him roll a cigarette under the shade of a spiny thorn tree, and smiled as I asked for 'just one more'. He obliged and rolled on, his goats scattering like marbles in front of him. It's this sort of experience that delivers that old-world feeling. Somewhere untouched by mass tourism.

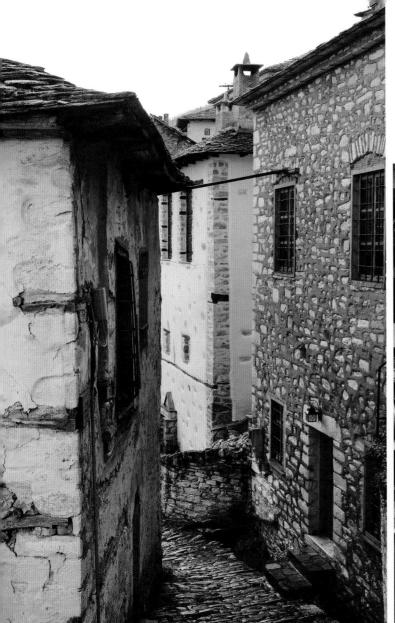

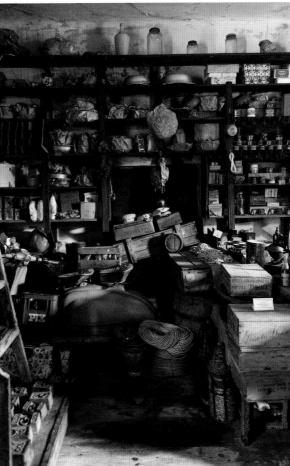

‹ Characteristic cobblestone streets in Pelion.

˅ Dimitris Papadopoulos's hardware store has remained largely undisturbed for over 40 years. Stacked with memories, the store is a portal to a bygone times.

The villages feel ancient, and the houses are testimony to a prosperous past and a pastoral economy where self-sufficiency was a necessity in order to survive. Situated on a steep slope overlooking the Pagasitikos Bay, Ano Gatzea is one such village. Well off the beaten track, Dimitris Papadopoulos' hardware store, was once at the bustling heart of Ano Gatzea. It has remained mostly undisturbed since the doors closed for the last time following his death over 40 years ago and his grandson Giorgos showed us around. A fascinating place, I could have spent all day there – timeworn, memory-stacked, and no plastic wrapping in sight.

The following afternoon, we hired a couple of horses in Agios Lavrentios and, vowing to cover more miles in the time we had, continued to explore on four legs. Passing through damp oak forest, we dismounted in search of mushrooms for that evening's pizza. The hunting grounds were perfect - deep piles of leaves underfoot. A musty, comforting smell erupted as we revealed Chanterelle, Parasol and Morchella fungi.

Emerging from the woods, we met Eleni outside her small farm surrounded by baby goats and chickens. We talked a while, mostly about apples. Pelion is renowned for its orchard fruit, with pride of place going to the Firíki. Originally an Egyptian variety, it is small and oval in shape, intensely fragrant and a little tart. Delicious. We parted company laden with firíki and some fresh eggs for breakfast.

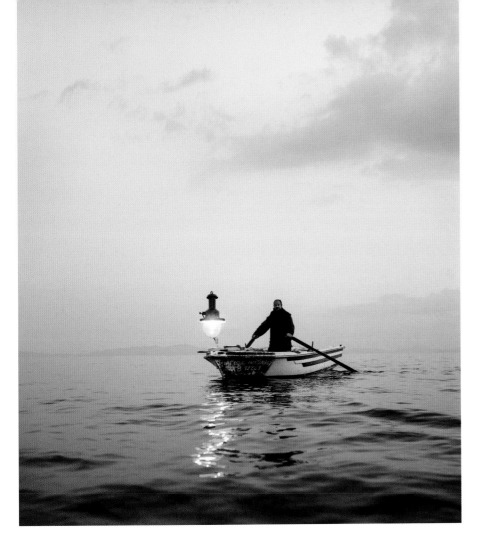

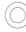

BEHIND THE LENS

Head down to the coast at dusk and you might be lucky enough to catch the night fishermen as they head out to sea for the evening. Known as *pirofani*, from the words fire (πυρ) and light (φανός), they fish using a large lantern at the bow which attracts specific species to their boats. Shoot with a fast lens at blue hour (the hour just after sunset) and capture the orange glow from their gas lamps bobbing on the water. It makes for the perfect complementary colour combination: blue and orange.

〈 Vaios heading out to sea under the light from a full moon.

The following day I spent the afternoon photographing Thomas, a beekeeper responsible for over 250,000 bees. A great bear of a man, Thomas' hands were tattooed with stings, but he didn't flinch once as I photographed him checking the health of his brood. His bees play a vital role in the pollination and survival of the flowers and plants on the mountain, which in turn are responsible for the survival of Kostas' goats who graze on them. The goats supply the mountain folk with meat and milk, continuing the cycle, and that's before we even get to the honey! Such farming techniques are age-old, and similar methods were once practised throughout the world. Yet, in our quest for convenience, I fear we have forgotten them. We left with a few jars inspired to establish a hive of our own back home.

A breakfast of yoghurt topped with a drizzle of wildflower honey preceded a day at the beach. Steep steps led to a sleepy cove divided in two by a massive stone arch. The sound of water lapping gently at a pebble shore. We floated in the turquoise sea and

absorbed unobstructed views across the Agean – a welcome slip in time until curiosity interrupted my break from the day.

Intrigued by the large lantern sitting pride of place at the bow of a fishing boat, I arranged to shoot Vaios, a 'night fisherman', later that evening. There were no blanket trawl nets aboard his vessel, no belching engine for chasing catch across empty seas. Vaios, an ex-professional rower, is smarter than that. Attracted by the light burning bright above the water, the fish come to him, just as moths are drawn to a flame. Vaios spends up to six hours at sea each evening, slowly rowing back and forth, selecting the fish he takes according to size and species.

Pelion is undoubtedly beautiful, but meeting and photographing the locals who produce food in a way that is in tune with their environment was the most inspiring aspect of my visit. Life is about balance, and there are lessons to be learned from Pelion.

FINN BEALES

VOLCANOES NATIONAL PARK, RWANDA

coordinates
1.4321°S, 29.5666°E

Situated in the northern provinces of Rwanda, Volcanoes National Park protects the steep slopes of a majestic range of mountains. Home to the endangered golden monkeys and chimpanzees, and covered in a dense bamboo forest, Volcanoes National Park is named after a chain of sleeping volcanoes that make up the Virunga Massif straddling the border between Rwanda and the Democratic Republic of Congo. It is one of Africa's most prized, untouched parks and in 2018 was expanded to better protect its most famous inhabitant: the mountain gorilla.

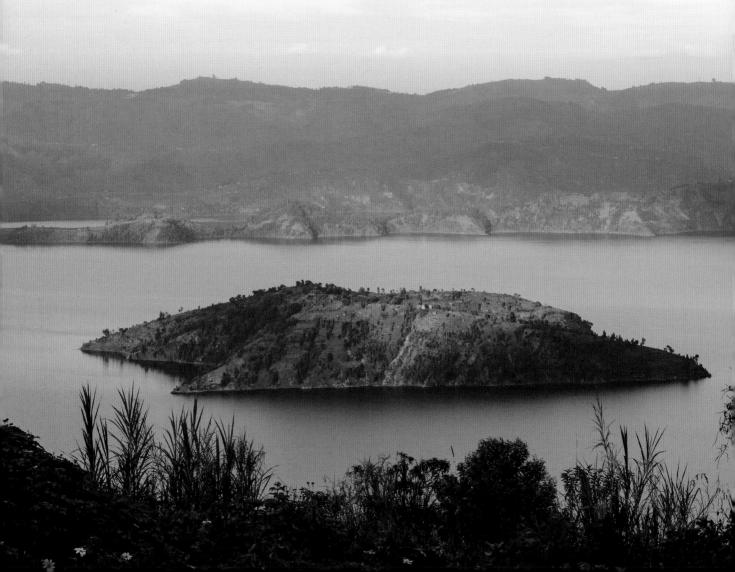

...THE SWEET SCENT OF EUCALYPTUS AND CHARCOAL SMOKE DRIFTED THROUGH OUR OPEN WINDOWS ON A WARM WIND.

Like most who visit, I wanted to spend time with the park's most famous residents: the mountain gorillas. As their name suggests, they live at altitudes of around 3,050 metres (10,000 feet). Mountain gorillas are one of the most critically endangered species in the world, so it's heartening to hear that the population in Virunga has grown by 25 percent since 2010 as a result of conservation efforts. Permits to visit are strictly controlled and not cheap at $1,500 (£1,050) per person, at the time of writing, but the high price keeps levels of tourism manageable and pays for the protection of the gorillas' habitat.

I was travelling with friend and journalist, Emma Barlow, and we arrived in Kigali, the bustling capital of Rwanda, late in the day, and after a night in the city we travelled three hours north to Volcanoes National Park in a 4x4. We caused mayhem on the outskirts of town when a bus full of school children spotted my camera and started waving. They leaned far out of the windows, shouting and smiling, eager for me to take their picture. 'Land of a thousand smiles!' joked our jovial driver, Tumaini Kalisa, from the front seat.

The journey north is an experience in itself. We passed fields of beans, peas, sweet potatoes and bananas, while the sweet scent of eucalyptus and charcoal smoke drifted through our open windows

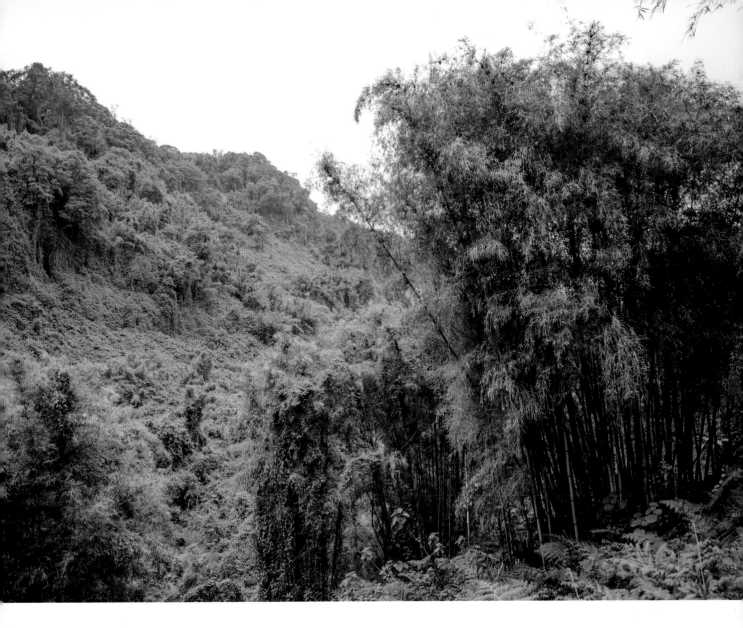

Thick bamboo forest covers the volcano.

A sparsely inhabited island sits in a huge freshwater lake.

on a warm wind. The terrain began to change as we wound up steep slopes before descending into dark valleys on the other sides. 'Land of a thousand hills!' laughed Tumaini.

We eventually arrived at Virunga Lodge, sitting high above the plateau overlooking one of the volcanoes that makes up the park. The hotel staff seemed excited about what was to come. 'It's an extraordinary experience,' they kept telling me. We retired early, knowing that finding gorilla begins at the crack of dawn. The following day, I was stirred from slumber by the sound of the hotel manager Elesi singing a melodic tune as he approached my lodge, before his knock on my door pulled me sharply from my dreams. 'Today is the day, Finn! They are waiting for you,' he proclaimed.

Hiking an extinct volcano covered in thick bamboo forest in search of mountain gorilla is no stroll in any old park. The vegetation is dense, and it is hard going. We moved slowly, as our

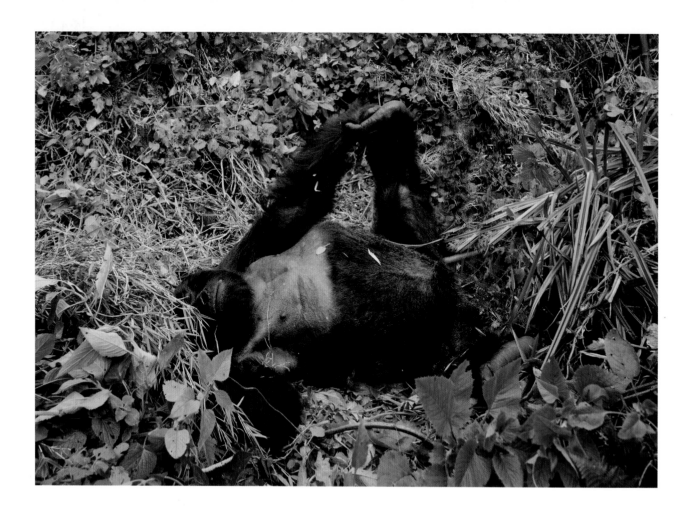

⌃ Gorillas do yoga too.

ONCE I FELT HIS ACCEPTANCE, I EVER SO SLOWLY BEGAN TO INTRODUCE MY CAMERA.

trackers called out in low grunts or coughs to mimic the apes and warn them of our approach. There are 12 families in the park, each with a dominant male silverback at the head. We were tracking a clan sired by Agaysha, meaning 'special one'. His family is large, with 27 members. As we proceeded, our guide, Patrik, pointed out spots where the gorillas had rested and made their nests. He also showed us how they peeled bamboo with their teeth to reach the soft stems inside. I was surprised to learn they rarely drink water, instead quenching their thirst with the vegetation they eat.

There was little warning before we came across a large female breakfasting on bamboo in a clearing at the bottom of an inactive crater. It was a tense encounter, for me at least, but I soon relaxed and became fascinated by her movements and seeming similarity to ourselves. Patrik began signalling excitedly. He beckoned to follow him under the arch of a low hanging branch. 'The special one!' he exclaimed, grinning from ear to ear.

Agaysha heard my approach and turned his giant silver back to face me, fixing his deep brown eyes on my own. I knew instantly who was in charge and bowed my head slightly in deference, a signal he seemed to acknowledge. Once I felt his acceptance, I ever so slowly began to introduce my camera. He seemed curious, so I started to photograph him using the screen on the back of my camera to frame

❯ Looking along terraced valleys from the road towards
Volcanoes National Park.

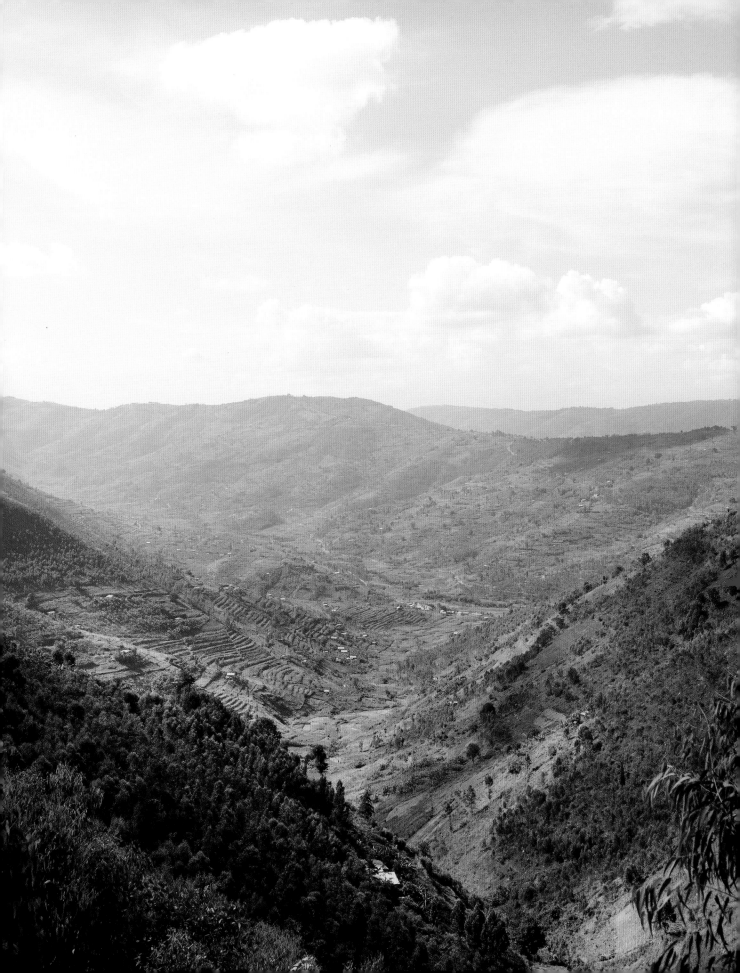

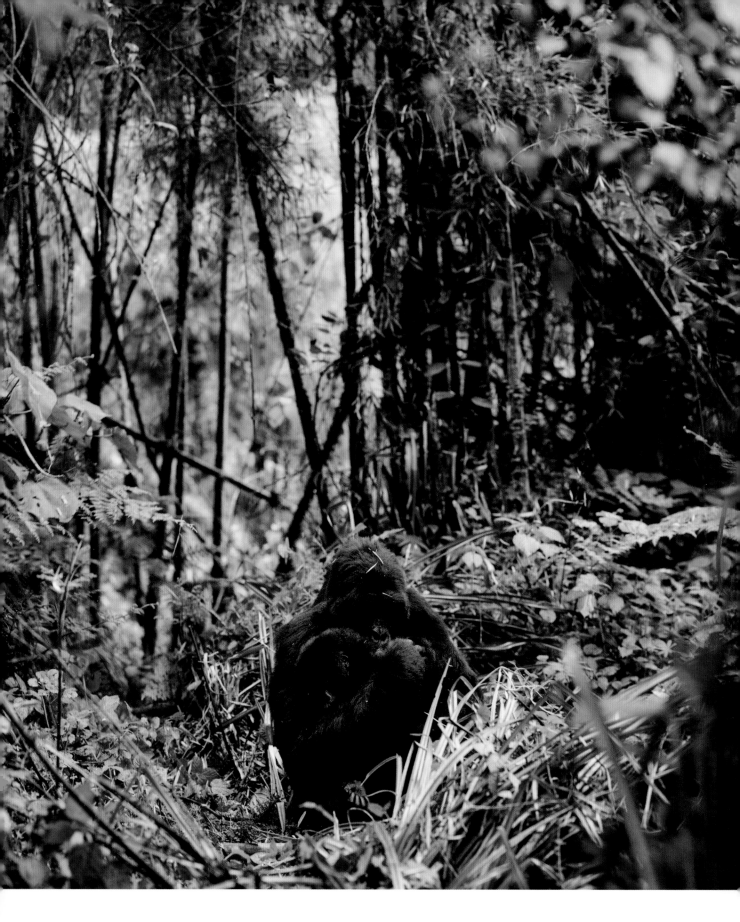

LET'S GET LOST ⌃ Mother and baby find some quiet time in a clearing in the bamboo.

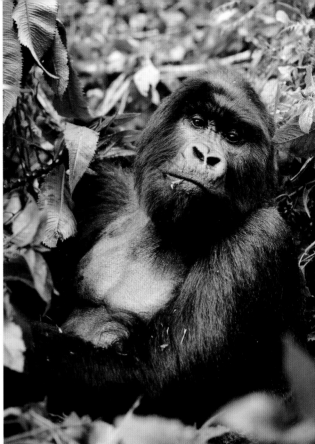

BEHIND THE LENS

Photographing gorillas isn't so different from photographing people. Eye contact and body language are crucial. Don't start excitedly snapping away. Get comfortable with your subject, and let them do the same with you. Introduce your camera slowly and frame your shots using the LCD on the back of your camera so you can maintain eye contact. You can glance down at the screen now and then to check your composition.

⌃ Thick bamboo forest cloaks the mountainside, providing food and cover for the Gorillas.

⌐ The dominant male Silverback, Agaysha, holds my gaze as I take his portrait.

him. I didn't want my camera to cover my face; eye contact and body language felt essential in this situation. I was close to him, close enough to touch, but he wasn't in the least bit threatening and he let me photograph him and his family for the hour we were permitted to spend with them. Being around these animals is an incredibly unique experience, and if you're lucky enough to get the opportunity, do make some memories for yourself away from the camera. The hour you have with them will pass all too quickly.

When our time was up we retreated in silence, backtracking the way we came. I was stunned; it had been one of the most extraordinary hours of my life and with the anticipation of meeting the gorillas now behind me, I could more readily take in my surroundings. The forest was dense with thick, ringed, tree-like trunks of bamboo. I caught the quick flash of a golden monkey crisscrossing the canopy overhead. An odd-looking beetle crawled across my camera bag, before it was quickly whisked away by Patrik: 'Lucky that didn't bite you.' He flashed me a smile before rolling up his sleeve to reveal a nasty scar. 'Not to be messed with.' he declared.

We returned to our lodge, high above the valley below. The sound of singing and beating drums floated in the air. I looked across at the volcano from where we had returned. Sunlight pierced the rain clouds swirling the summit, and bold rays lit up the bamboo forest. I whispered my thanks to Agaysha. It was clear to me how this special gorilla had earned his name.

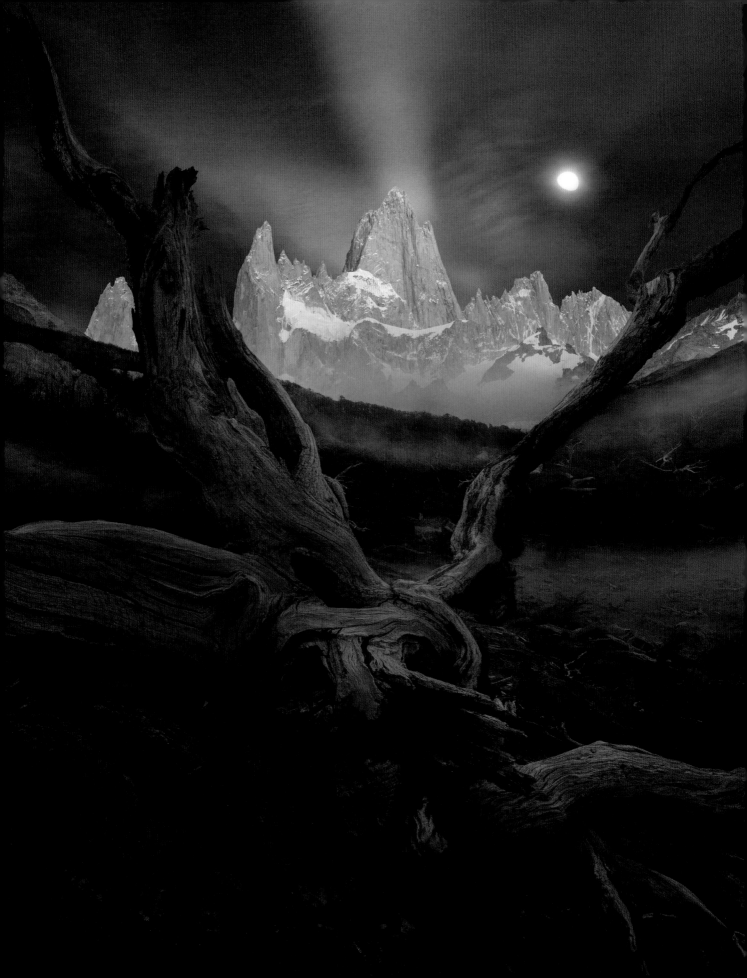

CATH SIMARD
PATAGONIA, ARGENTINA AND CHILE

coordinates
41.8101°S, 68.9063°W

Patagonia is a spectacular land of snowcapped mountain peaks that frame glacier-fed lakes, waterfalls and an eclectic mix of flora and fauna. The region is rugged and the weather is moody. Be ready to hike long distances, wake up in sub-zero temperatures and shoot in extremely windy conditions. You have to work hard for your shots here; however, the scenery and natural splendours on offer are so mind-blowing it makes all these inconveniences worthwhile. The physical barriers to entry ensure tourist numbers stay low. It remains pure and unspoiled, and all the better for it.

...THE SURROUNDING CHAOS BROUGHT ME A SENSE OF PEACE.

I've always been attracted by Patagonia's mountains and the remoteness of the region as a whole. I'm obsessed with glacial lakes and jagged peaks, and this area has them in abundance. It's the perfect place to go offline and disconnect from the outside world.

With the conditions being so challenging, you have to choose carefully the time of year you visit. December through to February are the warmest months, but also the busiest and usually when the winds are at their strongest. If you can brave colder temperatures, I find it's best to go in March and April, which is autumn in the southern hemisphere. During these months, the autumn colours are incredible – March especially so – the winds are less severe and there are better chances to see wildlife.

There are so many locations to visit and experiences to be had in Patagonia. Landing in El Calafate is one of the best ways to start a trip. From there you can rent a car and drive to El Chaltén, named Argentina's Trekking Capital, where I recommend spending at least a week. Most trails start from the village and present incredible scenery after only a few kilometres of hiking. One highlight is Laguna de Los Tres, a small glacier lake up in the mountains that sits at the base of Mount Fitz Roy.

From El Chaltén you can retake the road and cross over the Chilean border to get to the Torres del Paine National Park, home to a series of breathtaking mountains, valleys, rivers and lakes. I wanted to scale the Cuernos del Paine, also known as the 'Paine horns', a collective name given to a set of spiky granite peaks, all of which stand at over 2,000 metres (6,600 feet) high.

⌄ A view of Cerro Torre, Laguna Torre, El Chaltén.

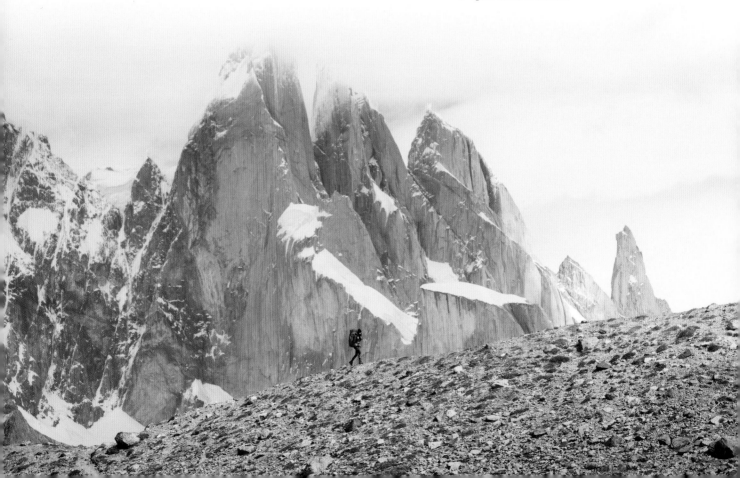

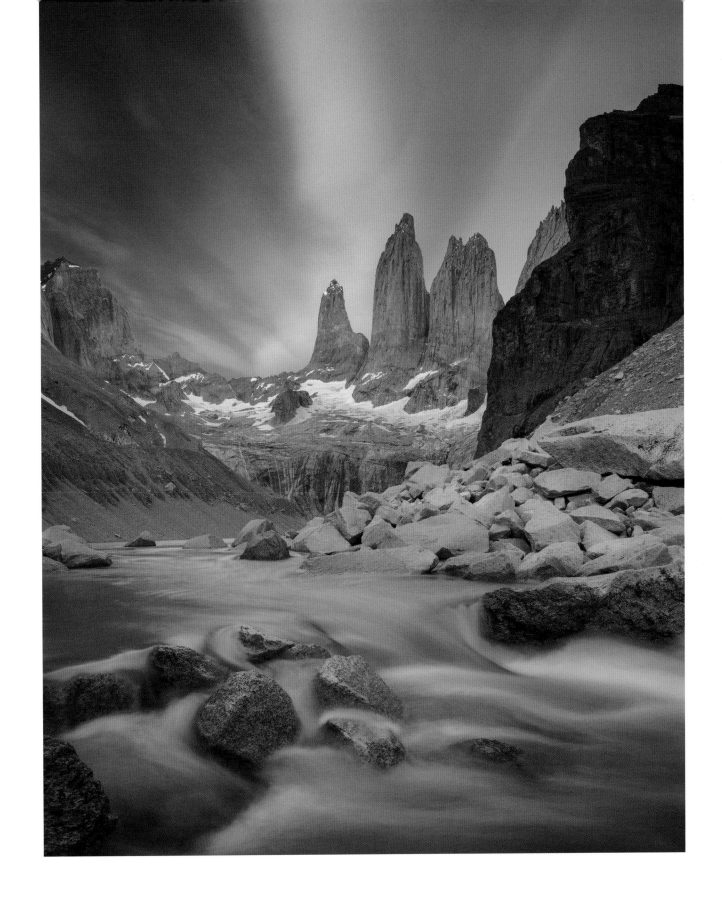

∧ Sunrise at Base de las Torres, Torres del Paine
(a view of Las Torres).

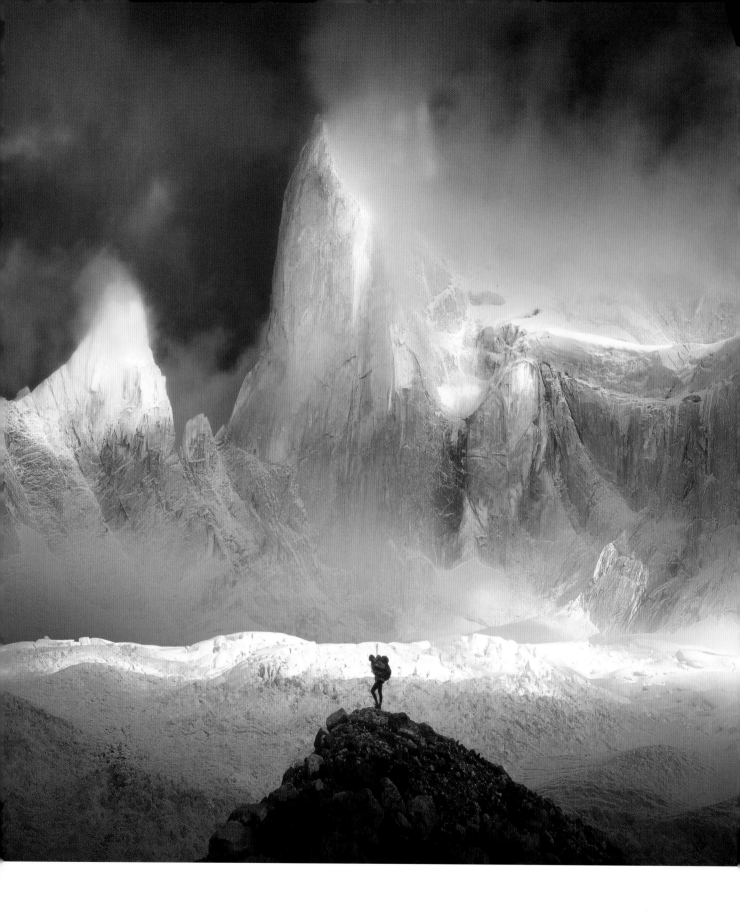

∧ Morning light on the way to Laguna Sucia, El Chaltén (Fitz Roy in the background).

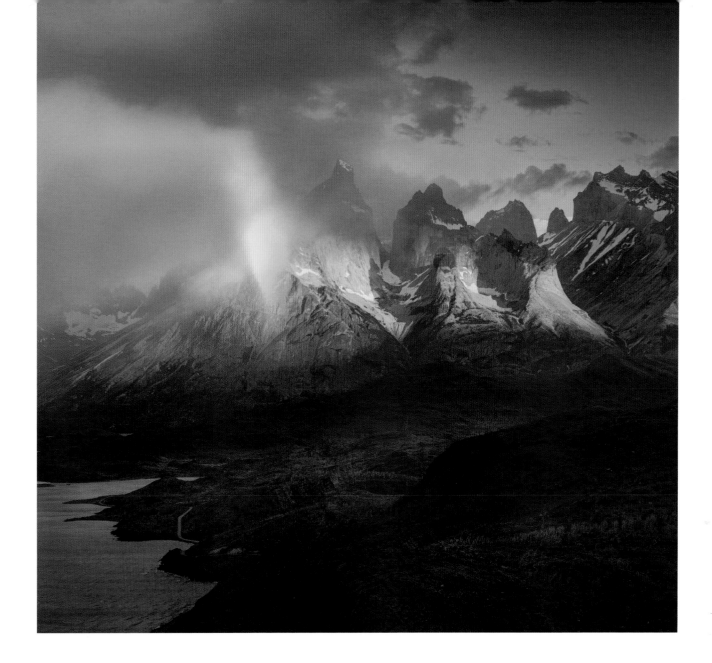

Sunrise is usually the best time to photograph the landscape of Torres del Paine, when the skies are typically the clearest. Sunset is generally cloudier, but if you're lucky you'll catch the light behind the peaks and capture a beautiful display of colours. For those who don't mind hiking in the night, I recommend starting extra early to catch the sunrise at the top, where you'll witness the most intense alpenglow. It's a beautiful, hard-earned reward for those who complete the demanding hike.

We woke at 6am, after a short and cold night camping in the mountains. My hands and feet were cold, and my backpack was heavy with all my camera gear. I set out in the dark, headlamp on. The winds were ferocious – around 120 kilometres per hour

(75 miles per hour). The ascent was steep and the wind kept pushing me down the muddy trail that had been flooded by the previous night's rainstorm – the same one that had left all our equipment wet. An hour after we had set off, on the final switchback towards the top, the faint silhouette of Los Cuernos slowly appeared, standing tall in the sky. At the summit, the wind was even worse. I sheltered behind a huge rock, crouched down, awaiting the sun. With my camera on a tripod and my hair blowing everywhere, I struggled to keep my equipment still and take a shot. Everything felt chaotic, but, bizarrely, the surrounding chaos brought me a sense of peace. After the sun hit those noble mountaintops, a rainbow emerged from the rain. I

Sunrise at Mirador Condor, Torres del Paine
(a view of Los Cuernos).

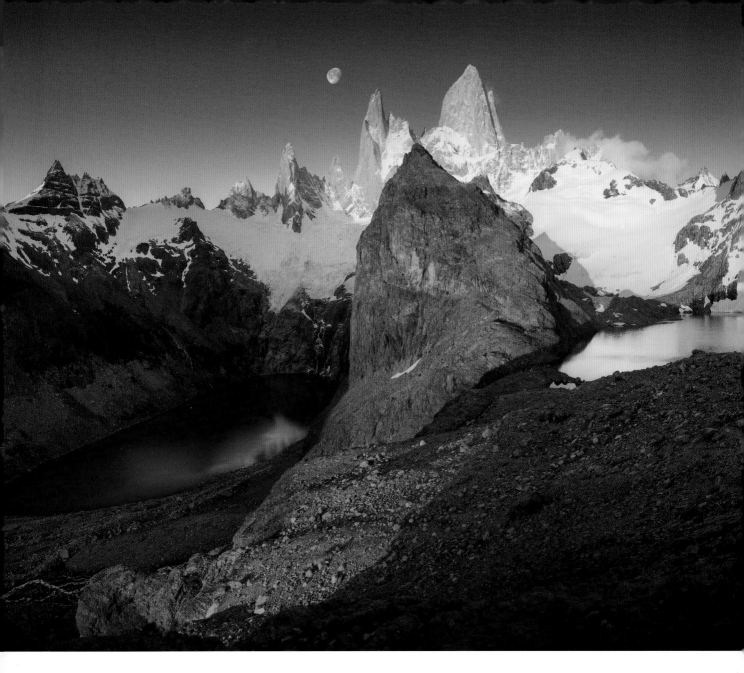

couldn't believe my luck to capture so many extraordinary elements all in one frame.

Patagonia has some of the fastest-changing weather in the world; it can go from hard rain to sunny within minutes. It's better to brave the elements and come back with nothing than it is to stay in the comfort of your room and miss out on a shot. More often than not, I've found that even in the worst conditions there will be a window when you're able to shoot.

I was exhausted after my Cuernos del Paine climb, but decided to give it one last push and pursue another landmark before leaving the park. When it struck midnight I began a 20-kilometre (12-mile) hike to catch the sunrise at Mirador Las Torres. The first few kilometres in the dark were the hardest, a steep 400 metres (1,312 feet) of elevation gain in under 2 kilometres (1.2 miles). So many times on the ascent I considered turning back; the lure of sleep was strong, but I knew I would only regret it. Three hours and 10 kilometres (6 miles) later, I reached the base of the columns; three distinctive granite peaks. This place was the reason I came to Patagonia: a magnificent, dazzling turquoise glacial lake nestled in a mountainous valley and surrounded by three giant pillars of rock. It has always had a hold on me. It felt like time stopped still for a moment. The immense beauty made me forget the cold and my exhaustion, and I sat quietly, patiently waiting for the sun to paint the towers in red.

⌃ Sunrise at Laguna de los Tres, El Chaltén (Fitz Roy in the background).

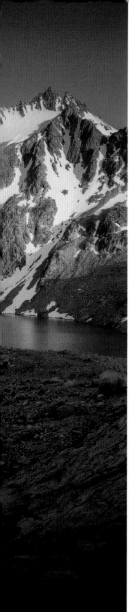

BEHIND THE LENS

Patagonia's landscapes are immense and a wide-angle lens is a must.
You can get really close to the peaks in many locations, so it's essential to
have a large field of view to photograph the scene before you in its entirety.
With its dark skies, Patagonia is also ideal for astrophotography, so bring
a fast lens to capture the canvas above. A long telephoto lens would be an
added bonus to allow you to focus in tight on the towering mountain peaks.
When the weather was stormy, or there wasn't enough time to hike to a
vantage point, my 100–400mm lens saved the day.

⌄ A blend of night and sunrise, halfway between dreams
 and reality. Mirador Cuernos, Torres del Paine.

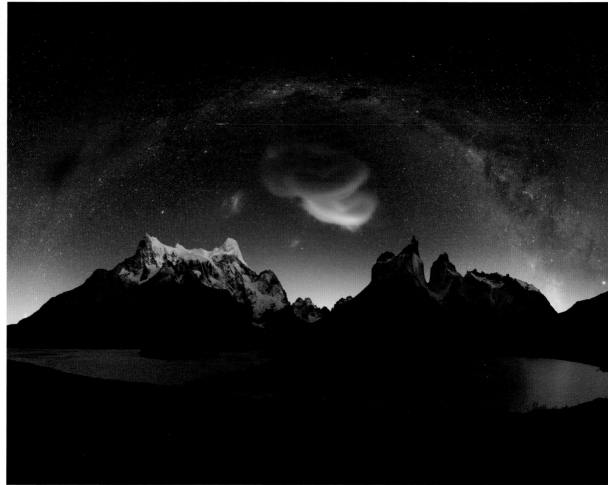

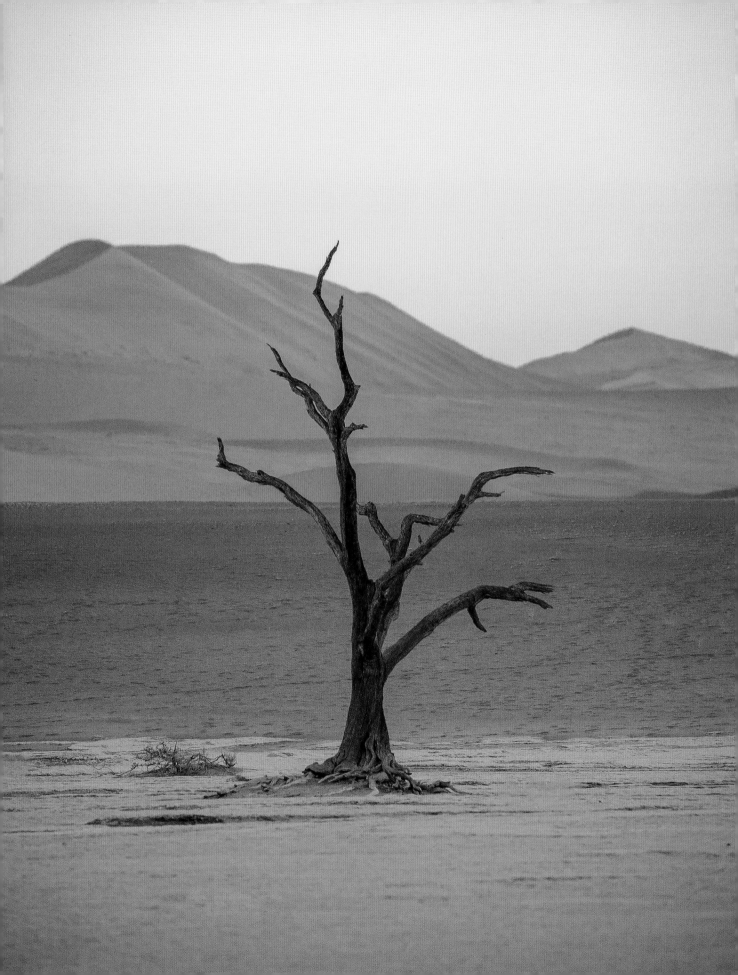

EMILIE RISTEVSKI

NAMIBIA

coordinates
22.9576°S, 18.4904°E

Located on Africa's southwest Atlantic coast, Namibia stretches over 800,000 square kilometres (310,000 square miles) and is considered one of the oldest deserts in the world. *Namib* means 'an area where there is nothing' in the local language, and, on first glance, the featureless dunes, bleached white riverbeds and clear blue skies bear out that description. However, there is far more to these ancient, fragile landscapes than first meets the eye. Namibia is a transformative land, rich in wildlife and somewhere that remoulds itself in the ever-changing light. You need do nothing more than simply spend some time in the region to fully appreciate its majesty.

❮ A lone tree standing within a sea of sand and vibrant orange light, Deadvlei.

WILDERNESS

59

IT'S A CURIOUS FEELING, WANDERING THROUGH THESE LANDS WITHOUT ANOTHER SOUL IN SIGHT...

On leaving Windhoek, Namibia's capital and the country's largest city, the scenery immediately elicits an otherworldliness. Namibia is a vast land with one of the lowest population densities in the world, and the surrounding silence underscores these truths.

One of the oldest and largest deserts in the world, the Namib stretches inland from the Atlantic Ocean, covering large swathes of Namibia. It has been dry for over 50 million years, and in some of the most arid parts the average annual rainfall is just 2mm (0.08in). Considered to be one of earth's most extreme environments, it would be easy to think that nothing could survive in the region. However, life finds a way. Namibia is home to some of Africa's most unique flora and fauna. Many species have learned to adapt to the harsh climate, such as the desert elephant and the endemic Namib desert beetle, to name just two.

It's a curious feeling, wandering through these lands without another soul in sight, and one that adds to Namibia's unique atmosphere. In the wide-open spaces of the desert, under the burning sun, the scent of Namibian Myrrh, which is similar to citrus, fills the air. I was in complete awe when walking beneath the skeleton trees in the middle of these sun-scorched plains. Hundreds of years old, they are petrified and preserved. Lost, but still standing. You'll find a new perspective still from above, whether that's by hiking to the top of one of the tallest dunes or floating

⌄ Hundreds of African oryx running through the golden desert light, Maltahöhe.

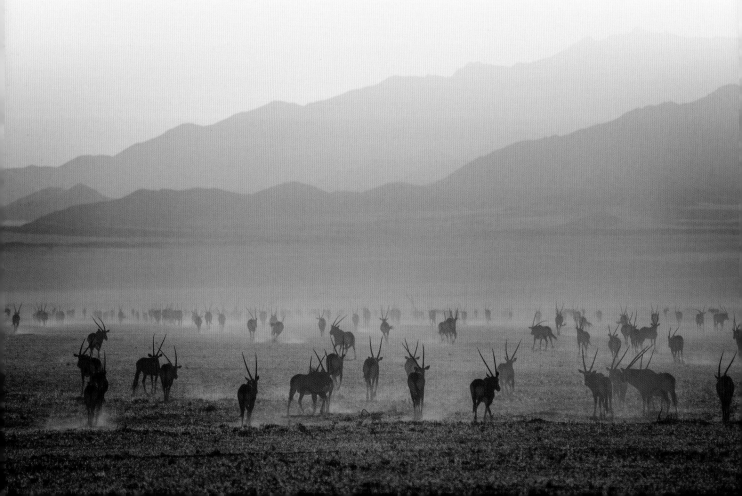

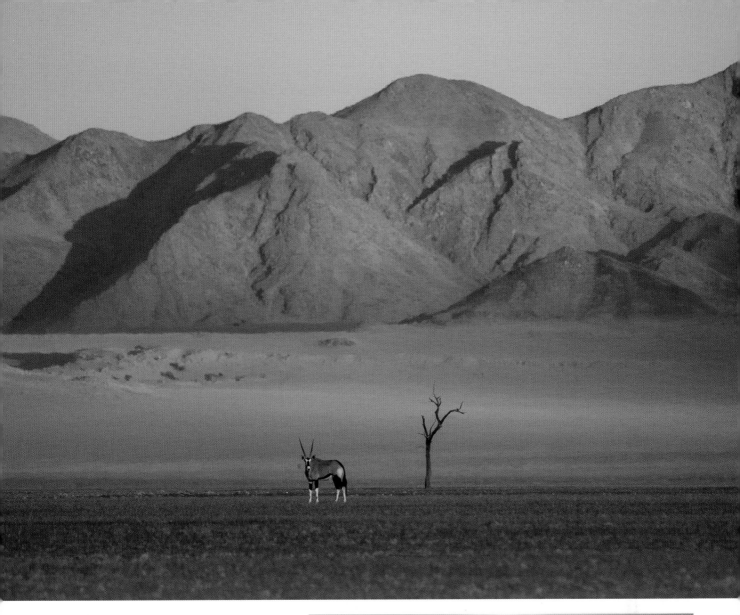

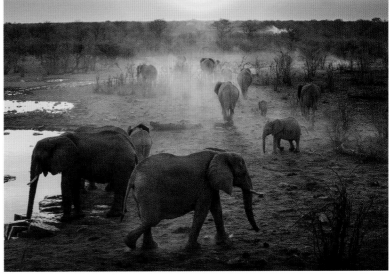

∧ A desert oryx standing alone among the
open desert plains of Maltahöhe.

❭ Golden dusk, as a family of elephants drink
from the waterhole, Etosha National Park.

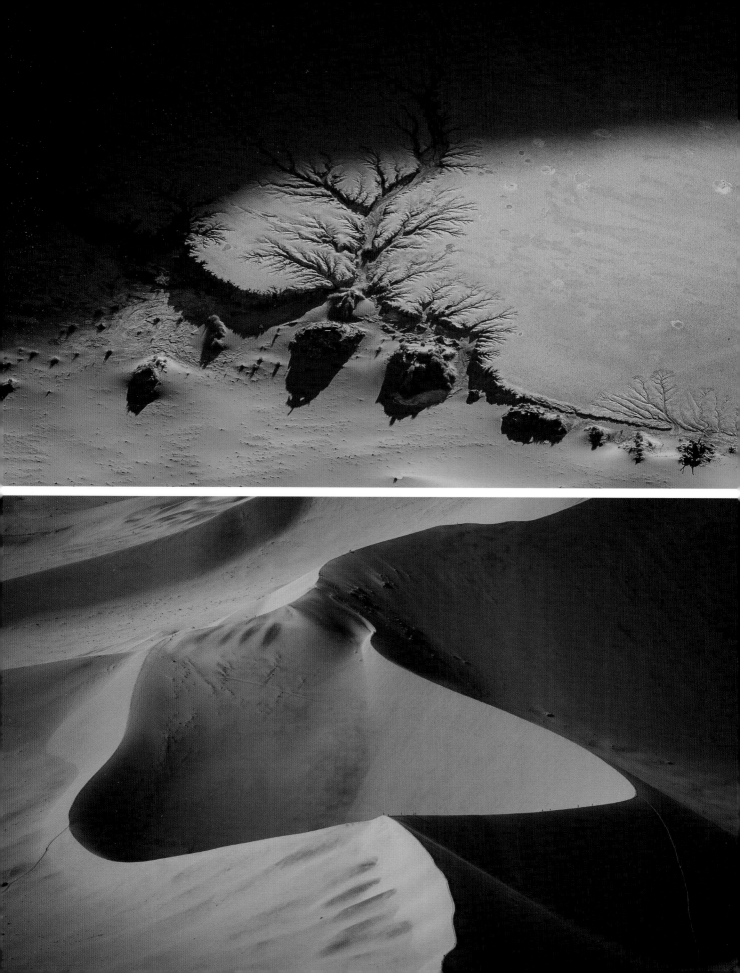

over the desert in a hot air balloon. You can only truly appreciate the immense scale of this place from the air.

On the desert plains of Maltahöhe, I experienced a rare natural event one evening. Significant rainfall had brought with it the migration of 10,000 African oryx. They crossed the empty savannah searching for watering holes, kicking up billows of sun-filtered dust as they passed and creating clouds of gold in the sky. It was an unforgettable sight – one that even our guide and those in our group who were local to the region had never observed before.

For a photographer, these lands are pure eye candy. The intense desert light casts harsh shadows and forms textures and patterns that shift with the sun as it tracks across the sky. It's excellent light for shooting the dunes; a rare occasion when the strong contrast between bright light and harsh shadow works in your favour. However, when the sun sinks low, the landscape changes again. Ethereal colours and shapes present themselves to your lens. Under the cloak of night, clear skies offer incredible stargazing opportunities. Come daybreak, without fail, the desert yawns awake and forms anew.

From the endless burnt orange dunes of Sossusvlei to the windswept beaches along the Skeleton Coast, the granite peaks of Spitzkoppe and the plains filled with wildlife in Etosha National Park, Namibia is a land of vast and untold beauty. The richness of this landscape challenges the idea that this is an area of complete emptiness. Instead, it is a place full of majesty and endless wonder.

⟨ An aerial view of the dried riverbed patterns, surrounded by a desert white clay pan, Deadvlei.

∟ Abstract sand dune details, Sossusvlei.

⌄ Time stands still amongst the skeleton trees lost in the ancient riverbed in the middle of the desert, Deadvlei.

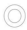

BEHIND THE LENS

Namibia's deserts are continually shifting and changing with the light. Watch the sand glow bright orange as the first light shines upon the dunes. The orange colour comes from specks of iron mixed in with the sand, creating beautifully rich tones that are enhanced by the soft rays of sunrise and sunset. Look for leading lines cast by shadows, especially in the harsh midday light, and play with compositions using a range of different focal lengths. Try going from a wide-eye 16–35mm lens to a long and narrow 70–200mm to create more depth.

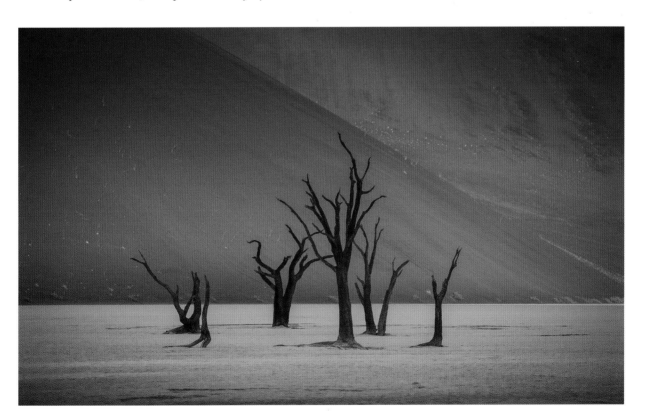

REUBEN WU

THE PASTORURI
GLACIER, PERU

coordinates
9.9133°S, 77.1836°W

The Pastoruri is a cirque glacier, and one of the last
that still exists in the tropics. Located in the southern
part of the Cordillera Blanca, this glacier is receding
at a shocking rate due to climate change in northern
Peru. As a result, there has been a considerable
drop in tourism and an inevitable impact on the
local community. So while the region is an extreme
environment and wilderness area, it is technically a
small tourist destination, albeit one in severe economic
and environmental decline. Nevertheless, getting up
close and personal to this glacier is a magnificent sight
to behold. Seeing its epic scale, hearing its sounds and
standing at the dizzy heights of the altitude make for
an unforgettable experience.

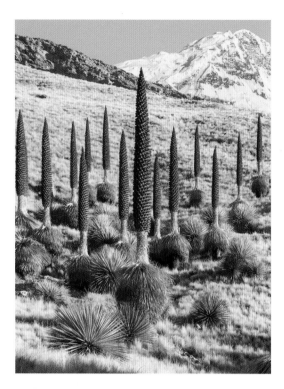

∧ Puya Raimondi trees located on the valley slopes.

I travelled to Peru in July 2018 to photograph Pastoruri for my Lux Noctis series. Lux Noctis is a personal project of mine where I use a powerful LED light mounted on a drone to illuminate landscapes under the cloak of darkness. The work is about presenting familiar sights in a new and unfamiliar light, renewing a sense of seeing and reliving the experience of discovery. After exploring and photographing much of the American West, I wanted to go further and photograph glaciers and ice landscapes using the same aerial lighting technique. However, considering the glacier is situated at around 5,250 metres (17,200 feet) above sea level, I was aware it would be a physical and mental challenge. I was also planning to photograph it at night and in freezing conditions, making it an even more daunting endeavour.

We flew into Lima and then took a long bus ride to the mountain city of Huaraz, capital of the Ancash Region in the northern Callejón de Huaylas valley. Our drive from there to the glacier took around 3–4 hours in a 4x4. Access was difficult, over sparsely inhabited terrain. I had the distinct feeling we would be in serious trouble if we were to break down. As our elevation increased, the temperature decreased, and my head felt lighter and lighter. Rich orange-hued grasses covered the landscape as we drove, and the valley slopes were dotted with thousands of giant *Puya raimondii* bromeliad trees. They looked like alien seed pods; an extraterrestrial invasion just waiting to happen.

∧ Serene view of glacier and ice landscape situated above sea level.

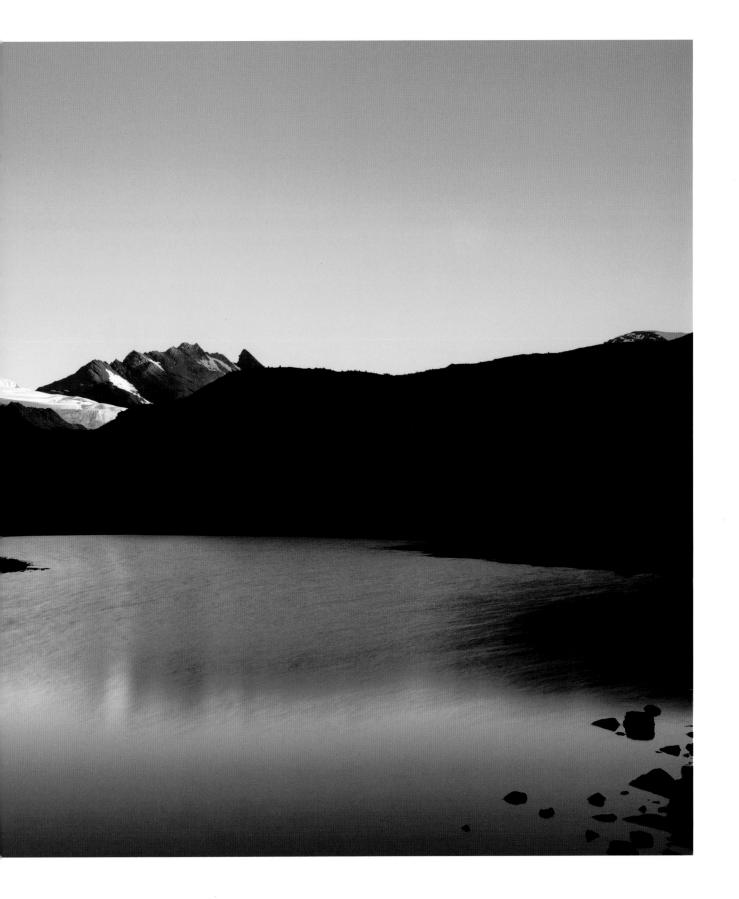

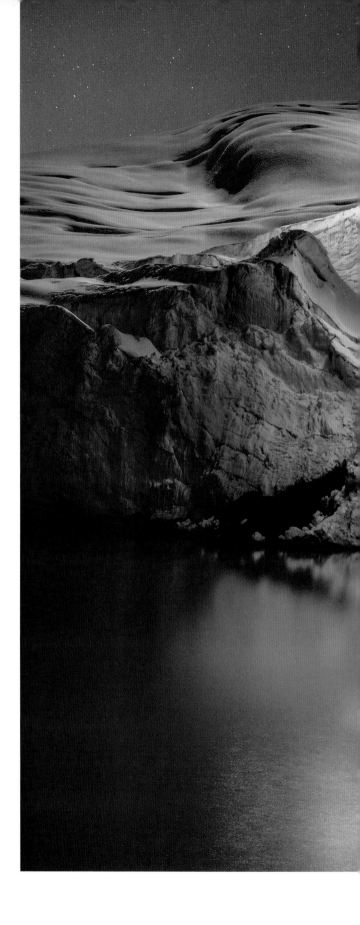

THE CAMERA AND DRONE ARE TOOLS THAT ALLOW ME TO DEPICT A SPACE BEYOND THE LIMITS OF SIGHT.

BEHIND THE LENS

Ice is bright white and will easily overexpose in broad daylight. It is only once the harsh sun has set that the true colours and tones become apparent. Ensure you know what direction the sun is setting and whether it will cast a shadow on to your subject. It's also useful to know if/when and where the moon will appear. Make sure you nail your focus before it gets too dark, as once darkness falls, it gets much harder. Focusing in the dark is never easy, especially with modern lenses, but do this manually, as autofocus can get confused in the dark.

› Receding Pastoruri glacier on the verge of toppling into the melt-water.

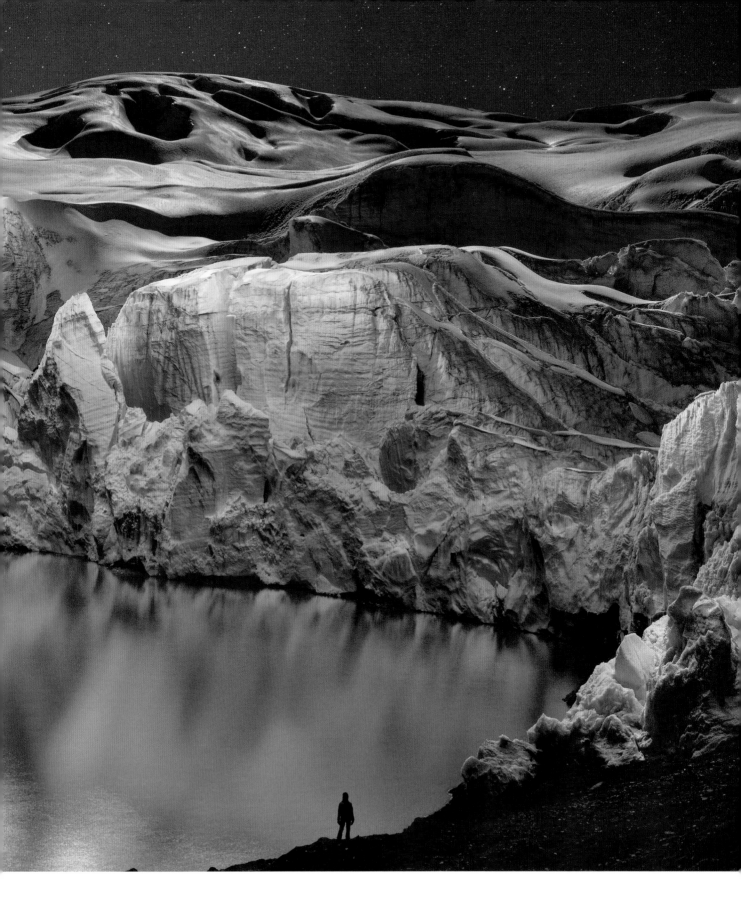

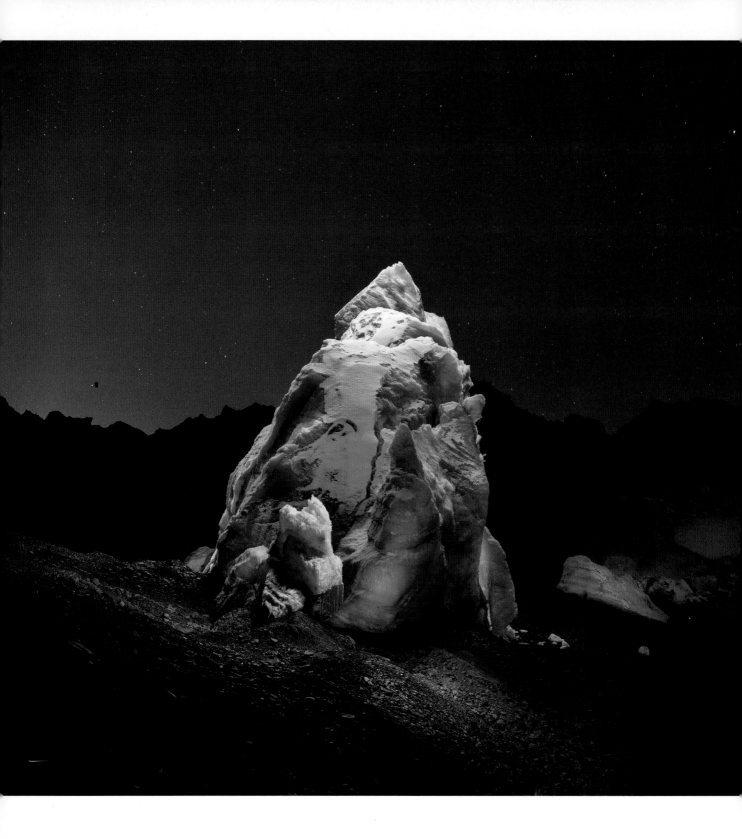

∧ Pastoruri in a state of deterioration.
¬ The moon rising behind a distant peak to welcome the night.

With Pastoruri being at such an extreme altitude, walking is labour intensive, let alone with a heavy backpack full of gear. I had packed additional oxygen for the trip and frequently stopped to check my blood levels. Technically, Pastoruri is no longer a glacier because it loses more ice than it gains, meaning it is in a constant state of 'ablation', and our route showed many signs of its deterioration. I could make out U-shaped mountain valleys, glacial lakes, immense glacial erratics and dark grey moraine deposits of pulverized rock. Glaciers move downstream, carrying boulders and depositing accumulations of rock (moraines). The cirque glacier is usually the source, feeding ice downwards into the glacier, itself remaining fixed in position. The ice in front of me was a remnant of something much, much more extensive: rather than a vast river of ice like its polar siblings, it looked more like an ice cap nestling at the top of the peak. Either way, it still appeared huge to my eyes.

Photographing at night shifts my experience of a place in subtle ways. Rather than feeling overwhelmed and dependent on my sense of sight, I am forced to engage with my environment using my other senses. It's a quiet affair. Surrounded by silence, I find myself working more slowly, more instinctively and in a more meditative fashion. Using long exposure techniques combined with an aerial light source, I can remotely explore obscure landscapes from a stationary position. The camera and drone are tools that allow me to depict a space beyond the limits of sight. The idea was born out of science fiction notions about off-world exploration. In effect, time is suspended.

I remember a beautiful clarity of light and colour as the day ended, and then the moon rose behind a distant peak, sending visible rays shooting across the valley. I photographed the glacier with conflicting feelings. I realized I had a different, more urgent message to convey with this location. I wanted to document and preserve the memory of a landscape in peril, one which may not even exist in a decade. I wanted to show evidence of its alarming retreat, yet I was drawn to the scale of what still remained. Each photograph represents a bleak reality, a fading memory of what once stood, yet at the same time is a testament to the enduring magnificence of the glacier.

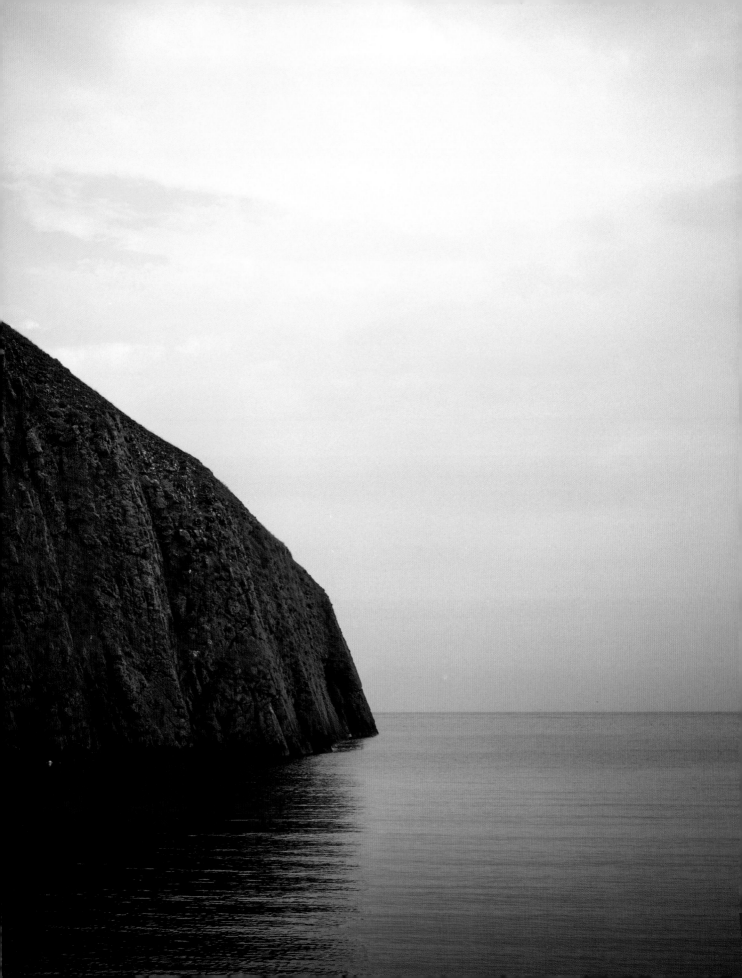

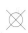

FINN BEALES
FAIR ISLE, SCOTLAND

coordinates
59.5339°N, 1.6333°W

Fair Isle lies halfway between mainland Shetland and Orkney in northern Scotland. Howling gales and thick sea mist are a regular part of life for the 50 or so inhabitants, and the island is often marooned in the ocean, disconnected from the mainland by the weather. Sat atop precipitous cliffs, high above a rolling sea, the people who live here are safe from the worst of the elements. Nevertheless, resilience and an acceptance of their predicament are a prerequisite for the inhabitants of Britain's most remote populated island.

❮ Steep cliffs ring the most remote inhabited island in the United Kingdom.

Ian Moss, the captain, relayed the news that our leisurely cruise from Shetland to Fair Isle was to be superseded by a six-hour rollercoaster ride with an uncertain smile. 'Tis usually a two-hour crossing, but there's a ruff swell offshore an' we're headed straight intae it.' Even his crew were grimacing. I have a sailing background, and I'm used to high seas, but that crossing aboard *The Good Shepherd* is one I'd like to forget.

After a hellish journey, we finally arrived. A thick mist had replaced the swell, and although the island was there (according to radar), it was nowhere to be seen. Ian, with 15 years behind the helm, expertly navigated the rocky coastline and guided the *Shepherd* into North Haven harbour without a hitch. A small party of islanders emerged from the fog on the quayside. They were a welcome sight.

I awoke early the following day and peered out of my window, expecting the worst. A smattering of shapeless clouds raced flocks of birds across deep blue skies. 'Unpredictable!' Ian's description of Fair Isle weather rang true. I wolfed down breakfast, itching to get outside to explore the rocky Atlantic outpost.

At just under 5 kilometres (3 miles) long and 2.4 kilometres (1.5 miles) wide, it's easily navigable by foot, and I set out in good spirits, following the island's only tarmac road towards the South Lighthouse. I soon strayed, drawn like a sailor to a siren, hopping a stile in the fence to reach a spectacular viewpoint towards Sheep Rock and the ocean beyond. An ear-piercing scream from above was a signal that I was entering great skua territory. An enormous bird, known by islanders as a bonxie, clipped the back of my head with its beak – a frankly terrifying experience! It was an effective method of removing me from its nesting area. I made my escape through damp, russet-coloured bracken, swinging my camera bag overhead in defence. I vowed to pick my line towards the clifftops carefully from thereon and returned to the safety of the tarmac.

I circumnavigated the island, passing through green fields and moorland, never far from dramatic sandstone cliffs, that drop away to small beaches at the waters edge. I walked on, past the island's only shop, Stackhoull Stores, a school, a church and the occasional white-washed croft house, but I didn't see a soul. There are only 55 permanent residents on Fair Isle, and many of the islanders perform a variety of roles within the community: fishing, farming, ferry skipper, minister and, of course, knitting. The Fair Isle jumper made from the wool from their Shetland Sheep being the islands most famous export. Life on an island is not easy, but the limit on resources means the community have an appreciation and respect for their surroundings and a tolerance of others that too many of us lack. You don't need to live on an island to have these attributes, of course – just a step back now and again to think about this extraordinary world and our place within it.

I noticed a group of puffins away to my left, and knowing them to be far more affable than the dreaded bonxie, I headed their way.

⌄ Puffins, the Fair Isle sentinels, always keeping watch.

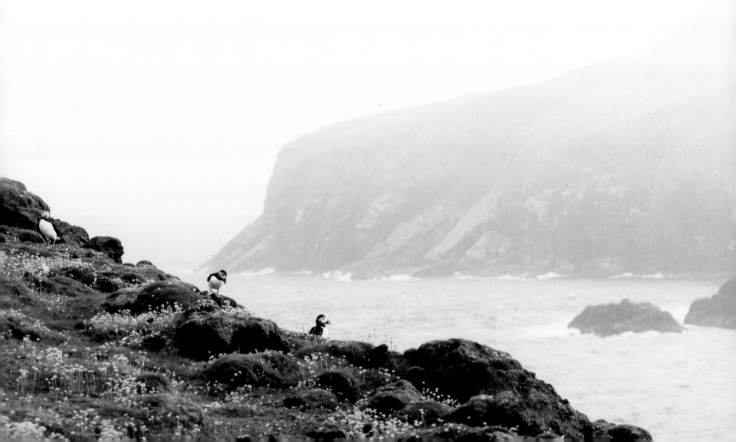

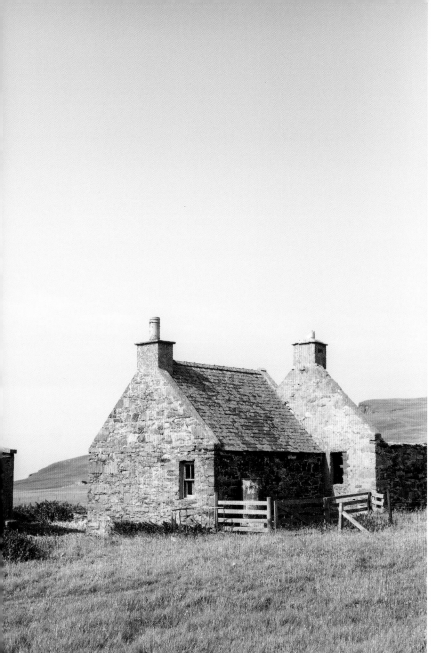

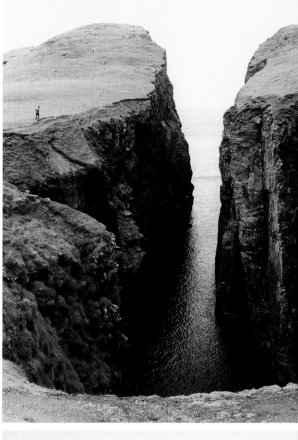

⌐ An abandoned croft house in the centre of the island.

≪ Hiking along precipitous cliffs on the east of the island.

∧ Cotton grass flutters in the wind.

≪ Immature bracken lines the cliff tops.

‹ A long abandoned vessel, enjoys retirement on dry land.

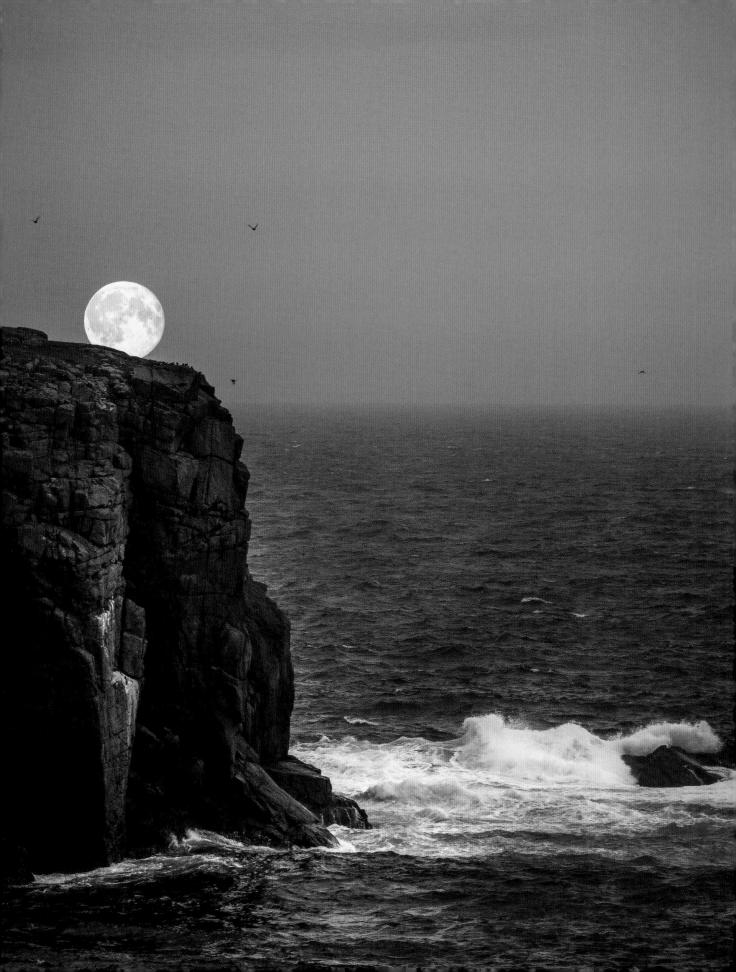

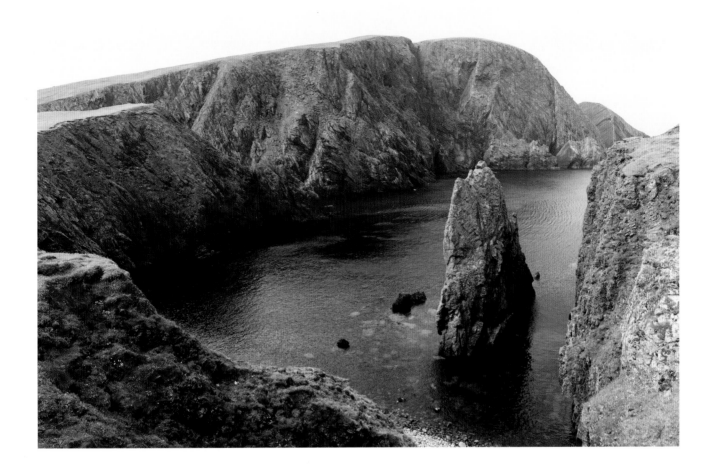

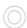

BEHIND THE LENS

Download a sun/moon/star tracking app to your phone. It pays to be in place ahead of time, and these apps allow you to accurately predict where and when the sun or moon will rise. I like Sun Surveyor, which uses augmented reality to simulate how the sun/moon will interact with surrounding landforms.

These comical birds ring the cliffs on Fair Isle. Standing like sentinels, immaculately dressed in a black-and-white uniform with a ribbon of colour across their beaks, they keep watch all day. For what, I'm not sure – certainly not me. Unconcerned by my presence, they seemed to actively pose for my camera, and I spent the day photographing their amusing antics.

The clouds of the morning had won the race and were nowhere to be seen. The sky was clear, and I knew a full moon was soon due on stage. As the sun began to set, I moved to the western side of the island, eager to witness the silvery orb's appearance. More puffins joined me for the performance, jostling for position on the clifftops. So, there we all sat, marooned on an island way, way north, marvelling at the unfolding spectacle. The moon rose behind a cliff, lifting slowly into the sky as the evening darkened. I thought of islanders passed and their sense of wonder at witnessing the same scene 5000 years ago. Smiling, I looked to the puffins for their response, but they seemed nonplussed. They had seen it all before – no big deal.

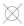

FINN BEALES

VOLCANOES NATIONAL PARK, HAWAII, USA

coordinates
19.4194°N, 155.2885°W

Home to one of the most active geological areas on earth, Volcanoes National Park on Hawaii's Big Island offers an extraordinary spectacle. The park covers around 1,355 square kilometres (523 square miles), but this is growing daily, with the Kīlauea volcano producing enough lava per day to resurface a two-lane road 32 kilometres (20 miles) in length! It's an uncompromising landscape, and one in constant flux, shaped by powerful forces far beyond our control.

HIGH ABOVE
THE COASTLINE,
WE WATCHED
A RED RIVER
FLOWING
INTO THE SEA,
AN ANGRY
CAULDRON
AND TOWER
OF STEAM
LIFTING INTO
THE AIR WHERE
THEY MET.

The furious typing on a beaten-up laptop gave John away across the sea of weary travellers in Heathrow's departure lounge. 'John?' I inquired. 'You must be Finn!' John Silcox looked up from his long-suffering computer and smiled. John is a journalist and would be writing the story for the magazine for which we were both working. We had never met before and spent the next 40 minutes chatting through the week ahead.

He was easy to talk to, and relaxed, which was a relief, as editorial assignments are often intense run-and-gun affairs and require a good degree of cooperation between writer and photographer. We were heading to Hawaii, one of the most geographically isolated landmasses on earth, and the next 10 days would be spent hiking up a series of erupting volcanoes.

Fourteen hours later, and after a minor brush with US border security (stowaway apple in my camera bag), we arrived in Honolulu, the capital city of the Hawaiian Islands. We were tired after the journey, but eager to explore. We picked up a 4x4 and began winding away from the airport along deserted roads fringed by trees and topped with a fine layer of volcanic fog.

Volcanoes National Park is located around 72 kilometres (45 miles) southwest of the town of Hilo and is home to some of the most volatile volcanoes on earth. The youngest, Kīlauea, has erupted repeatedly since 1823, making it a great place to start. We met our guide Robert at the entrance to the park and he checked over the kit we were planning on taking. My bag was massive. 'It's a long hike man, and you're gonna need a lot of water too.' I quizzed him on what we were likely to see on the crater rim. I find it a strain leaving gear behind. A mistake in lens choice can

⌄ The shadow cast by Mauna Kea, a now dormant volcano.

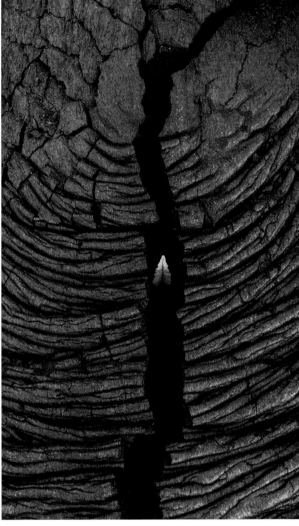

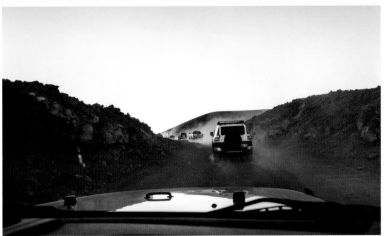

┌ The Kilauea volcano is between 210,000 and
 280,000 years old.

∧ A small ae fern making the best of it in the
 otherwise desolate lava fields.

⟨ Heading into Volcanoes National Park ahead
 of a long hike across the lava fields.

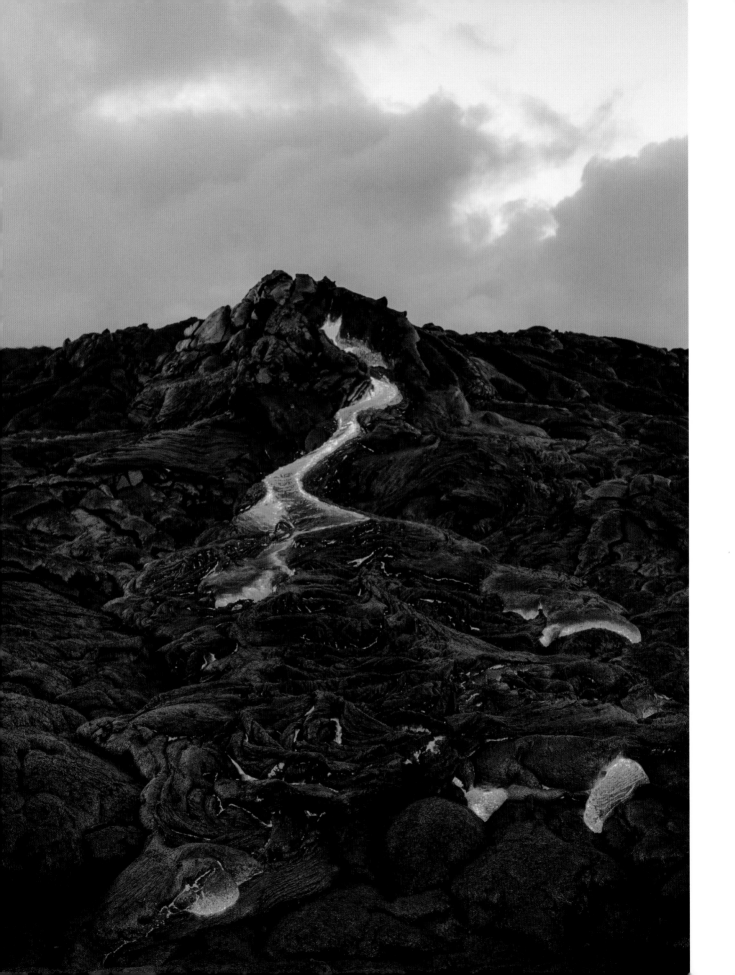

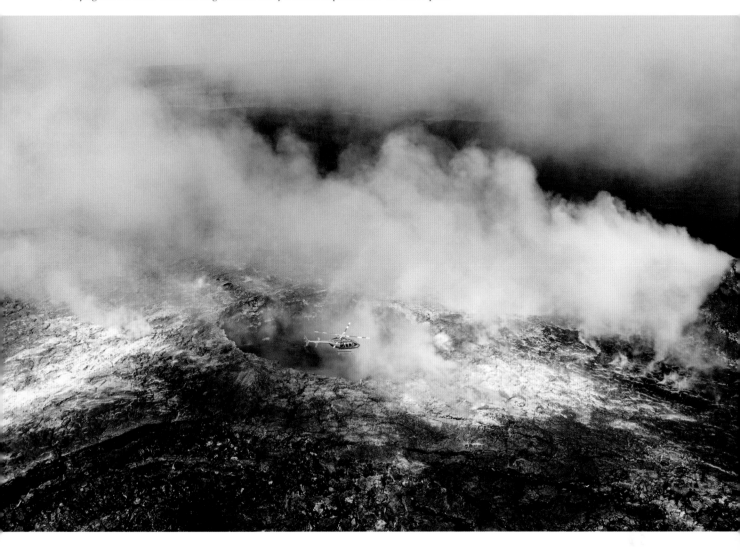

lead to lost opportunities but glass is heavy, and Robert's right. An eight-hour hike under the searing heat of the Hawaiian sun is not to be taken lightly. Robert assures me we will get 'very close' to the lava flow, so I ditch the unnecessary gear – in this case, my longest (and heaviest) zoom lens – and we set out across the all-black lunar landscape en route to the crater rim.

For the most part, Hawaii's volcanoes erupt at a leisurely pace, and viewing lava from the ground is relatively safe, but the flows do shift daily, so a guide is a good investment when it comes to actually locating the hot stuff. We set off at a fair lick, conscious we only had a few hours before sunset. The terrain was strange. Deep folds of rock glistened in the sunlight. Formed from solidified magma, they look uncannily like the bedsheets I had discarded in a mess of folds in my hotel room that morning.

It is difficult to believe that anything can survive in this unforgiving environment. Yet, small green ae ferns sprout from a myriad of cracks and crevices, the only interruption to what is otherwise a lifeless landscape. Ae is a tough, pioneering species and often first on the scene after the lava cools. I thought of *Jurassic Park* and smiled as I stooped to photograph their flashy green fronds – life always finds a way.

Three hours later, we reached the first of the surface flows. It was blast-furnace hot, but the unfolding scene was fascinating. I vied to get as close as I could, before smelling burning rubber from my shoes... oh for a longer lens! I watched a slowly advancing tongue of liquid red rock lazily falling over itself, consuming all before it. A small hiss and a pop signalled the end for an unfortunate ae fern.

‹ Liquid rock flowing towards my lens.
At 1,250°C (2,280°F) it is extremely hot!

BEHIND THE LENS

Take note of the following aerial photography tips:

+ Chat with the pilot before take-off and let them know what you are looking to capture from the flight. You need to direct the show – they are a pilot, not a mind reader – and will appreciate your direction.

+ A helicopter moves quickly, and the closer you are to the ground, the faster the ground will travel past your lens. Increase your shutter speed the lower you fly.

+ Helicopters vibrate, and camera shake is the enemy when you're in the air. Shoot in Shutter Priority mode. That way, you can react quickly and let the camera look after the relative exposure settings.

+ Don't forget to take your eye away from the viewfinder now and again to enjoy the experience!

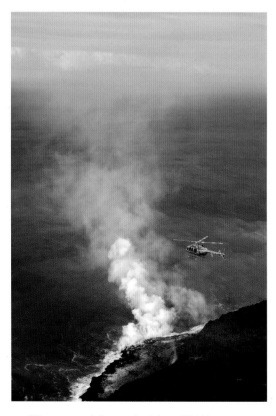

∧ Kīlauea emerged above sea level about 100,000 years ago.

As day drifted into dusk, the sun began to relent, which made my job a little easier picture-wise. Cooling magma is highly reflective, essentially a type of glass, and the dimming light overhead allowed me to capture the colour of the lava against a welcome backdrop of black. I beavered away, excited by the photo opportunities that were arising around me, but the downside to peering through a viewfinder is a total lack of peripheral vision. I soon realized I was standing on a thin crust, and through the looking glass below, I stared at fissures of phosphorescent liquid running inches beneath my feet.

The hike was an extraordinary experience. Up close and personal, volcanoes give you a rare glimpse of the world as a work in progress. However, I was in Hawaii to tell the whole story of these fiery mountains. Although I had a card full of excellent lava shots, I needed to give them context. I needed a broader view, which meant taking to the air.

We arrived at the heliport the next morning, and after a rather severe safety briefing, crossed the tarmac to the waiting chopper. Stooping low below the rapidly rotating blades, we braced ourselves against the heavy downdraft and climbed aboard. Headphones on, a quick radio check and we strapped ourselves in, an important step considering I had requested we fly with the doors off. Helicopter flights are always an exhilarating experience, but a flight over an active volcano had my adrenalin surging. I checked my camera, lenses and settings and gave our pilot a thumbs up before looking over my shoulder. John was smiling ear-to-ear.

The flight to the rim took about 10 minutes, a mere fraction of the eight-hour hike we had completed the day before. High above the coastline, we watched a red river flowing into the sea, an angry cauldron and tower of steam lifting into the air where they met. Hundreds of giant trees lay discarded like spent matchsticks; a desolate sight. Yet, close by, their neighbours remained standing, still green, granted a short reprieve until the volcano sent forth its next wave.

Our pilot had warned us about unpredictable thermals coming off the magma lake in the crater. Sure enough, as we descended over the rim, over the angry maelstrom of orange and red, the helicopter started lurching back and forth as our pilot fought with the controls. I had to work rapidly and rattled off frames. A quick nod that I had what I needed and we banked hard left, away from the cone and the sulphurous gasses that surrounded it. We fled to the north and found respite in a landscape at total odds with the devastation in the south. Lush rainforest valleys and cascading waterfalls abound. The flight, like the hike, was extraordinary – a glimpse of heaven and hell over the course of an hour.

Once back at the hotel, I headed to the beach and reflected on the past few days. A turtle hauled itself out of the ocean and rested up alongside me. The extraordinary is ever present in Hawaii.

< Mature trees, no contest for the volcano look like
spent matchsticks when viewed from above.

∨ Tiered waterfalls on the northern shores of Big Island.

≫ A turtle taking a breather on the beach.

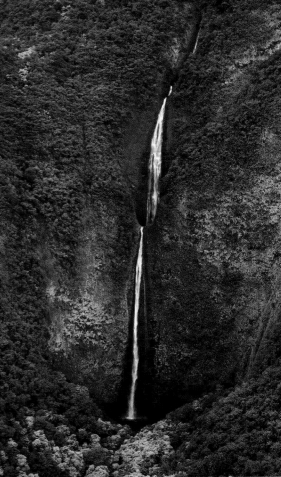

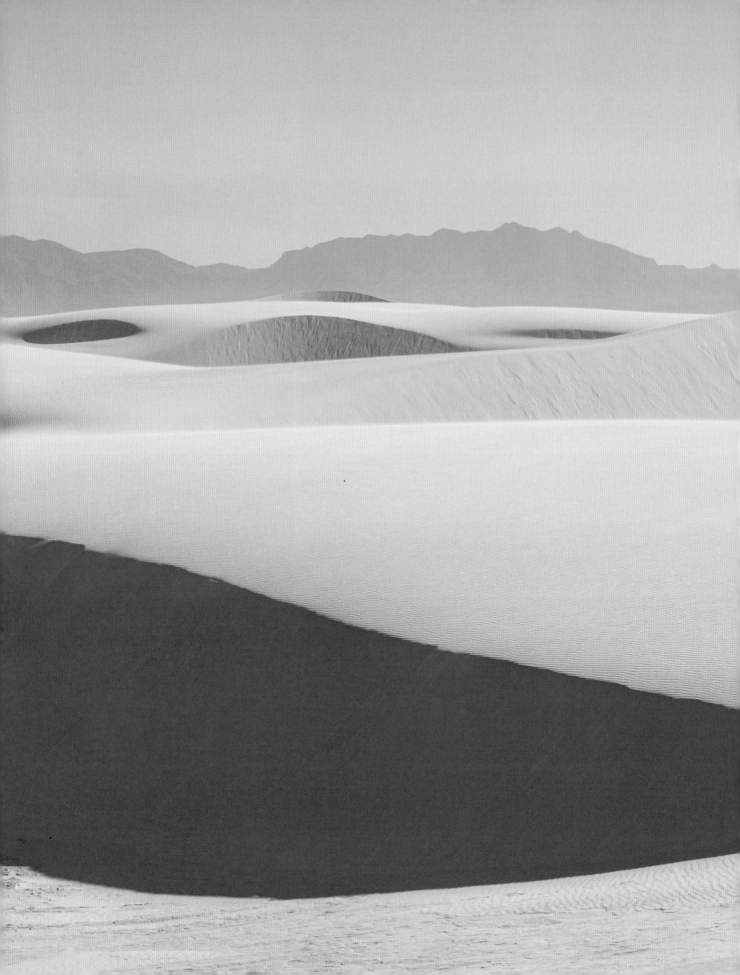

LAURA PRITCHETT
WHITE SANDS, NEW MEXICO, USA

coordinates
32.7872°N, 106.3257°W

White Sands is the simple, descriptive name of an otherworldly stretch of gypsum dunes located in the Tularosa Basin in New Mexico. These glistening white hills span 712 square kilometres (275 square miles), making up the world's largest gypsum dune fields. Visible from a distance while driving through the surrounding red desert, White Sands looks like a great pile of sugar stacked high on a rusty tray. Over the years, White Sands has drawn people from all walks of life, from miners to filmmakers to the US military. Yet, this ever-shifting terrain, constantly reimagined by the wind, maintains the magic of an undiscovered land.

DUNES
STRETCHED AS
FAR AS I COULD
SEE, TOWARDS
THE MOUNTAIN
RANGE, EACH
ONE UNIQUELY
CARVED OUT BY
THE ELEMENTS
AND MIRRORING
THE SUN IN
BLINDING RIPPLES.

The first word that came to mind as we wound the truck down the flour-white road was 'surreal'. It was white below, white above, and in the distance a hot white horizon faded into a cloudless sky, also drained of colour that day except for the palest of blue. From the cab's enclosure, my senses struggled. It was hard to tell whether I was looking at deep drifts of snow or the purest of desert scenes. The air was still, dry and warm, but the sand was indulgently soft and cool to touch. Gypsum reflects heat instead of absorbing it, and the sugar-sized granules, which glittered like glass, were irresistible. I kicked off my shoes and sank my bare feet deep into the colder layers below.

When I reached the top of the first dune, I paused to take in my surroundings. Ahead of me was a scene of Elysian proportions. Dunes stretched as far as I could see, towards the mountain range, each one uniquely carved out by the elements and mirroring the sun in blinding ripples. I could count on one hand the number of people who had crossed on to the second and third dunes in front of me. Perhaps it is the challenge of traversing the terrain, or the similarity of each dune at a casual glance, that prevents visitors from exploring further, but into the distance is where the real treasure lies.

Off the beaten path, you have to be sure of your landmarks, as the dunes continuously shapeshift with the wind and trails can be lost. Delicate tracks left by reptiles and rodent footprints were a

⌄ An obscured sand dune during high winds at sundown.

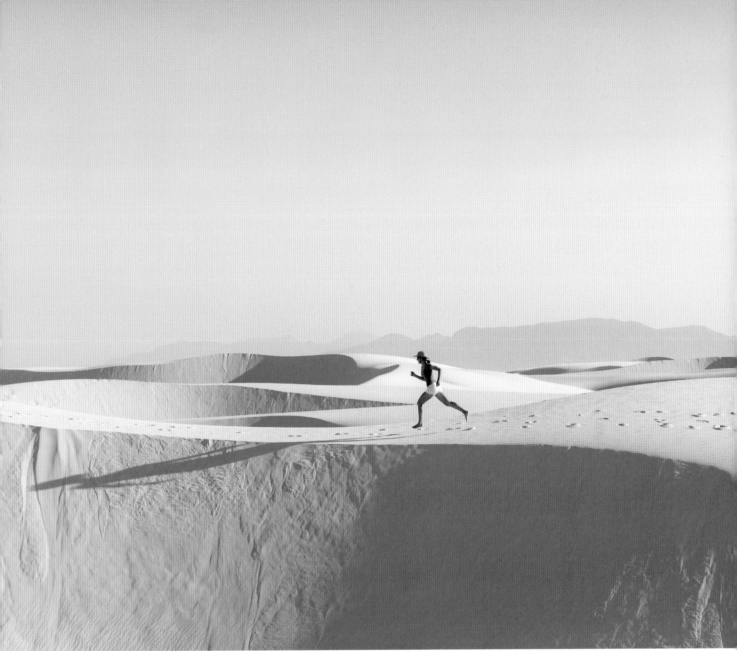

∧ Laura (self-portrait) running the rim of a dune on a clear day.

‹ Close up texture of the pattern that the wind traces in the softer layers of sand.

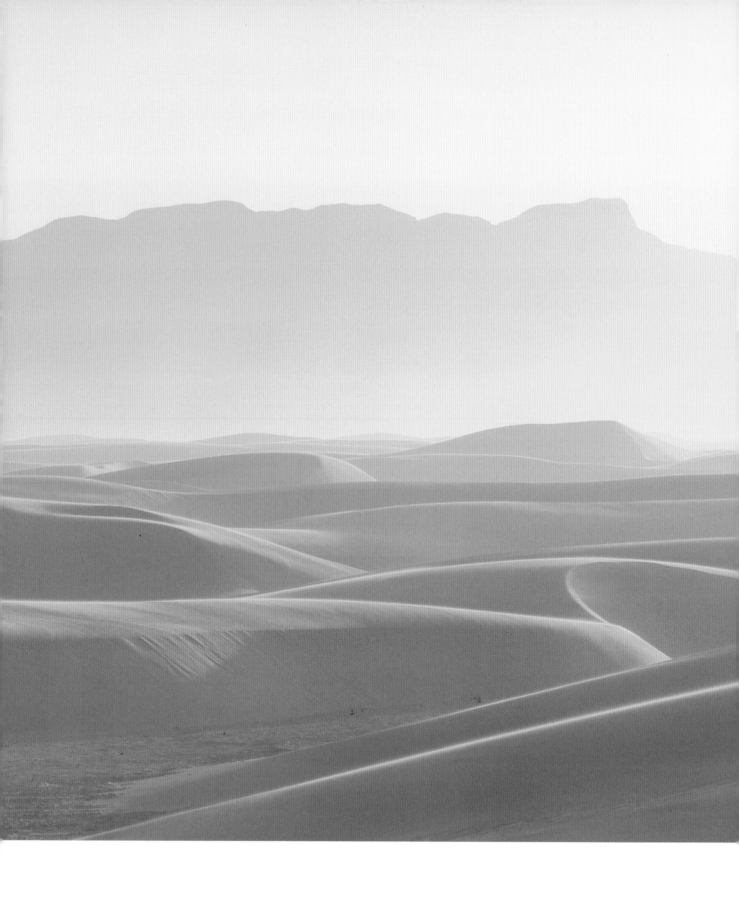

⌃ The most colourful sunset I witnessed at White Sands, captured just as I was leaving for the night.

RICH GRADIENTS OF VIOLET, ROSE, PEACH AND GOLD OVERWHELMED THE SKY AND POURED INTO THE SHADOWS...

telltale sign of more permanent inhabitants; each well adapted to the landscape. Many indigenous animals are white and very difficult to spot. Aside from the brief appearance of an albino lizard, which vanished as quickly as it had arrived, the only wildlife we saw was a lone black raven that floated above an adjacent dune as though it was tethered to it like a kite.

I was enamoured by the clear, bright scenes of the day, but the crescendo of the sunset that evening brought with it an even more breathtaking scene. Rich gradients of violet, rose, peach and gold overwhelmed the sky and poured into the shadows and sweeps of sand on the ground. As dusk descended all around me, it seemed to envelop me in a graceful embrace. I vowed not to miss a single sunset here for the rest of my visit.

When a place captivates me the way White Sands did, I naturally can't resist snapping away with my camera. But I also feel compelled to sit still and examine the shapes and hues around me with paint. I knew lugging an easel across the dunes would be difficult. Nonetheless, I set out the next morning with the help of my husband, my four-year-old daughter and a packed lunch. No sooner had I set up and begun outlining sketches, a furious wind whipped up my easel, sending it crashing into me. My leg began bleeding, and the sand stung our eyes and caked our hair. We all slid down the nearest slope into the shadowed valley between two large dunes to seek cover.

⌄ Close-up of hard packed salt and sand carved by the wind in the deep valley between dunes.

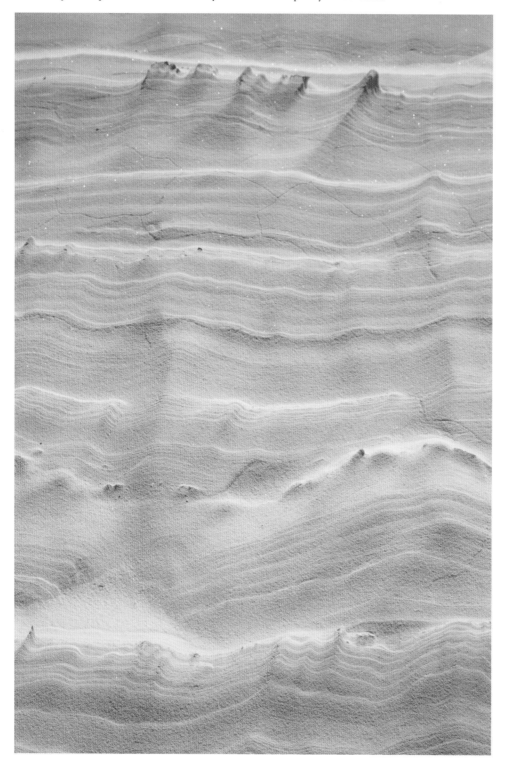

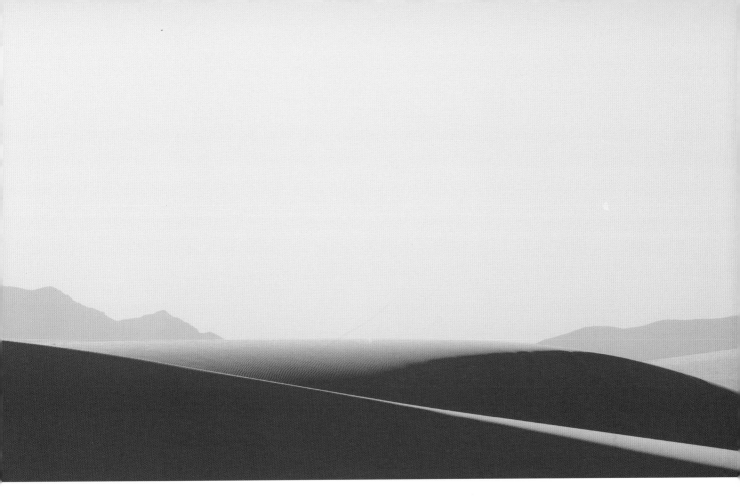

The still beauty that I had glimpsed the day before had been violently ripped away, but I remember laughing through my teeth. The excitement that had brewed in my chest in that moment was the same that I've felt by the ocean when dark clouds swirl and the power of the earth is so evident. I recall folding my body to shelter my daughter from the wind-whipped sand. She smiled, and proudly drew a bandage from her tiny backpack before sticking it on my cut.

While we were never in any great danger, it felt good to be reminded of how small we were, huddled together at the mercy of the wind and facing the folly of our best-laid plans with a chuckle. Although I didn't complete a painting that day, to this day I paint scenes from my memories of White Sands.

I grew up by the Atlantic and love the hypnotic waves forever rolling from the horizon. It never occurred to me that somewhere else could match that sensation, but White Sands compares in its own unique way: the salt in the air and encrusted crystals on your feet after a long day's hike, the remnants of an ancient sea which dried up long before our time. After days walking the dunes, always onwards, always looking for a new angle to capture, I realized that I was searching for some great body of water that must be on the other side of the last salt-laden dune. In reality, there was nothing. Just the ghost of a sea I'll never know.

BEHIND THE LENS

The photos of White Sands I had seen before my visit never managed to communicate the scale of the place. I found myself setting up my shots far away from subjects, continually striving to capture how small they really were compared to the surroundings. A wide-angle lens will be a great asset. At golden hour, shoot towards the sun the moment it dips below the western mountain range. Those last streams of light cutting through the dunes will reveal a spectrum of colours in the sand you never knew existed.

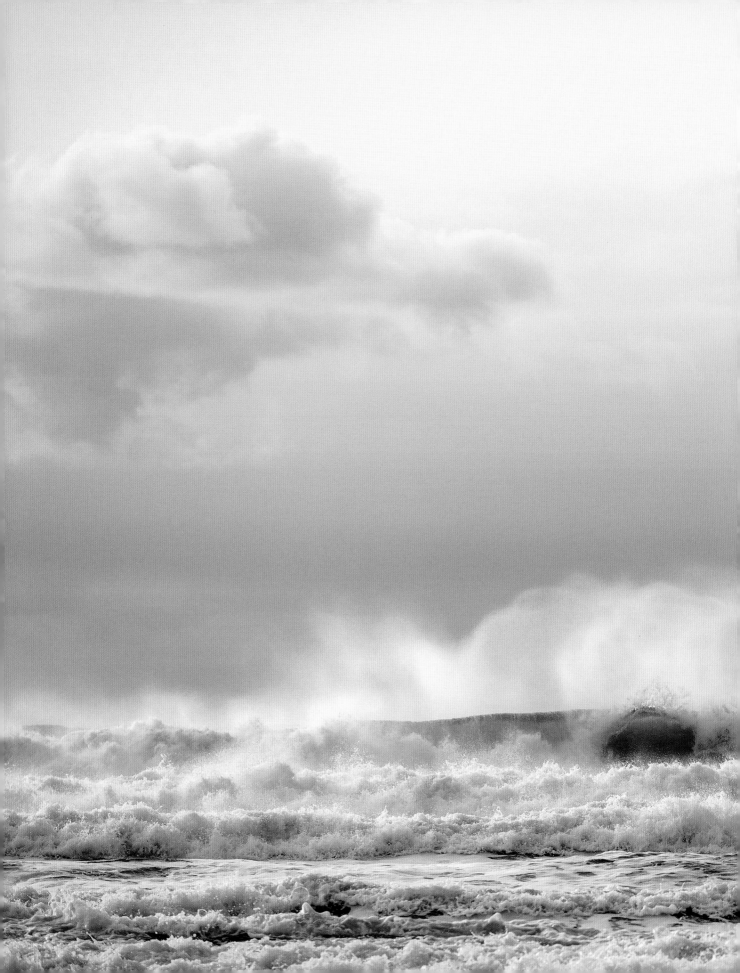

COAST

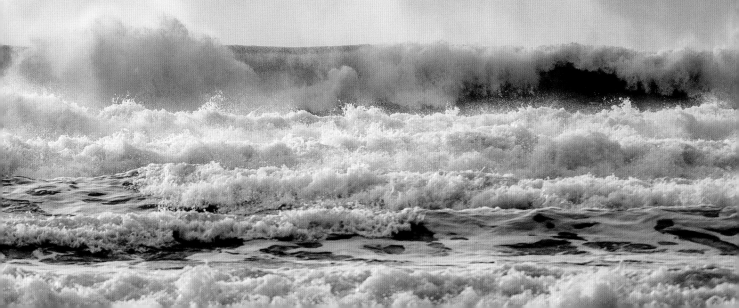

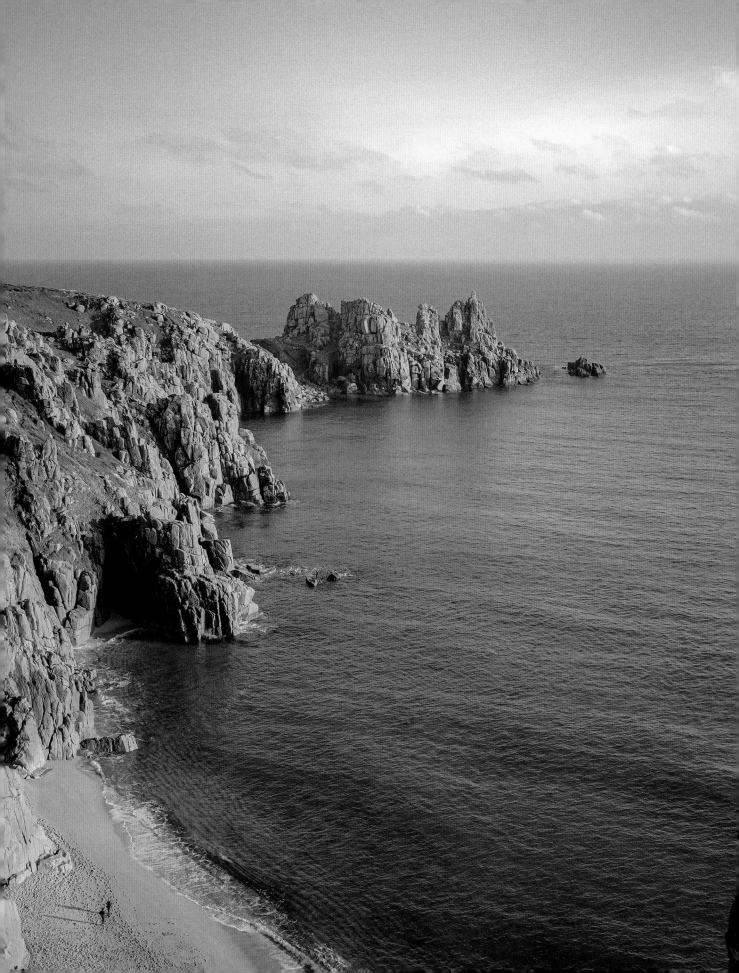

LUCY LAUCHT
CORNISH COASTAL PATH, ENGLAND

coordinates
50.0434°N, 5.6540°W

Cornwall is the farthest west taper of Great Britain, a peninsula fringed with wild coastline wrapped by the Atlantic Ocean. It has a lyrical and untamed landscape of cliffs and rocks, parishes and coves. The coast is home to harbours dotted with colourful fishing boats, sleepy villages and expansive sandy beaches. There is a strong sense of place here; Cornwall is proudly independent, with a rich heritage and connection to the land. This translates to a vibrant community of creatives and thinkers; people forging a life with an affinity to the natural environment: filmmakers, photographers, potters and artists, fishermen, farmers and foragers.

CORNWALL IS A LAND SHAPED BY THE ELEMENTS, AT THE MERCY OF THE EVER-CHANGING MOODS OF THE EARTH AND THE SKY.

I spent my childhood on the beaches of Cornwall. I have a nostalgia for striped windbreaks and rock pools. The names of native plants and birds, like thrift, skylark, wood sorrel and primrose, are a form of poetry to me. I recently returned home to England after nearly fifteen years of living in America and Australia. A longing for the ocean took hold, and I boarded a train to south Cornwall.

Cornwall is a land shaped by the elements, at the mercy of the ever-changing moods of the earth and the sky. The light moves across the land in a way I haven't seen in other places. In summer, the days stretch on and in the evening the sky takes on a blush that makes my heart sing. There are turquoise coves and waterfalls to be discovered, and if you're lucky, incredible phosphorescence to swim among in hidden creeks. Woodlands offer a soft dappled respite from the summer sun.

In spring, wildflowers carpet the coastline, with lines of purple foxgloves nodding in the breeze, while winter holds a beautiful melancholy, delightfully empty, with quiet creeks on which to canoe.

The South West Coast Path, England's longest waymarked footpath, stretches 1,014 kilometres (630 miles) from Somerset to Dorset. Like a jewel necklace, it rings some 530 kilometres (330 miles) of the Cornish coastline. With nothing but open ocean on one side and the rolling Cornish landscape on the other, this winding trail is the reason I returned here. My journey would be

⌄ Local fisherman Will Taffinder of Curgurrell Farm.

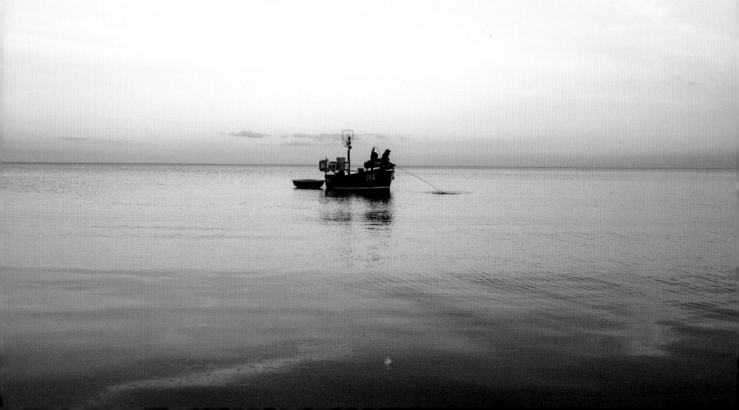

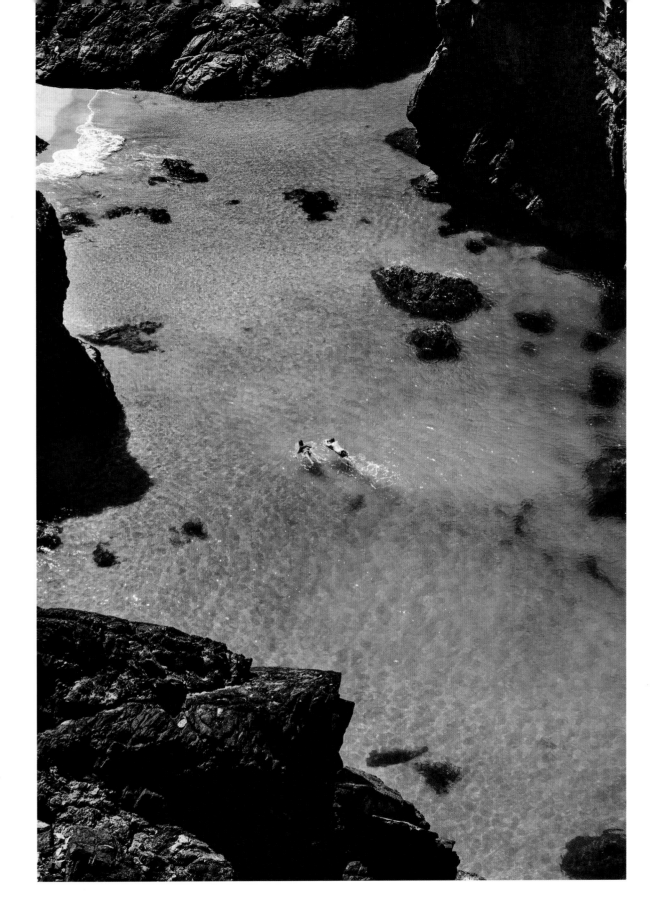

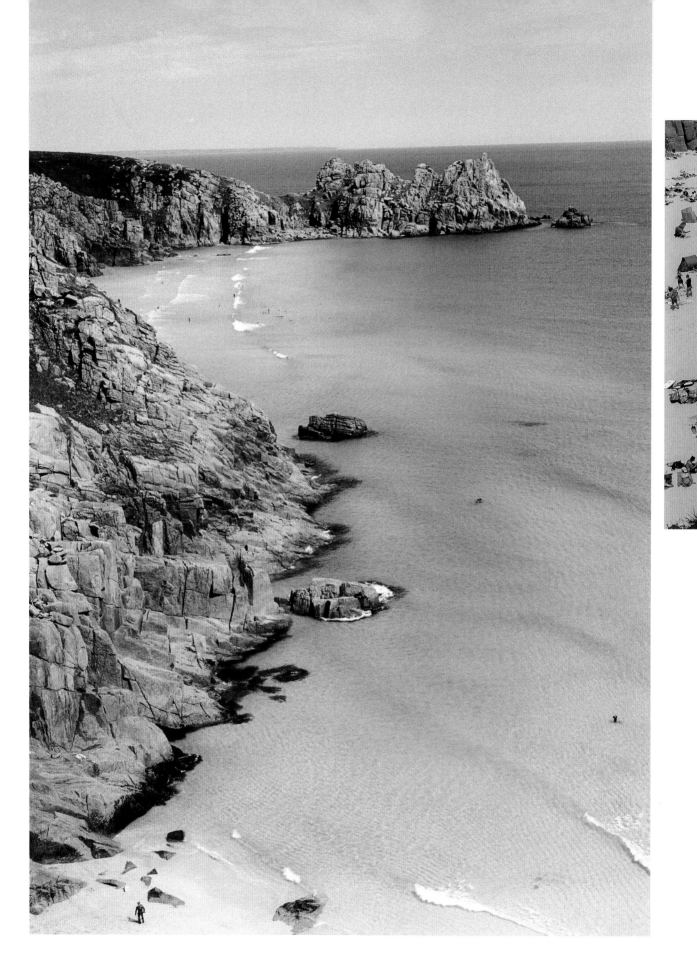

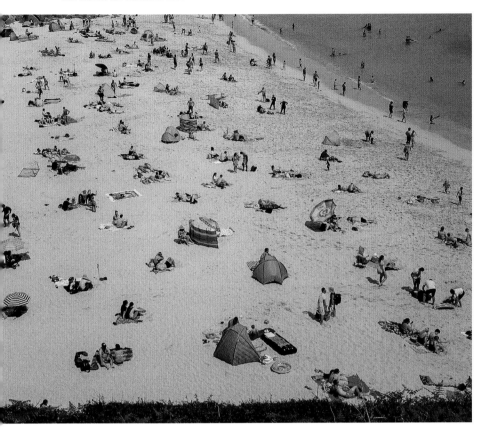

BEHIND THE LENS

Cornwall has a beautiful quality of light, and the winding coastline provides plenty of elevated aspects for photographing the beach life below. The path above Porthcurno beach makes for a lovely view in summer; a white sand beach dotted with colourful umbrellas and windbreaks, and bobbing swimmers. To capture the vivid beach scenes and vibrant colours, time your visit to coincide with when the sun is high in the sky; the hard light will lend a nice contrast to your frame.

an ode to my dad, whom I'd recently lost. I wanted to complete a section of the path, the missing piece of a trail he'd quietly ambled for years. My dad held a special reverence for the Cornish coastline, and walking the path brought him vitality.

I set out along a coastal path lined with late summer honeysuckle. To my left was the Atlantic, which wavers between inky black or brilliant turquoise, depending on her mood. I walked for two days straight, scrambling down overgrown paths to swim in hidden coves. The crystal-clear waters and white sand were a blissful reward at the end of a long hike. Under a slip of a moon and a setting sun, I met a herd of wild ponies.

I remembered a certain childhood nostalgia for British beach scenes. Beaches in summer are like billboards for the collective identity of a nation. In England, we go to the beach even when it rains. We sit in deck chairs, eat fish and chips and demonstrate stoicism while complaining about how we mustn't grumble.

In pretty little Portloe, I stopped for the night as a storm rolled in. I took a room looking out to a boat slip where two brave souls were swimming, wild winds shaping the ocean. There's something elemental and healing about being near the sea: all that briny air and the sense of being very small.

In the undisturbed woodlands, and in the quiet stretches of gloaming light where waymarkers were few and far between, I questioned whether I was on the right path. My dad undoubtedly showed me the way and reminded me of how walking is a balm for the soul. I left Cornwall knowing in my bones that I would return.

Those two days felt like a homecoming. Throughout that summer, I returned to Cornwall, each time making new friends, forging connections and discovering new stretches of the coast path. On these solo walks and wild camps, a kernel of an idea formed; to photograph my journey, an ode to the Cornish coastline, the people who make this corner of the world so special, but perhaps most importantly to my father, who taught me how to come home again.

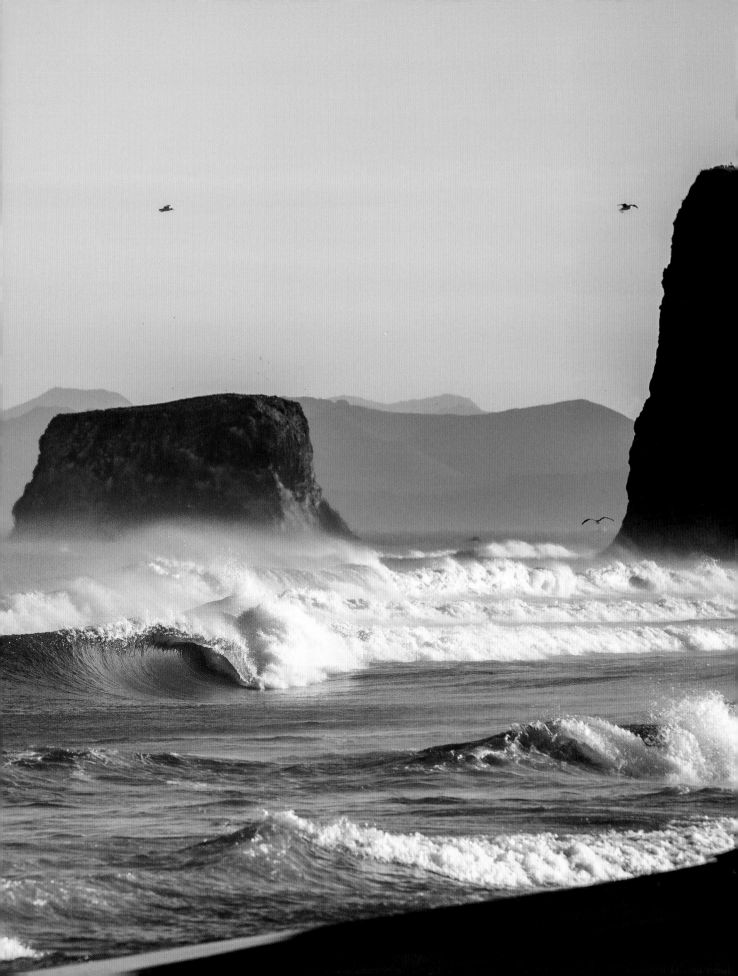

CHRIS BURKARD
KAMCHATKA, RUSSIA

coordinates
53.0584°N, 158.6321°E

The Kamchatka Peninsula is nestled between the
Pacific Ocean and the Sea of Okhotsk in the far east
of Russia. It sits at the same latitude as Alaska, Siberia
and Norway and feels the full force of the weather
found this far north. A lonely strip of land, jutting out
into the ocean somewhere between Asia and North
America, the peninsula is the most volcanic region
on earth and is known to many as the 'Land of Fire
and Ice'. A designated UNESCO World Heritage
Site, Kamchatka is technically a peninsula but feels
more like an island, with no roads connecting it to the
Russian mainland.

❮ There was one goal: find new, untouched waves.
It was no easy feat and many days we came up empty
handed, but here and there we achieved our goal.

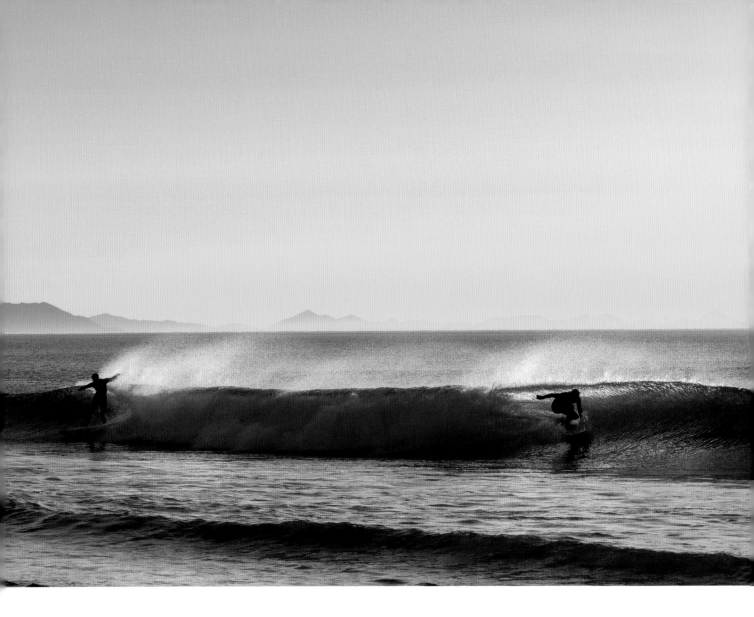

We landed in Petropavlovsk-Kamchatsky, the industrial, scientific and cultural centre of Kamchatka, with a population of 180,000. The area has always been of strategic military importance to Russia and was closed to the public until the early 90s. I had been looking at the area for over two years before finally boarding a plane. I was building a career as a surf photographer, specializing in cold, rugged regions around the world, like Iceland and Norway. These places interested me the most. Despite requiring patience and bit of suffering, they always delivered the most stunning imagery. A trip to the far east of Russia promised adventure, discovery and hopefully waves as well. So when a new flight connected Anchorage to Petropavlovsk, I knew the time had come.

We planned our trip for October, hoping to get there as winter storms start brewing and generating waves. The paperwork involved was no joke, and everything had to be submitted a month in advance with no exceptions. My recommendation is to do your paperwork correctly; check it twice, and a third time. Maybe even a fourth… Unfortunatey, I managed to get a date wrong. As I tried to enter the country, I was promptly denied entry. I was interrogated and held in a Russian jail in Vladivostok overnight, and then deported to South Korea, before the issue was resolved and I was permitted entry. It might be the most scared I've ever been to this day, all because my visa was one day off. Check those dates!

The peninsula is rooted in military history, and the signs were immediately clear upon landing. We loaded our gear into an old six-wheeled army juggernaut and set out for the coast to camp for two weeks. As we left the city behind, civilization dwindled and the few people we did see seemed ingrained in their own lives, shooting guns from the side of the road or walking nude on empty beaches. We hauled our truck high through mountain passes, traversing

⌃ You go right, I'll go left. Surfing on the Kamchatka Peninsula.

> Twenty five years ago, the peninsula was actually restricted to all outsiders - even Russian civilians. Although it's now open, it's rarely visited.

» A slightly concerning visual to wake up to, reminding us that we weren't alone out here.

⌐ When we set off on the expedition we weren't sure if we would even find any surfable waves... but we certainly did. In moments like this, all of the planning and hard work paid off.

⌐ After a long day of surfing and casting lines for steelhead trout, an evening like this is the icing on the cake.

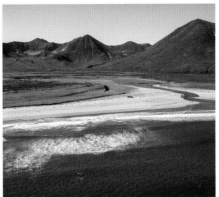

between volcanoes, and at one point co-opted a creek as a road in our efforts to reach the sea. However, thick forest covered these pristine lands, an emerald green carpet, disrupted only by rivers that had their free pass to roam.

We transferred to an ancient Mi-8 helicopter – an ageing hulk from the glory days of the Soviet Union over 50 years ago. It was a daunting prospect, but the lure of sea was strong, and our thirst for adventure quelled any fears we had. A bird's eye view introduced a new perspective, a myriad of volcanoes, steam venting from their tops. Thousands of rivers zigzagged between them, jostling to reach the sea. My good friend Ben Weiland had spent a long time studying aerial maps and searching for remote waves in the area, and it was a thrill to us both to witness these views with our own eyes at last. We saw one person during that flight; a small wooden cabin sat proudly amid a patch of grassland, with a man and his dog

outside. Consider living an 18-hour boat ride from the nearest port. There is no road access.

As clichéd as it sounds, the trip was everything we hoped for and more. We did find waves – perfect, hollow, empty waves – which we surfed endlessly despite the frigid water temperature. But, more importantly, we spent over two weeks in the wilderness. We fished for our food most days, rivers so plentiful with salmon, that at times we didn't even need rods. We were alone and exposed, and reminded continuously of bears in the area.

I left Kamchatka with a feeling of contentment – something that doesn't always happen on photographic assignments. We had achieved what we came for and left knowing this relatively untouched strip of land appeared to be thriving.

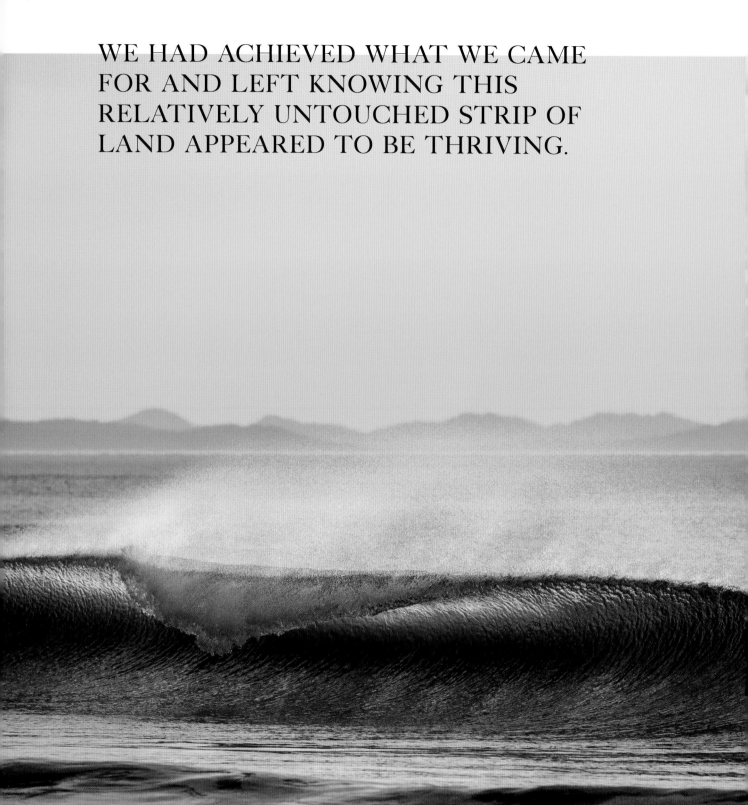

WE HAD ACHIEVED WHAT WE CAME FOR AND LEFT KNOWING THIS RELATIVELY UNTOUCHED STRIP OF LAND APPEARED TO BE THRIVING.

∧ For me, I don't think there is any feeling more magical than surfing
waves you know have never been surfed before.

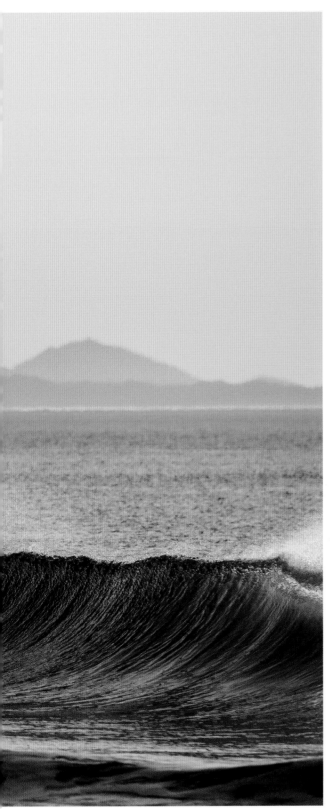

After over two years of planning and a long day of travel in an old soviet military truck, we found ourselves in front of this sunset and astonishing cloud formation lingering amongst the active volcanoes. There was no option other than to stop, get out, and take it all in.

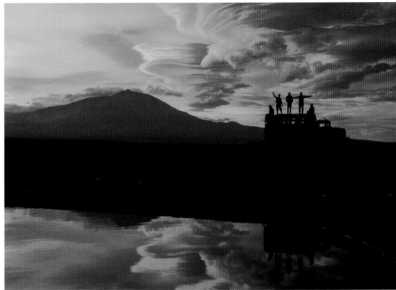

BEHIND THE LENS

Most photographers know this, but landscapes really come to life at sunrise and sunset. Some of the most magical moments I've ever witnessed were on this peninsula at these times. I was up before sunrise every single day, no matter what, even if deep down I wanted to be in my warm sleeping bag. I also think this place really comes to life from the sky, and if you're looking to travel here to take photos, getting up in a plane or helicopter is an amazing experience that will help elevate your photos.

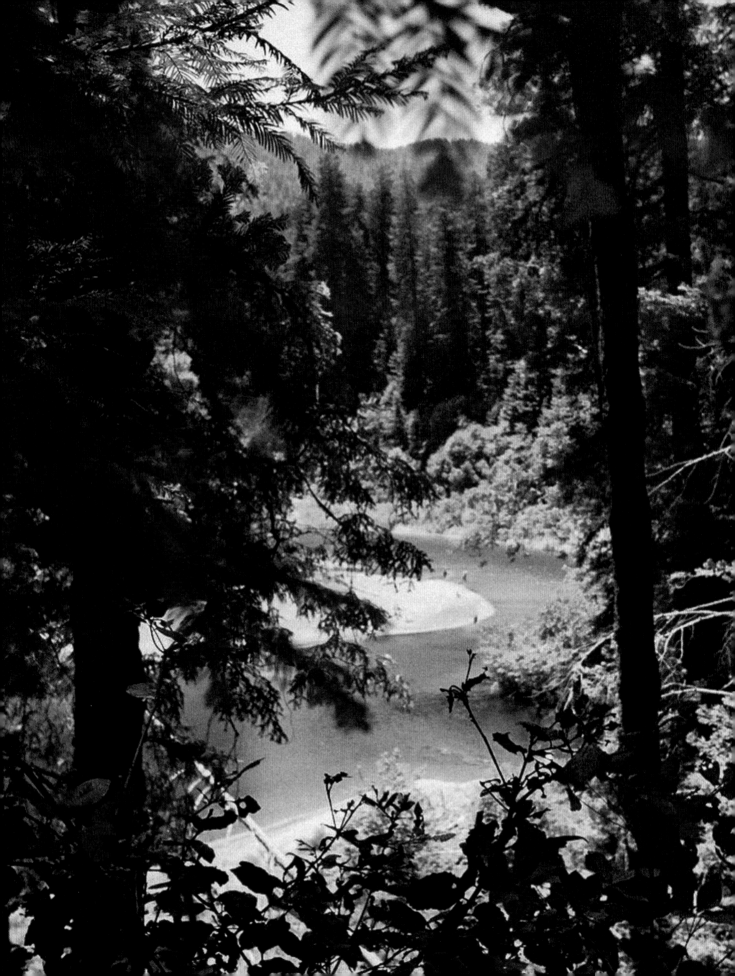

MOLLY STEELE

THE LOST COAST, CALIFORNIA, USA

coordinates
39.9203°N, 123.9397°W

The Lost Coast is a wild, undeveloped stretch of the northern California coastline that includes the King Range of mountains. It stretches from Humboldt to Mendocino County just a few hours below the Oregon-California state line. Originally home to the Eel River Athapaskan people, the Lost Coast is the most remote stretch of California coast. In the late 1800s, during the Bald Hills War, most of the indigenous communities were destroyed by white settlers. However, after the 1930s its settler population declined, abandoning the area to its more natural inhabitants. Migrating grey whales, sea lions and harbour seals frequent the coastline, and Roosevelt elk walk along meandering streams that sweep out to the ocean. The land is rich and fertile, lush with life, and expansive, allowing for room to breathe.

THE LOST COAST MADE ME QUESTION OUR PRESENCE IN THESE PLACES AND WHAT MY PRESENCE MEANT ON THIS TRAIL.

It was one of those 'get in the car and just drive' solo trips – you know the ones. A friend had quietly tipped me off about a place called Needle Rock on the Lost Coast, and I left without hesitation. The route was fairly treacherous, just wide enough for a single car, with a steep gradient dropping down into the ocean on one side. It's the kind of road where you spend the whole time crossing your fingers that you don't meet anyone coming the other way. This is how it was for the hour-and-a-half it took to drive along it. But, on that day, my only company was the sun and a dozen or so elk, munching on the roadside, watching me pass.

The Sinkyone Ranger Station is an old wooden house sitting at the very edge of the world. Home to an old couple, who act as caretakers for this portion of the coast, they welcomed me with affection and let me camp close to their home where the forest meets the sea. At sunrise, I packed up my tent and began exploring the Lost Coast Trail. My favourite flower, the foxglove, grew wild throughout the region, often edging freshwater creeks. It is hard to articulate the lush surroundings that unfolded in front of me as I pushed forward towards Bear Harbor.

It was a quiet place. Elk and bears are known to roam the beaches, drinking from streams in the eucalyptus groves adjacent to the ocean, before passing peacefully back into the forests on the cliffs above. The coast was empty of people, with migrating grey whales far out to sea and too distant to photograph.

I sat against an old-growth redwood, sunlight filtering through the upper canopy, eavesdropping on the wilderness around me. To witness a space so lightly touched by man is a rarity, especially on such a casual trip. It made me question the impact we have had throughout California from the coast to our inland desert borders. In what ways have even the lightest paths reshaped and trampled native food sources, ecosystems and the harmony that existed before us? The Lost Coast made me question our presence in these places and what my presence meant on this trail.

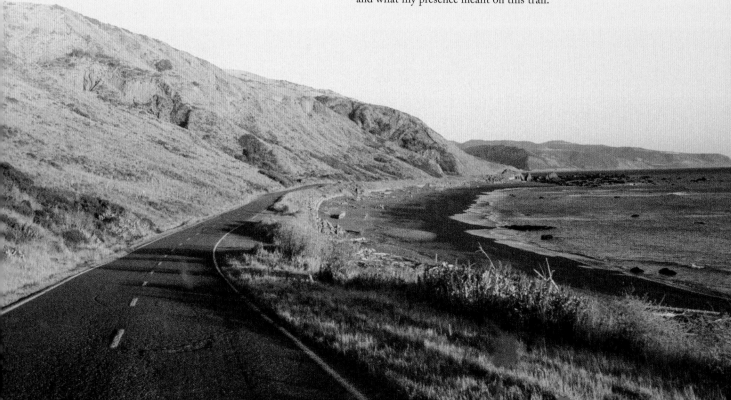

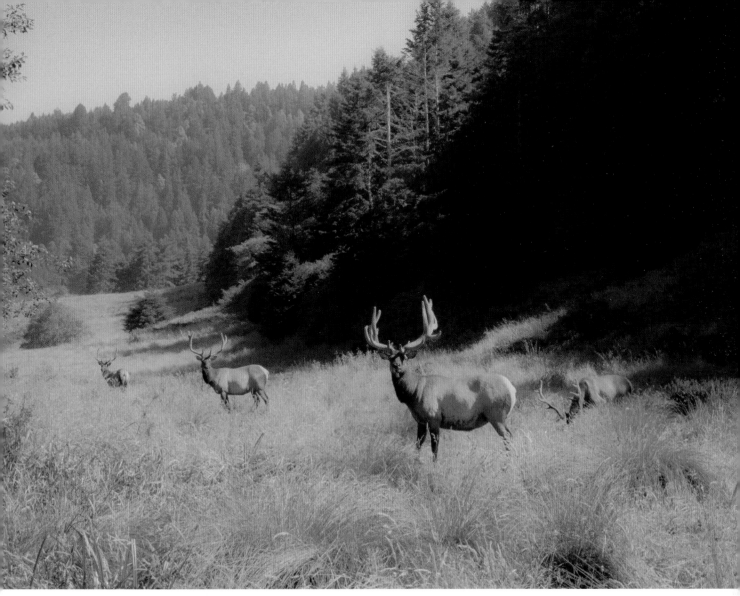

⌃ Elk gather at the edge of the valley.

‹ Forests of driftwood gather along the coast.

TO WITNESS A SPACE SO LIGHTLY TOUCHED BY MAN IS A RARITY...

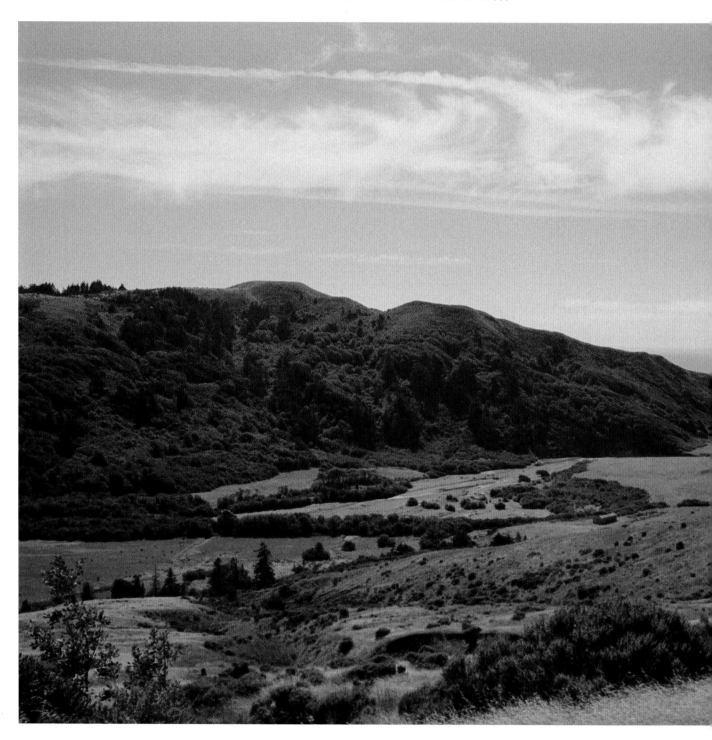

∧ Grazing land of an old homestead south of Ferndell.

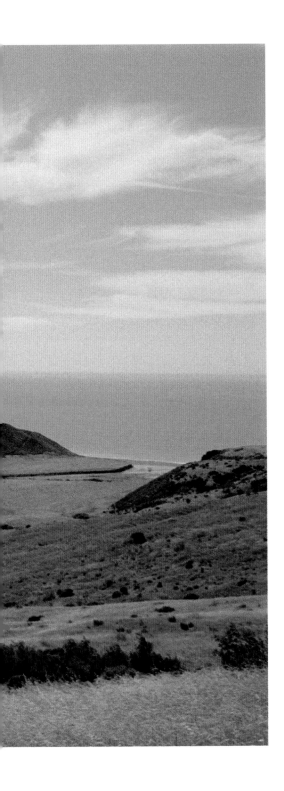

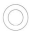

BEHIND THE LENS

Focus on being present and in your feelings. Forget about the technical. Your perception of a place is related to your mental state, and when you're present in yourself, your levels of awareness increase. Working in this way will transfer the spirit of a place into your photographs more effectively than any gadget.

Be mindful of your impact on this unique place. Visit with respect, and hold it close like a secret. Bring all your provisions and take home everything you take in – leave no trace. Prepare for no phone reception and keep screen use to a minimum so you don't damage your night vision; the stars are mesmerizing. Challenge yourself to pack lightly. It will be a reminder of how little you need.

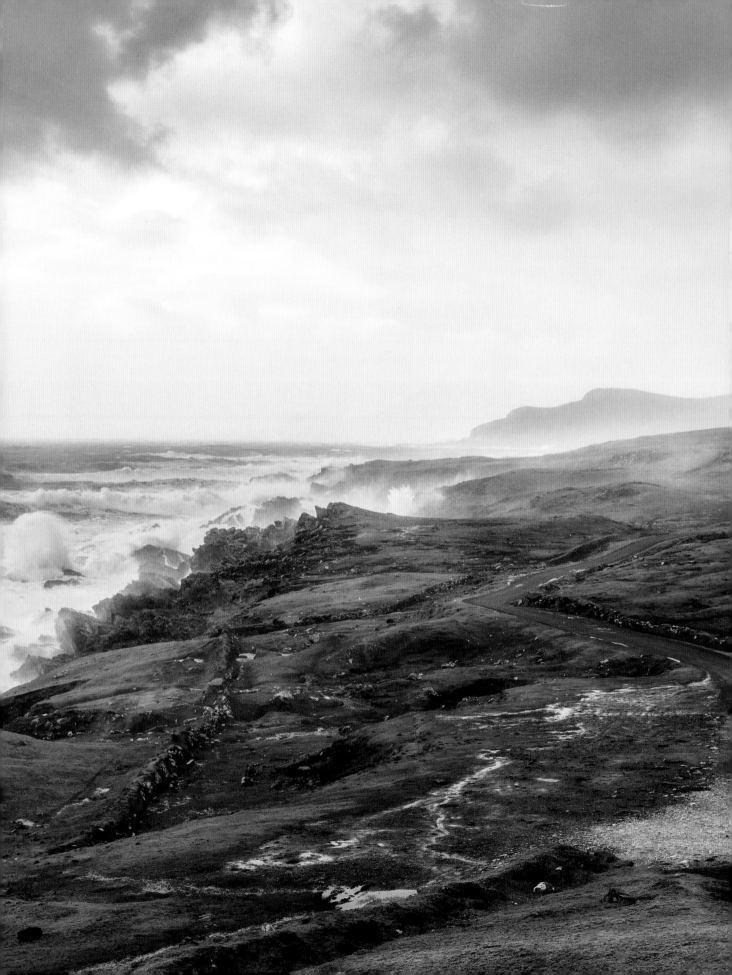

FINN
BEALES
WILD ATLANTIC WAY,
IRELAND

coordinates
52.9715°N, 9.4309°W

The Wild Atlantic Way is a 2,500-kilometre
(1,550-mile) journey of jaw-dropping cliffs, crashing
Atlantic surf and spectacular sunsets. It runs the entire
length of the west coast of Ireland, passing through
nine counties and three provinces, making it the
world's longest defined coastal touring route. The land,
comprised of rugged, round, quartzitic peaks, performs
an abrupt handshake with the sea, where a series of
spectacular cliffs jut into the Atlantic Ocean. Much of
the topsoil was scraped away in the last ice age, leaving
behind a region dominated by barren rock formations,
windswept bogs and numerous small lakes.

WE PLANNED
OUR TRIP FOR
FEBRUARY,
INTENTIONALLY
TIMING
OUR VISIT
WITH SOME
ATROCIOUS
WEATHER.

I spent most of my school holidays in Ireland as a child. My father, a sailor, would pack my mum, two sisters and me aboard his yacht before crossing the Irish Sea, from Wales. We would set off at night to arrive in time for breakfast the following morning. For two to three weeks, we sailed the South Coast, disembarking to explore castles and eat oysters, always invariably dodging a litany of rain showers. It was a happy, adventurous time, so when an invitation to photograph Ireland's wild west coast for the BBC arrived in my inbox, it brought with it a flood of memories. It was an easy gig to accept.

We never made it far up the west coast with my dad, so the area was new territory. A remote stretch, it's exposed to the full brunt of a westerly gale, and it was these unpredictable weather patterns that I wanted to capture with my lens. There is nothing like a winter storm to awaken sleeping seas. The coastline comes alive.

This time it was my turn to show my family the region. We planned our trip for February, intentionally timing our visit with some atrocious weather. Perfect shooting conditions if you ask me. With only a week to explore, and wanting to take our time over the journey, we chose a short section of the route to complete. We began on Achill Island in County Mayo, the largest of the Irish isles. It was blowing a stiff gale that first day – storm force 10, if I remember correctly. Every sensible person had retreated inside, their hatches battened, waiting out the storm. But where's the fun in that?

I convinced my partner Clare that it would be worth leaving the cosy confines of the inn we were staying at, and we began to slowly navigate our way along a single-track road labelled the Atlantic Drive. The noise of the sea pounding the shoreline was intense. With our windscreen wiper blades on full, we rounded the headland and the most spectacular views unfurled in front of us.

I had to capture the scene and exit as quickly as I could. With my camera safely tucked into my jacket and my head bowed, I

⌄ Seabirds wheeling over surf brought on by a stiff onshore breeze.

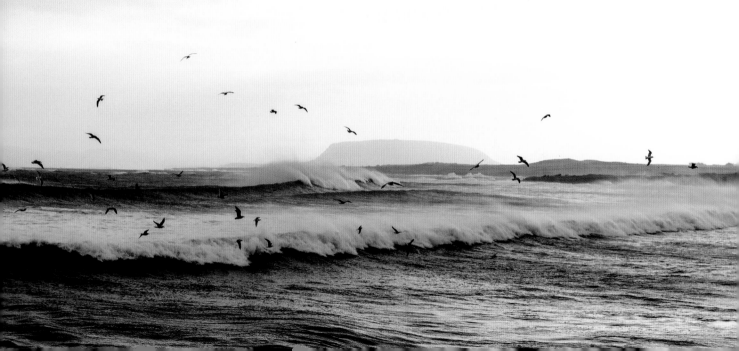

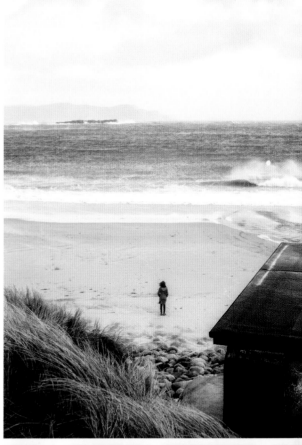

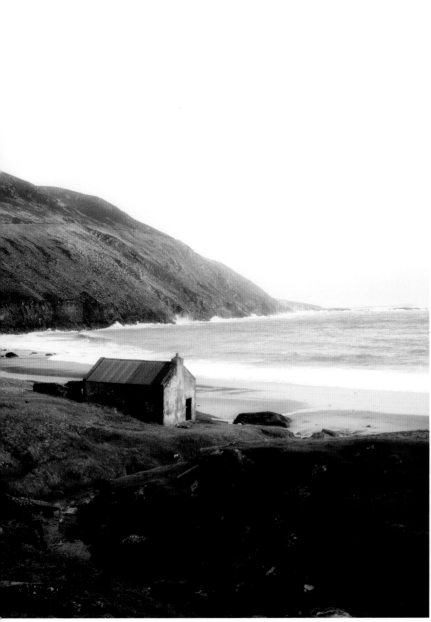

⌐ The seculded cove of Keem Strand on the east of Achill Island.

≫ Watching Atlantic rollers pound the shoreline.

⌃ Weather beaten pebbles line the shore.

‹ Only the sheep joined us on this wild day. Everyone else was safely tucked up indoors!

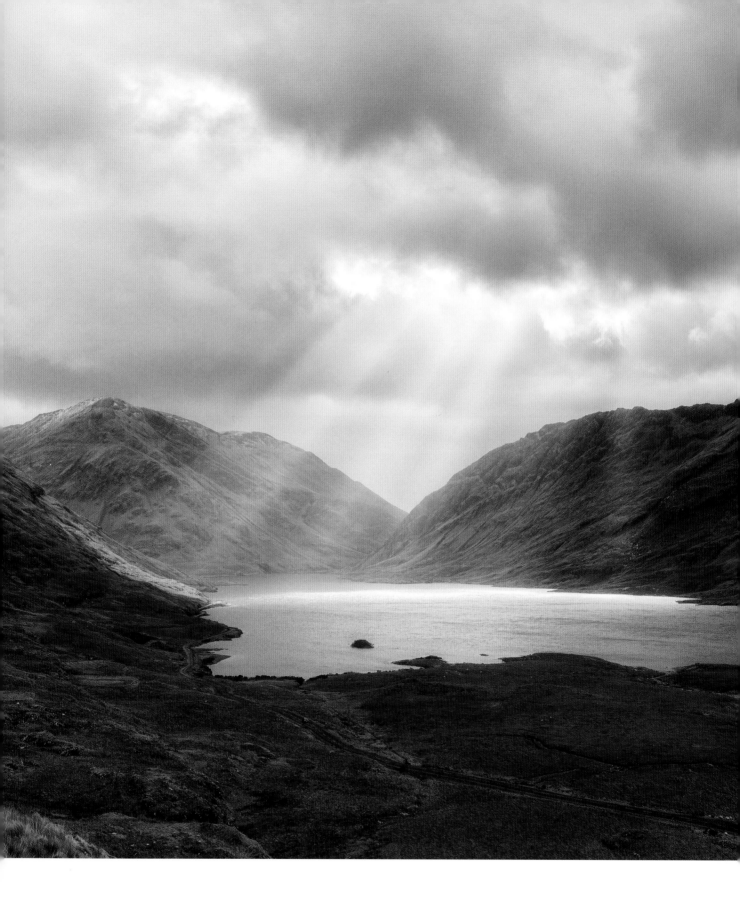

∧ Sunlight piercing leaden skies above Doo Lough in County Mayo.

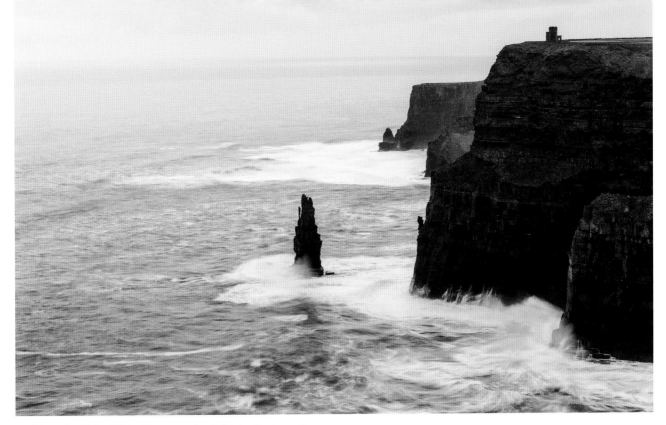

∧ The mighty Cliffs of Moher. Best captured at the height of a winter gale.

pushed uphill against the rain. More sweet-talking had convinced Clare that a sense of perspective was necessary for the photograph and she kindly braved the elements too. She was the perfect muse in her emerald green coat.

We battled back to the car and pushed on towards Keem Strand, a sheltered beach at the head of a valley on the east of the island. Hiding between the cliffs of Benmore to the west and Croaghaun mountain on the east, the pristine white sands offered some respite from the weather and made it easier to photograph our surroundings.

A contact following our trip on Instagram had suggested we track inland and take the route through Doo Lough. Local knowledge rarely disappoints, so we made the detour and passed through a beautiful valley backed by impressive mountains. We stopped the car and hiked up the western edge, and as we reached the summit, a break in the cloud poured light into the valley below. We made a pit stop at an eighteenth-century fishing lodge for tea, before pushing on towards our final destination beyond Galway: the Cliffs of Moher.

As a Welshman, I felt a sense of familiarity with the landscape. The wild vistas and barren moorlands reminded me of my home in the Brecon Beacons, but here they meet the sea, and nowhere is this junction more abrupt than at the Cliffs of Moher, one of Ireland's most famous sights. These dramatic sandstone cliffs drop vertically 214 metres (702 feet) to the ocean below. The rhythmic boom from powerful rollers is about the only interruption to a spectacular view across the Atlantic. Next stop, America!

The coastline was deserted, and realizing we were the only people out, we began to wonder if there was something we didn't know. Never ones to follow the crowd, we pushed on south along the clifftops, sea spray filling the air. We watched lazy-eyed puffins disappear over the cliff edge, only to come swooping back into view as they caught an updraft. The weather, always unpredictable, took a turn for the worse, so we retreated to a pub. We took our seats by a flickering fire and sipped on Bushmills whiskey while listening to the howling wind outside. I honestly can't think of a better way to spend a few days in February.

BEHIND THE LENS

Practise long-exposure techniques on the ocean and stretch time to capture silky smooth waves. An exposure of 10 seconds or more will flatten out the sea, whereas a shorter exposure of just 2–8 seconds will deliver more movement in the water. I prefer the latter effect, and if you shoot on a cloudy day or in the evening after the sun has set, you can often get away with not using ND filters. You simply need to lower your ISO and combine it with a small aperture of around f/11.

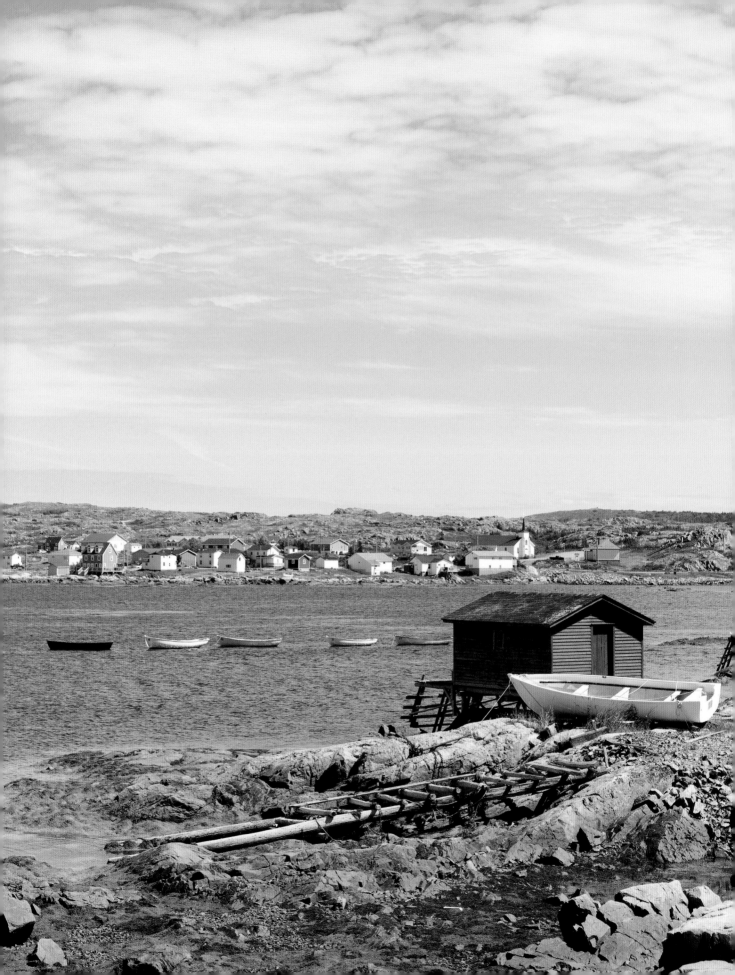

FINN BEALES
FOGO ISLAND, NEWFOUNDLAND AND LABRADOR, CANADA

coordinates
49.8471°N, 54.1797°W

Fogo Island is a remote yet accessible outpost off the northeast coast of Newfoundland; so remote, in fact, that it is recognized by the Flat Earth Society as one of the four corners of the world! It's quiet and isolated, with a long maritime history and a deep connection to the surrounding seas. The hospitality is generous and uncannily reminiscent of the island of Ireland. Simple wooden houses sit atop a landscape of contorted rock formed by ice, fire and the sea. The island is home to the Fogo Island Inn, a guesthouse and social enterprise guided by the arts and established to revive a community that was once supported entirely by a cod fishery that no longer exists.

As we scrambled over heavy granite boulders and weaved between brush laden with berries, Roy, a storyteller, poet and my guide to the island explained, 'There aren't many fishermen left here now.' The steady thump of Atlantic rollers greeting the shore was a constant reminder of how far away from home I was – a five-hour flight, a six-hour drive and a ferry ride, to be precise. Fogo is not the easiest place to reach, but therein lies its charm. Described by *National Geographic* as 'not so much a place, but a feeling', Fogo Island is a remote outpost lying off the northeast coast of Newfoundland and Labrador, Canada. It's hard to imagine how the first Irish settlers must have felt landing here in search of new beginnings. It's an isolated place, but that has helped it retain its heritage, and there are still traces of an Irish accent among the islanders today.

As we rounded the headland, Roy, handed me some blueberries. 'We're approaching Berry Season now; we just need a bit more sun to ripen everything up.' Berry Season is favoured among local people on the island and coincides with a cool westerly wind and the most astonishing sunsets. The island finds itself blanketed in a dizzying quantity of blueberries, raspberries, marsh berries and partridgeberries.

I had my head down, sampling the delicious fruit, when Roy reminded me of what we had set out to see and pointed to the shoreline. 'The old buildings and fishing boats have mostly gone,' he remarked as we gazed at a futuristic structure perched on the very edge of the ocean. We were looking at Squish Studio, located just outside the small town of Tilting on the eastern end of Fogo Island.

Its sharp, white, angular form is in stark contrast to the surrounding landscape, but somehow it fits, its jagged structure reflecting the dramatic shifts in the weather it is designed to endure and from which it shelters its inhabitants and boy does it photograph well!

I paid several visits to Squish Studio during my stay on Fogo Island. Places change throughout the day, depending on the light, and each visit left a distinct impression on me. At night, the cabin, illuminated by the soft glow of its solar-powered lighting, blinks into life, a lantern-like lighthouse overlooking the North Atlantic Ocean. I was excited to spend a blue hour shooting the structure from a range of angles. 'Wait till you see Bridge Studio!' said Roy, looking at his watch.

Roy met me the following morning and we drove towards Deep Bay, the smallest community on the island, with a population of just 150 people. The hike looked short on the map, but the rocky landscape took a toll on our speed. I reminded myself of my sailor father's favourite phrase: 'Life is about the journey as opposed to the destination.' I surveyed the landscape of rocks cloaked in lichen, and realized it more than made up for our slow pace.

Small wooden steps cut sympathetically into the ground were the first hint we were nearing our destination, and as we climbed, the form of a traditional saltbox structure (minus a roof) came into view. The nod to the stilt construction of Fogo's waterfront fishing sheds is clear, but the contemporary take on the past is bold and refreshing. The studio affords the resident artist uninterrupted views across an inland lake; a perfect space to think, create and contribute to Fogo's ongoing story.

⌄ The remnants of Little Fogo Islands, a resettled community around 5 miles off the coast of Fogo Island.

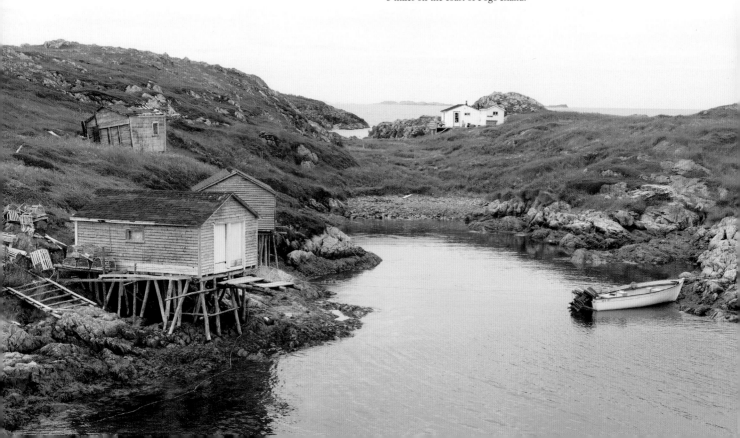

≫ Traditional saltbox housing typical of the area.

≫ Bridge studio, note the reference to traditional stilted architecture.

⌃ Tower studio situated on a stretch of rocky coastline in Shoal Bay.

WHAT DOES IT
MEAN TO BE ALIVE?
IT MEANS TO BELONG.

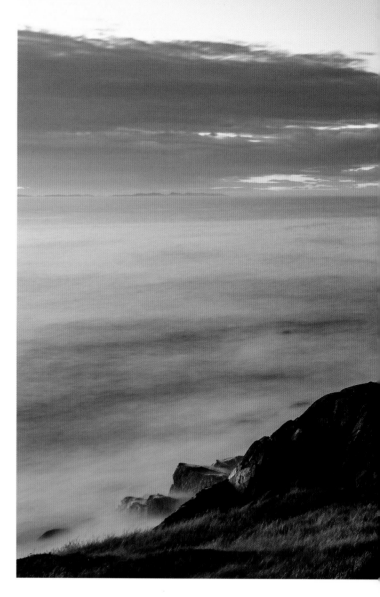

∧ Seaweed drying in Squish Studio.

❯ Squish studio, on the edge of the small town of Tilting
on the eastern end of Fogo Island.

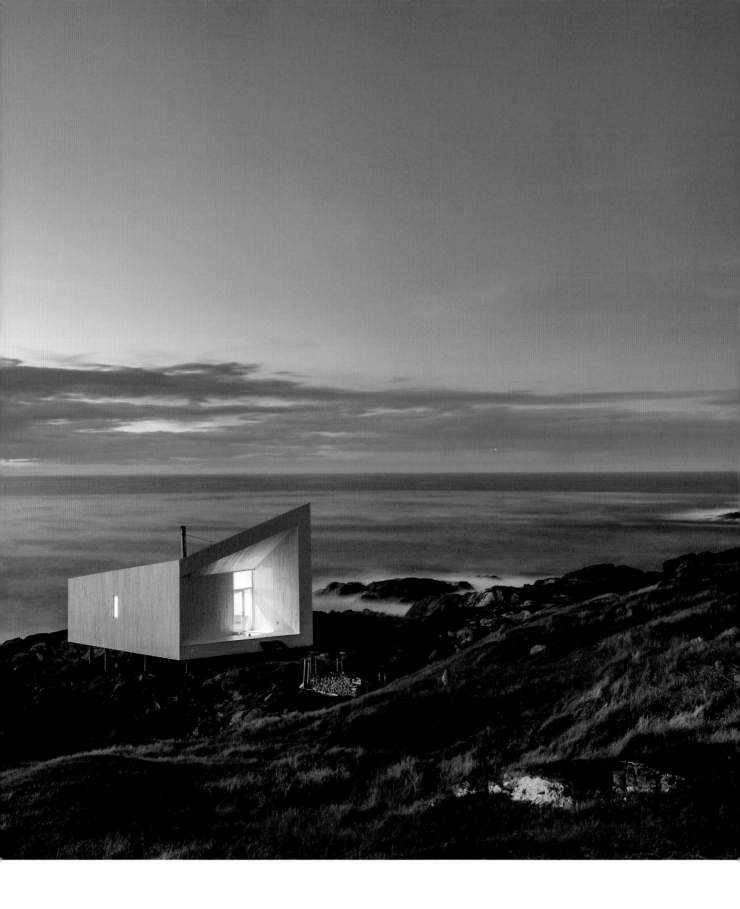

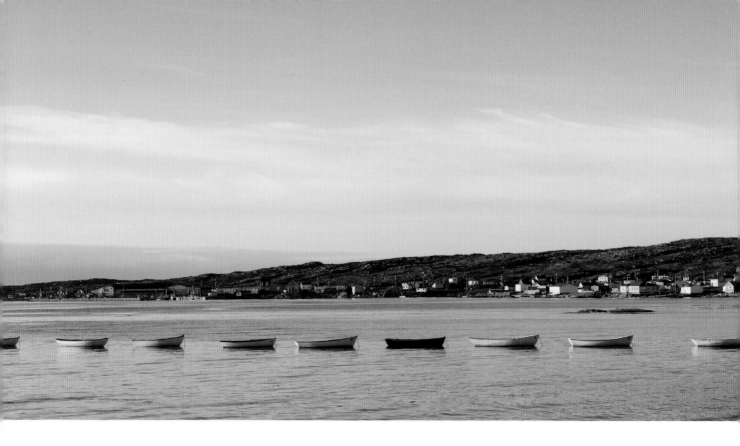

The studios – there are four of them – are the work of architect Todd Saunders and were commissioned by the Shorefast Foundation, a registered charity established by Zita Cobb, the daughter of a Fogo fisherman. Cod fishing was a mainstay on the island for centuries, but a ban introduced to protect fish stocks was devastating for the islanders, and many had no choice but to leave a place their families had lived for generations. Zita's father left, but only after nailing the gate in front of his home shut and declaring never to return. 'When there's a big flood or a volcano, everyone rushes in to help, at least for a little while until the next crisis,' she mused. 'But the thing about the disintegration of small places, and it's happening all over the world, is that no one rushes in to help anymore and that place just slowly disappears.' Zita returned to Fogo on a mission to save her homeland by putting art, hospitality and social value at the centre of her initiative. 'Art was a way to put this community into the conversation about where we are all going together. And what does it mean to be alive? It means to belong.'

As we made our way back to the car along clifftop paths, we had the most incredible views: out to sea there were passing icebergs and occasional spray from the blowhole of a migrating humpback whale. Bright clapboard houses dotted the distant headland, and I watched the bow wave of a tiny fishing vessel returning to the harbour's embrace after a day at sea. Fogo Island is in a world of its own. The artist studios are a stunning realization that successfully wraps the island's identity, culture and traditions into a series of buildings that reach far into the future, yet with a firm grasp on the past – a bridge between two worlds. My only hope is to return as a resident artist someday.

BEHIND THE LENS

If you are familiar with my work, you'll know that I like to shoot details to enrich a story. Fogo Island is, on the face of it, rather barren and featureless. However, look more closely, and you will find a rich and varied terrain. Take your time to capture the details in a landscape – the flora and fauna, the textures in the rocks and sea. When you pair these details with more sweeping shots, you will end up with a rich and detailed photoset. On page 124 I paired a detail shot of seaweed and sea urchin shells with a long shot of the artist studio to reinforce the sense of place.

⌃ Small fishing boats moored up on calm inshore waters.

❯ Icebergs, thousands of years old, sail past Fogo each spring.

FOGO ISLAND IS A
WORLD OF ITS OWN.

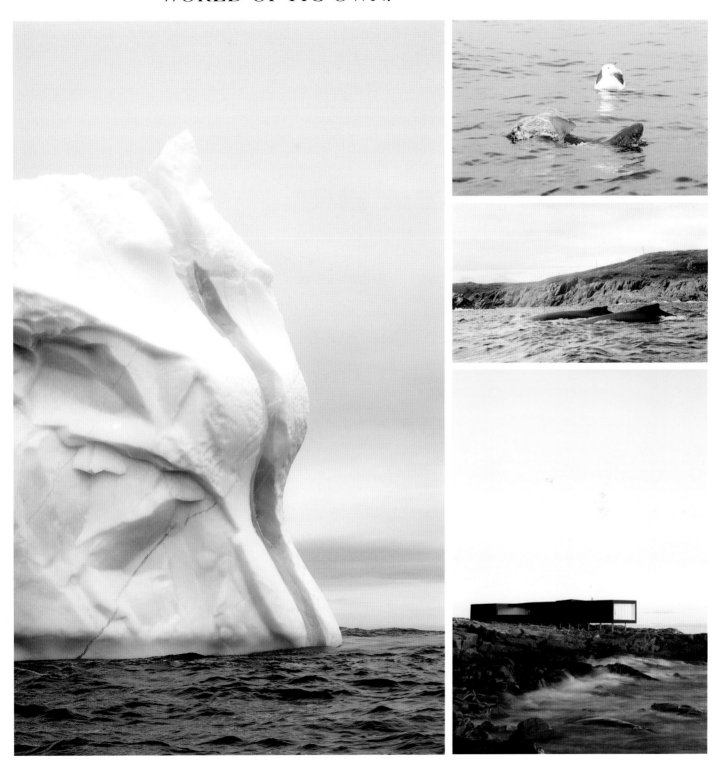

∧ The small fishing village of Joe Batt's Arme.

⟩ Fogo Island Inn.

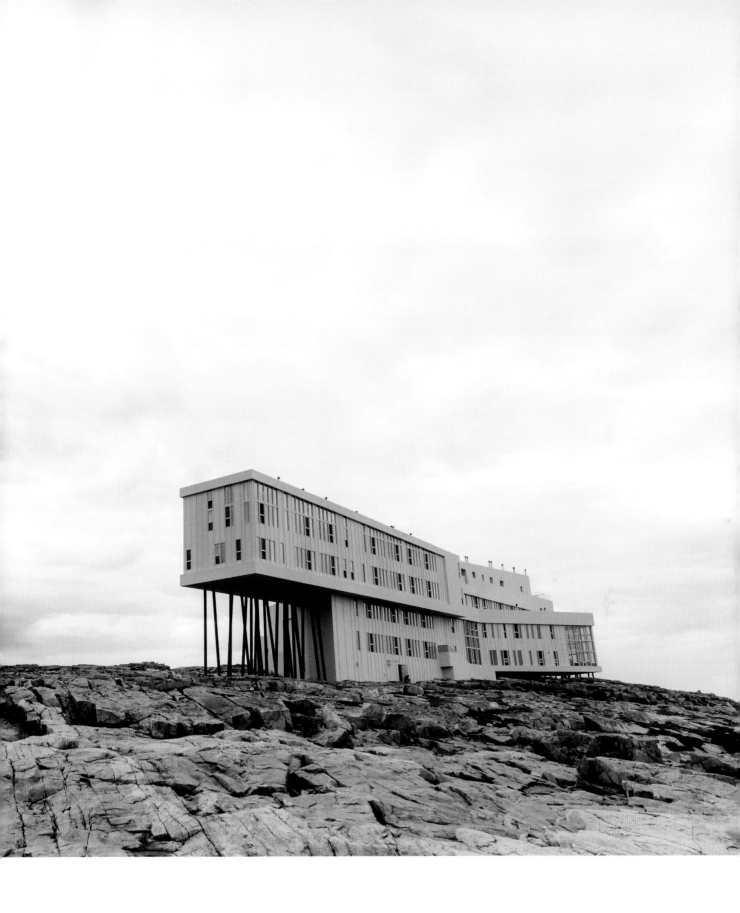

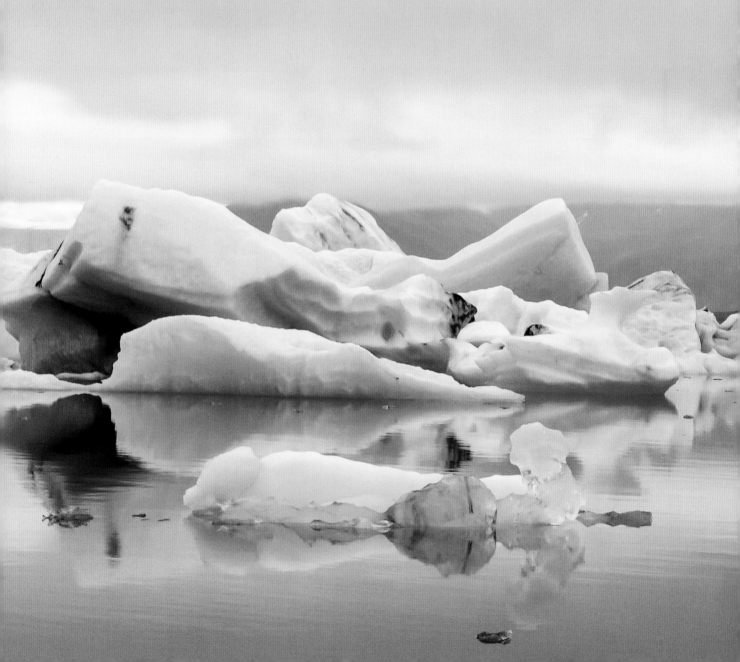

ICE & SNO ❋ MO

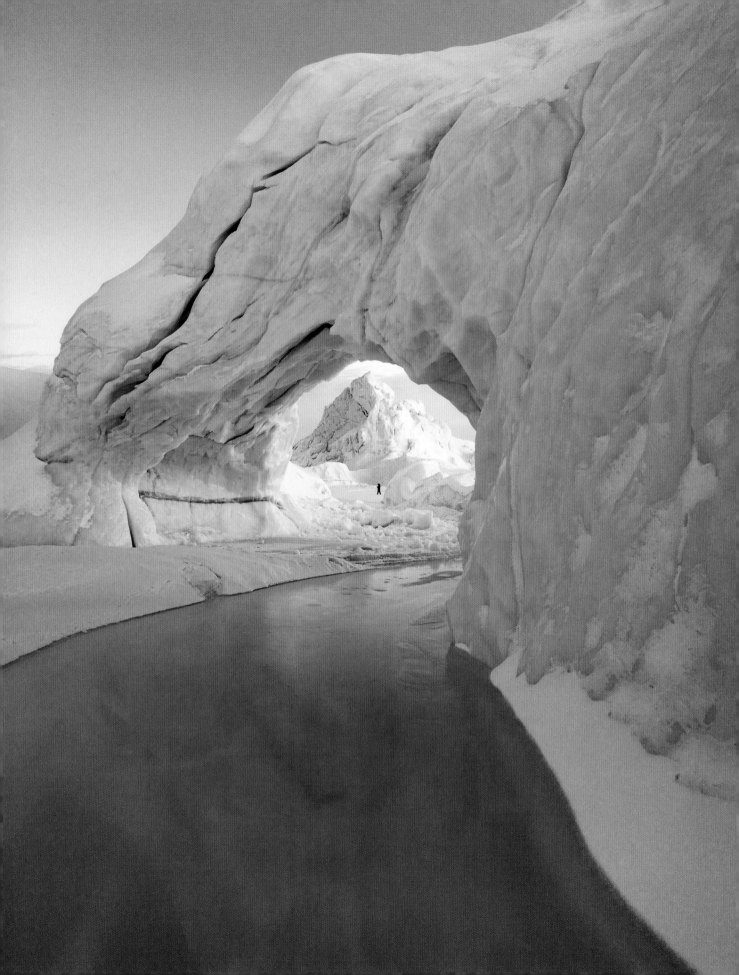

BENJAMIN HARDMAN
ILULISSAT, GREENLAND

coordinates
69.2198°N, 51.0986°W

A few hundred kilometres north of the Arctic Circle, at the edge of the Greenland ice cap, is the town of Ilulissat. Famous for enormous icebergs and the ice fjord oasis Disko Bay, it is a beautiful town, with breathtaking ice structures at every turn. The ice forms a constant soundtrack to your time here, a steady rumble echoing from one end of the town to the other. The winter solstice brings eternal darkness and the sun's return in the spring is a cherished sight among locals. Once the light has returned, a magical and unique winter world is revealed.

...THE LANDSCAPE WAS BEAUTIFUL. HARSH AND UNFORGIVING TO THOSE WHO ARRIVE ILL-PREPARED, IT FELT UNTOUCHED. VIRGIN TERRITORY.

Ilulissat translates as 'icebergs', and this makes sense considering the town is encircled by great towers of ice, birthed from the nearby Sermeq Kujalleq glacier. During the cold, dark winter months they lie in stasis, biding their time before the sun returns in late January, when they are slowly released into the ice fjord and North Atlantic Ocean. These behemoths of the Arctic then drift south, where they occasionally come into contact with ships. It is thought the iceberg that sank the *Titanic* was most likely born in Ilulissat.

It was early spring in Ilulissat, and I was here to take advantage of the longer days and snowy conditions. Stepping into the fresh -30°C (-22°F) air made for an effective sharpener that first morning, and I walked to the edge of the ice fjord. It was silent but for the sound of birds and lap, lap, lapping of waves. The colossal icebergs joined in the chorus, a slow creaking yawn in the morning sun.

I took a boat out into the bay, travelling into open water between pockets of ice. I like getting up close. It gives you a better perspective, and no matter how many times I take a boat into Disko Bay, there is always something new to photograph. The ever-changing weather conditions around the glacier produce unbelievably dynamic lighting conditions, making it a dream to photograph.

At the end of the fjord is a lookout point that bears witness to the frozen backcountry. It looked stark, remote and as about as far from anywhere I had ever been before. A foreign place, but the more I looked, the deeper I wanted to explore.

Dogsled or snowmobile were my only options for traversing these frozen lakes and valleys. With centuries of heritage traversing

﹀ A group of Husky sled dogs resting on snow.

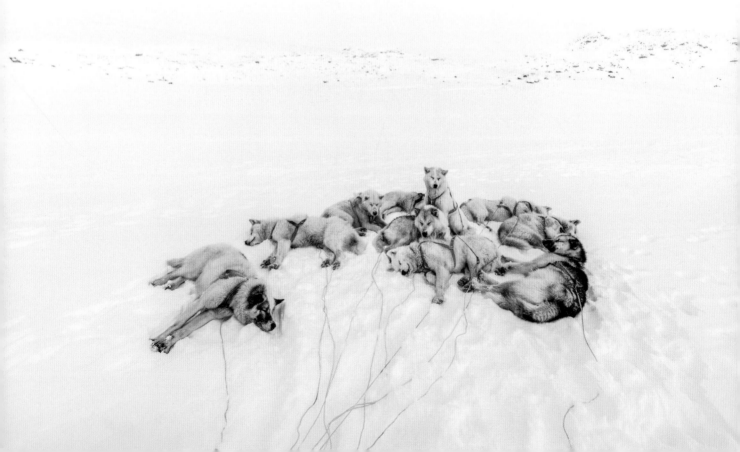

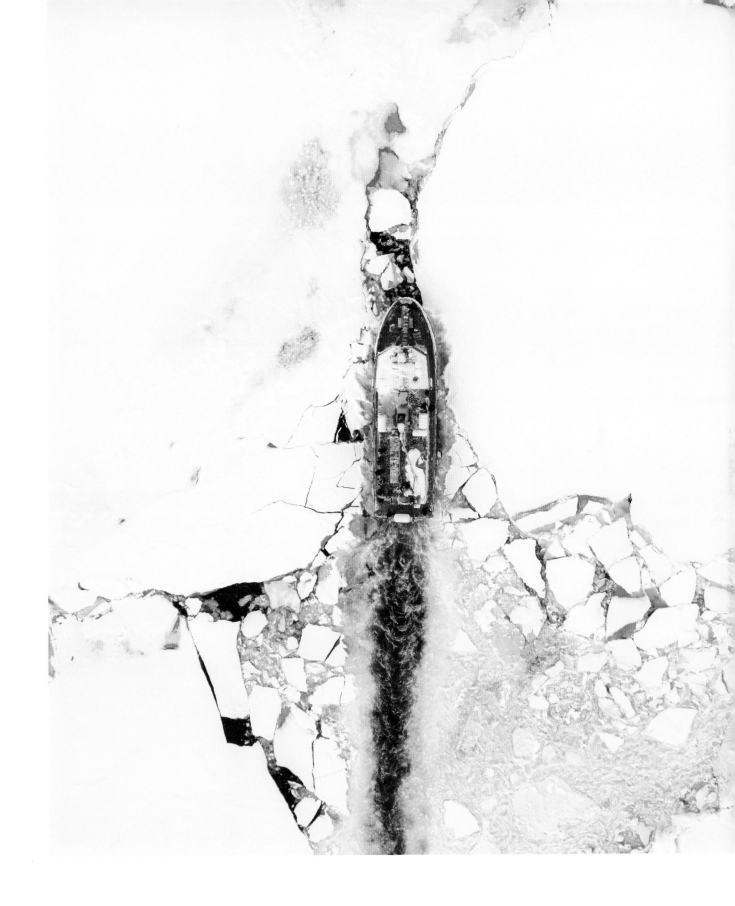

∧ A boat navigating through the sea ice.

ICE & SNOW

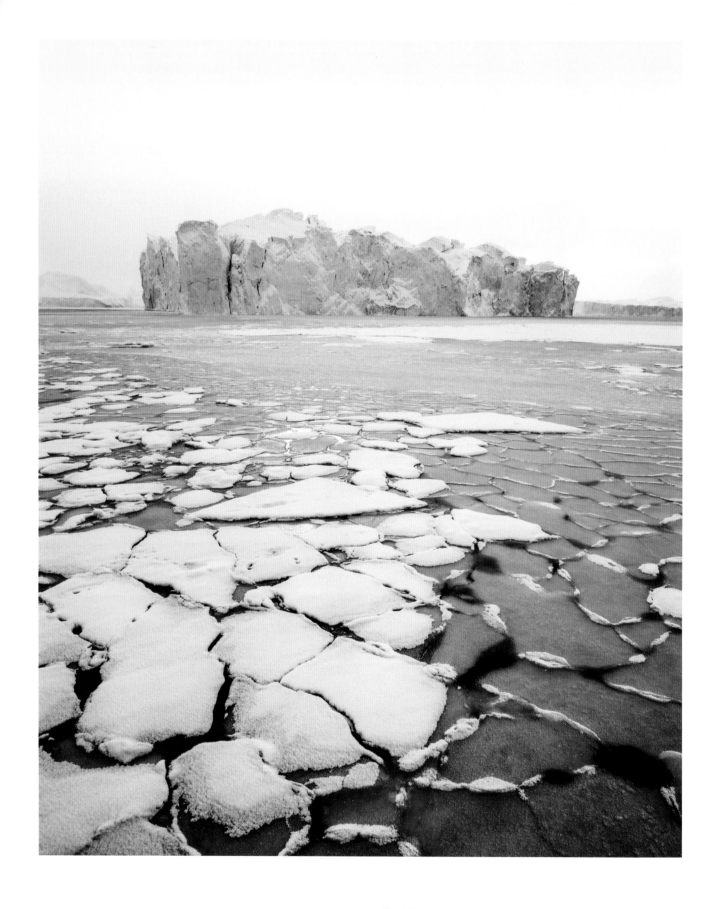

∧ Vivid blue ice calved into Artic fjord waters

⟩ Walking amongst towering icebergs.

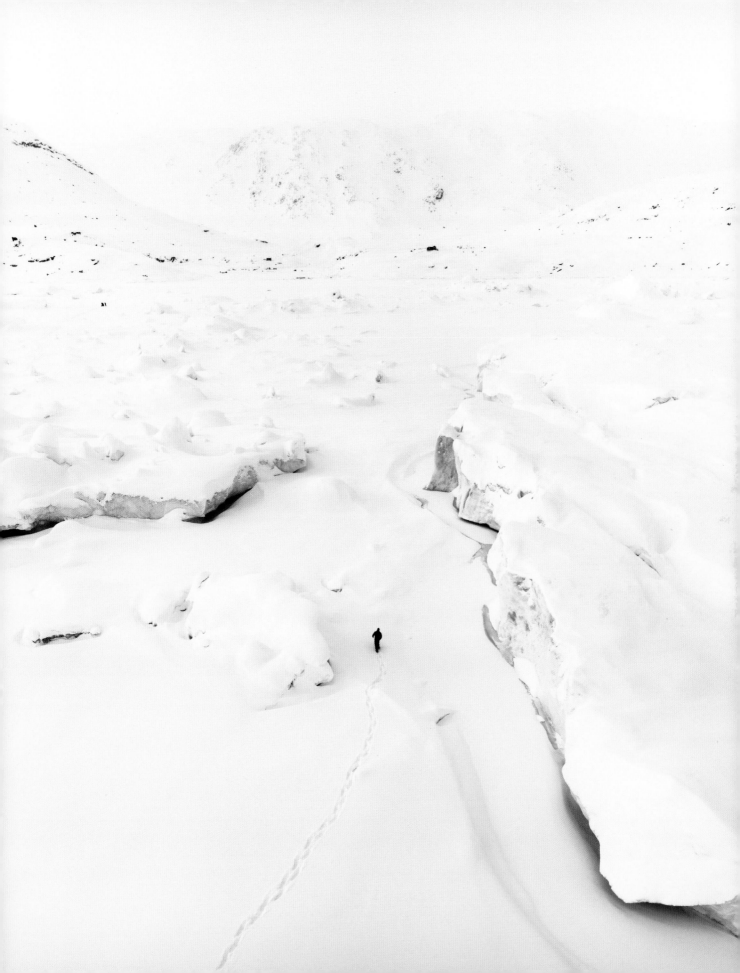

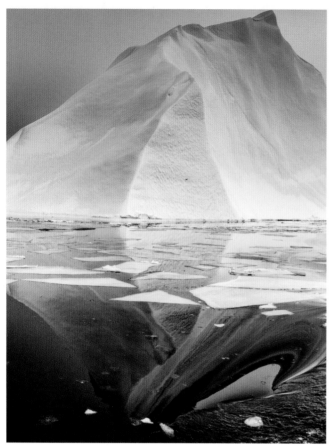

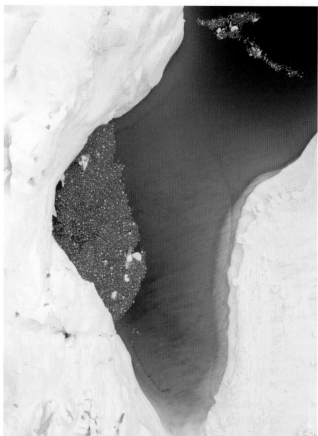

thick sea ice and deep powder running through their veins, the dog team seemed sensible, considering my destination. It was freezing on that sled, and journeying over the pack ice that day tested my resilience to the core. However, the landscape was beautiful. Harsh and unforgiving to those who arrive ill-prepared, it felt untouched. Virgin territory.

The feeling of remoteness was amplified on the sled. There was no one in sight, just the sound of the musher and his team of Greenland dogs, working in cohesion with the snowy terrain. We slowed to a halt and I stepped out into a frozen land, the sound of Arctic snow breaking through the ice crust; a distinctive sound I will never forget.

We slept that night in an igloo, situated along the Fisherman's Route just outside of Ilulissat. With enough space for two, the rectangular ice bricks make for a solid structure, and it was surprisingly warm and comfortable inside. I lay on a thick reindeer hide placed beneath my winter sleeping bag, watching the flicker from a few small candles on the roof of the igloo.

Having lived in Iceland for many years, Greenland feels like the next step to the north. Even though it's situated just across the ocean, only 300 kilometres (186 miles) away at the closest point, it really feels like you've stepped into a different world. The cold, crisp air above the polar circle carries with it a unique energy, and there is a sense of purity here that is hard to find anywhere else. It will continue to draw me back.

BEHIND THE LENS

When travelling to the Arctic in winter as a photographer, preparation is critical. Pick up some extra batteries and even a backup camera if you can get your hands on one. When the temperatures drop into the extremes, gear can start to fail without warning. When out in the field, keep your batteries tucked in the closest layer to your body and only take them out when you need to shoot; it will keep them running just long enough to get the dream shot. I love to hone in on the ice details, so I take a telephoto lens with a good range when out in the ice fjord.

ᐱ Layers of glacial ice.
ᐳ The Northern lights above a huge iceberg.

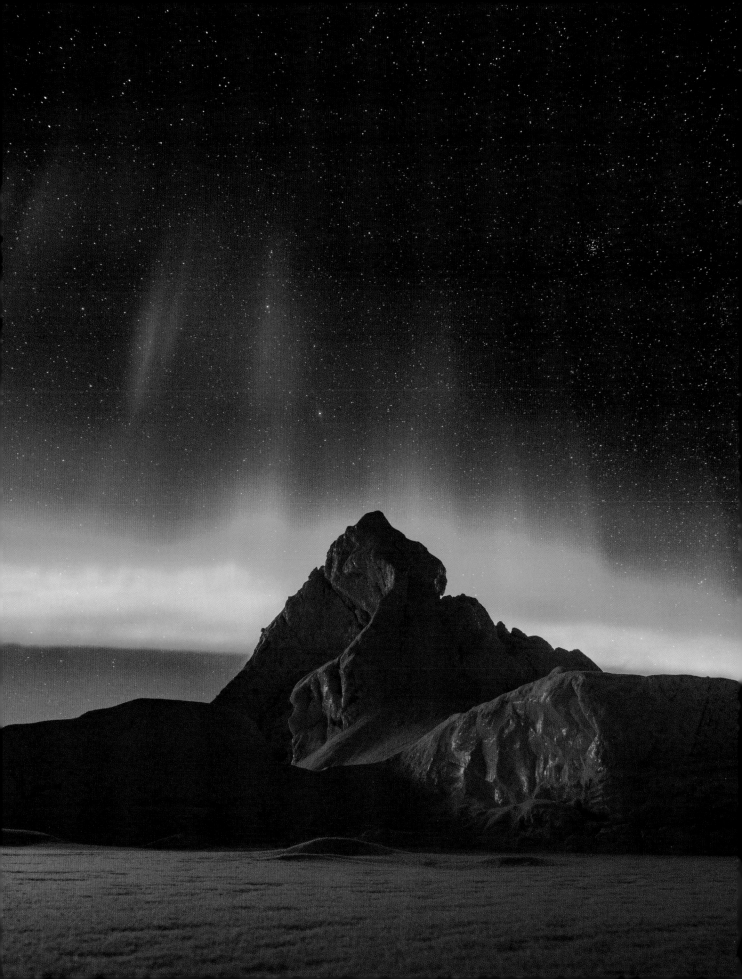

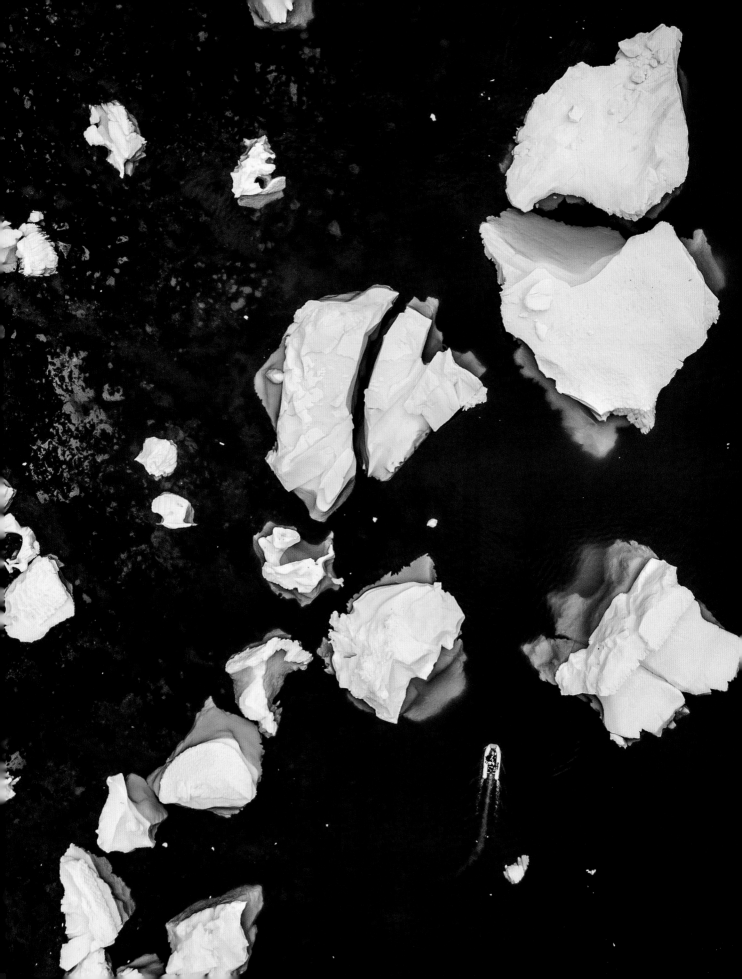

GREG LECOEUR

ANTARCTICA

coordinates
63.3198°S, 57.4812°W

The Antarctic Peninsula lies 1,000 kilometres (620 miles) from the southernmost tip of South America, Tierra del Fuego in Argentina. It is one of earth's most remote places. Declared a land of peace and science by the international community in 1959, Antarctica covers a surface of over 14 million square kilometres (5,400,000 square miles). Here, ocean and icy mountains unite as one and imaginary borders surround the continent, marked by a sharp decrease in temperatures, which channels the famous Circumpolar Current, the largest on earth. This isolated and mythical continent is entirely covered with ice and snow and hosts one of the planet's most barren environments. Inland, temperatures can drop to as low as -89°C (-128°F), and apart from 50 scientific bases on the coast, there is no human presence in Antarctica.

❮ Aboard the dinghy, we explore a maze of icebergs to find the best diving site.

I grew up in Nice, France, on the edge of the Mediterranean Sea. We have hot, sunny and sometimes sultry summers, and rarely see snow. My hometown is well removed from Antarctica, in a climatic sense. Yet both places edge the sea and offer access to a magical underwater world. I had dreamed of exploring Antarctica since I was a child. Moved by the desire to discover and document this isolated land, I wanted to witness the incredible biodiversity that existed below the surface.

I felt a wave of joy and a tinge of anxiety as we made our final approaches. I was finally about to realize a childhood dream. Yet, Antarctica is a hostile and unfamiliar environment, and diving under the pack ice is a human and technical challenge, with bodies and equipment subject to unimaginable temperatures.

We reached the peninsula by sailboat, crossing the notoriously treacherous stretch of sea known as the Drake Passage. A rough journey, it took 18 days longer than expected due to the weather conditions, but travelling this way limited the environmental impact of our expedition.

The first iceberg appeared like a colossal guard of honour; it was eerily quiet apart from the creaking ice. We anchored in a bay and loaded a small dinghy with cameras before performing obligatory safety checks. A small incident can quickly become a fatal accident in such an isolated and extreme place.

Stepping on to the ice pack for the first time felt strange, a pristine and immaculate land untouched by humankind. I felt a deep sense of humility towards Mother Nature and its beauty. Whilst not immediately obvious, the peninsula is hugely affected

⌄ Low light from the sun creates an epic atmosphere on the icy landscapes.

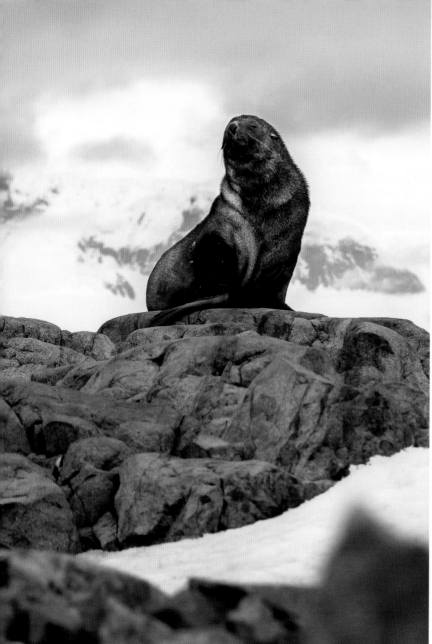

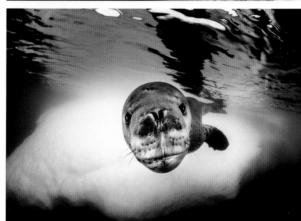

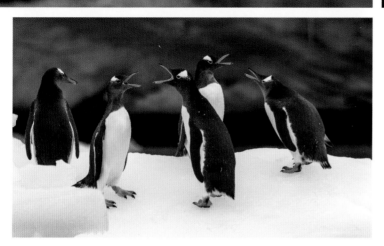

⌐ A fur seal enjoying the sunlight and absorbing its energy to warm up after diving in the cold water.

⌃ Free-diving along the hidden face of icebergs is like diving on another planet.

⌃ An underwater encounter with one of the planet's largest predators, the leopard seal.

‹ Gentoo penguins socializing on the ice pack offer very fun photographic opportunities.

VAST WHITE WALLS DROP AWAY TO NOTHING, A SHARP CONTRAST TO THE DARK DEPTHS BELOW.

⌄ When they are not diving, Weddell seals spend all their time resting on the ice pack.

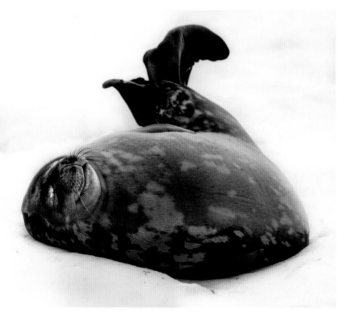

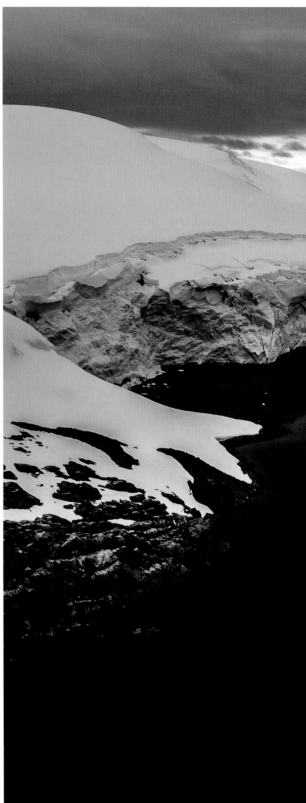

by climate change, and the melting ice has a direct impact on the feeding cycle of the animals that live here.

My quest was to photograph the largest predator in Antarctica: the leopard seal. Solitary and imposing, it only lives in these cold waters, and is known for its ferocity and cruelty towards penguins. Diving below the ice pack, I experienced a rush of emotions and an overwhelming, relentless biting cold – this, despite my 9mm wetsuit, thick gloves and diving socks. The cold became part of my daily routine, only relieved by a warm, wood-burning stove aboard our vessel; a refreshing tonic for worn-out bodies at the end of each day.

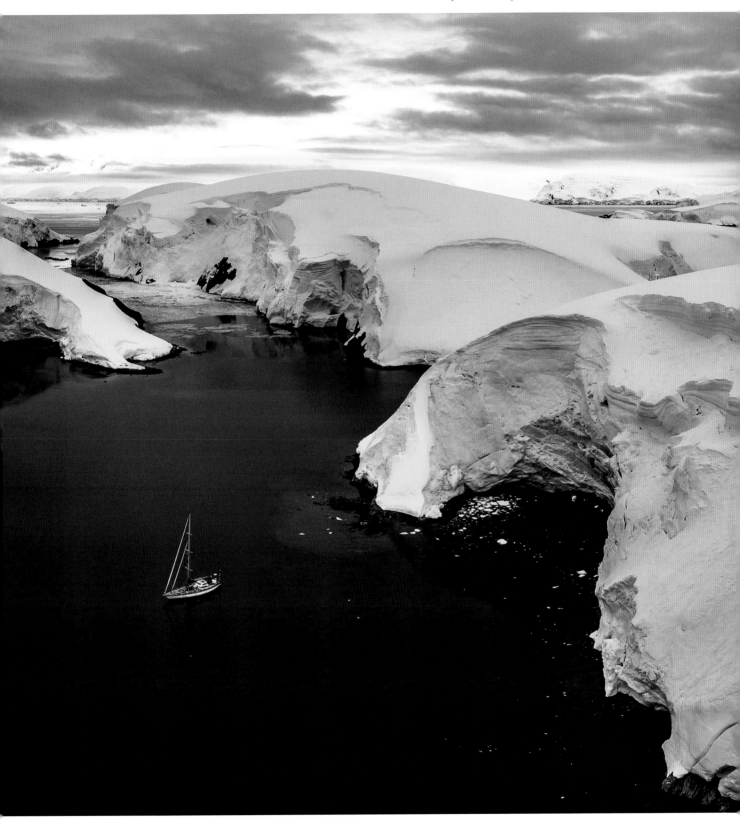

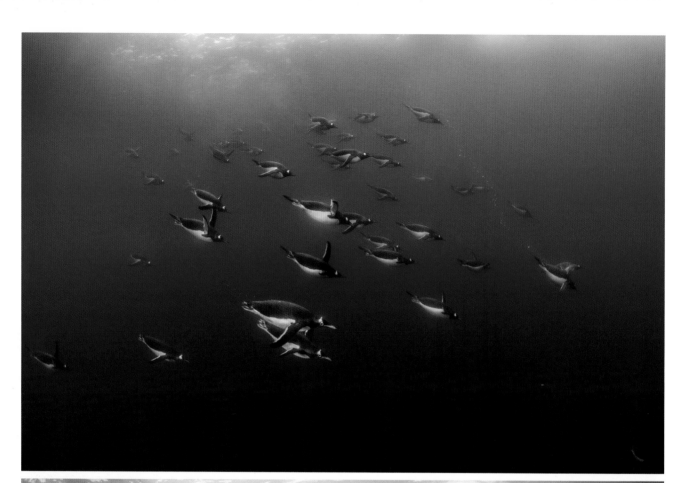

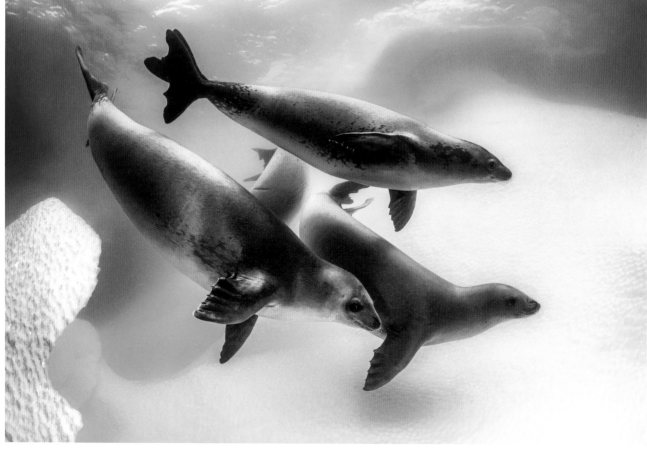

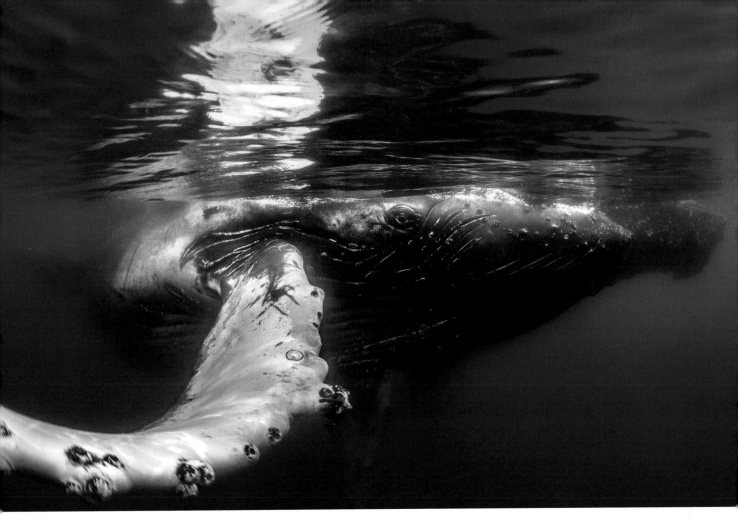

BEHIND THE LENS

In the field, the first thing to remember is that you are the guest and animals are in their home. Wildlife scenes are omnipresent; all you have to do is take time to observe and appreciate the majesty of the place. The icy landscapes are an inexhaustible source of inspiration. Compose and play with dimensions and low light from the sun to power the image.

⌐ Gentoo penguins are very clumsy on land, but underwater they are incredible swimmers. Here, they arelooking for krill shoals.

〈 Usually shy and fearful, crab-eater seals offered us an exceptional show in magnificent underwater icescapes.

∧ Humpback whales are very common in Antarcica during the austral summer, feeding on krill in abundance.

Under the water, life flourishes full of colour – a marked contradiction to the world above. The icebergs are dynamic habitats that shelter an incredible array of marine life, and diving alongside them is hypnotising. Vast white walls drop away to nothing, a sharp contrast to the dark depths below.

In Antarctica, and particularly underwater, local species aren't afraid of humans; we are a rarity in their world, and they are more curious than anything else. I photographed crabeater seals performing an aquatic ballet around an iceberg. They moved with agility, bashfully presenting themselves one by one before taking refuge in a cave sculpted in the ice. They tirelessly repeated the same merry-go-round, getting closer and closer to us on each pass.

Antarctica is beautiful, yet fragile, and the symbiosis between animals and the environment is finely tuned. Humpback whales, seals, penguins, sea leopards and otters have adapted perfectly to the hostile environs, but warming sea temperatures are directly impacting them and everything else that lives here, threatening the tightly balanced ecosystem. Photographing wildlife is a lesson in listening, observing and adapting without disturbing the world in front of you. Perhaps there is a lesson in this way of working for our species as a whole?

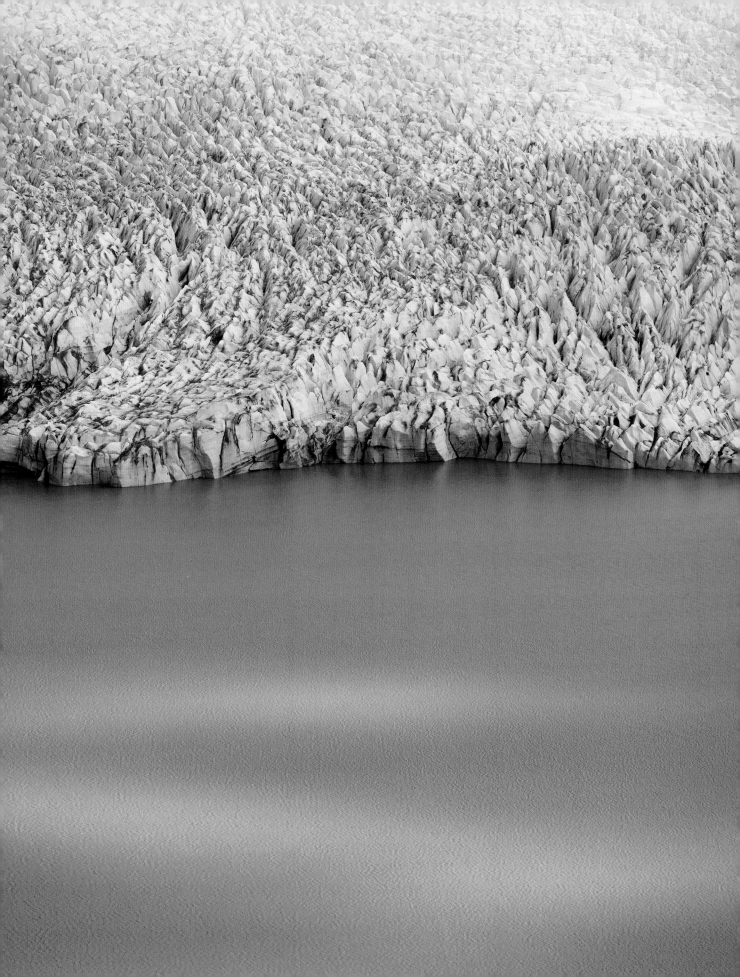

CHARLY SAVELY

ALASKA, USA

coordinates
64.2008°N, 149.4937°W

Alaska is the farthest northwest extremity of the continent of North America and the most northwestern state of the United States of America. A relatively new state, the land was purchased from Russia for two cents/acre in 1867. Geographically diverse, Alaska features rainforests, coastal beaches, volcanoes, mountainous regions and deserts, though much of the land is covered in a layer of permafrost, and always frozen. It is also vast – bigger than Texas, California and Montana combined. Only 20 percent of Alaska is accessible by road; most of the state is wilderness, untouched and truly wild. It is nicknamed 'the Last Frontier'. In the native dialect of Aleut, Alaska or *Alyeska* means 'great land'.

‹ Where the ice greets the water;
one of 100,000 of Alaska's glaciers.

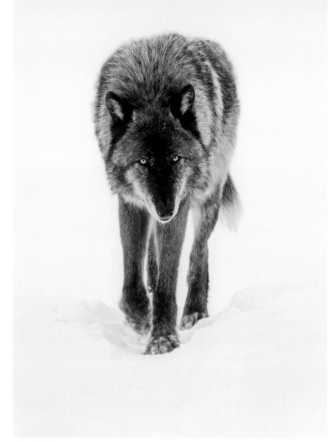

I grew up in the UK before moving to Singapore, then Australia, and finally ending up in the USA. Moving around meant I never felt grounded; I didn't know what 'home' felt like. I was jealous of my peers who lived in places they felt connected to, a bond with their land. Due to life circumstances, my husband and I could no longer afford to live in Seattle, Washington. We moved into our tiny van with our two dogs and decided to leave everything behind. We didn't know how long we would live like this, we just wanted to drive until we found 'home'. We ended up travelling all over the west coast in search of this place – this feeling. Then we discovered Alaska. We had made the very long drive up from Seattle and through Canada, hoping to photograph the autumn colours, but instead were met with a freak snowstorm. Living in a tiny van at -29°C (-20°F) was not pleasurable, but the landscape more than made up for the cold and lack of sleep.

I remember crossing the Canadian border and seeing endless snow-covered mountains stretch out across the horizon. It literally took my breath away, and we instantly fell in love with the location as well as the people. Alaskans are tough; they have to be to endure the terrain and the weather. Just walk into any bar and you'll meet some of the wildest characters and hear the most outlandish stories!

People often ask when the best time of year is to visit Alaska, but it really depends on what you're looking for. Spring is called 'breakup season', because it's when everything is melting, muddy and coming back to life. The flowers start to bloom, but the bears and mosquitos are also waking up. Summer is best for fishing, boat tours and hiking. It is when Alaska comes alive, and so does its people. Just watch out for the mosquitos – the insect is jokingly known as 'the state bird' in these parts. Alaska is nicknamed 'the Land of the Midnight Sun', and for over two months in the summer, it does not set at all. It definitely takes some adjusting to. However, it also makes for great photo opportunities.

Autumn is a special time, though its timing is unpredictable, and it comes and goes within a week or two. When it does arrive, everything turns orange and yellow and the skies grow moodier, as though preparing for winter, just like the animals who are busy trying to fatten up before the cold hits.

By the time winter comes around, most tours won't be running, but you can ski, ride snow machines and dogsleds, and see the northern lights. In March (which is still winter here), the infamous Iditarod dogsledding race takes place, which is always amazing to watch.

Alaska forces you to live in harmony with the seasons; it's a physical and mental experience and a way of being that I enjoy. After spending a week here, I knew this was going to be my forever home. I loved being able to walk on glaciers and listen to the ominous sound of cracking ice underfoot in the morning, to watch bears move along a river shore, patiently observing the water, waiting to catch their next bite in the afternoon. I am a lover of the cold and wild, and such things are plentiful here.

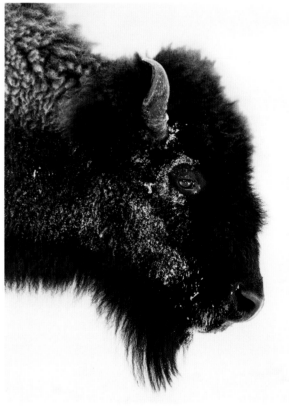

⌃ The fierce yellow-eyed wolf in whiteout.
⌃ A young bison with a snowy face and kind eyes.

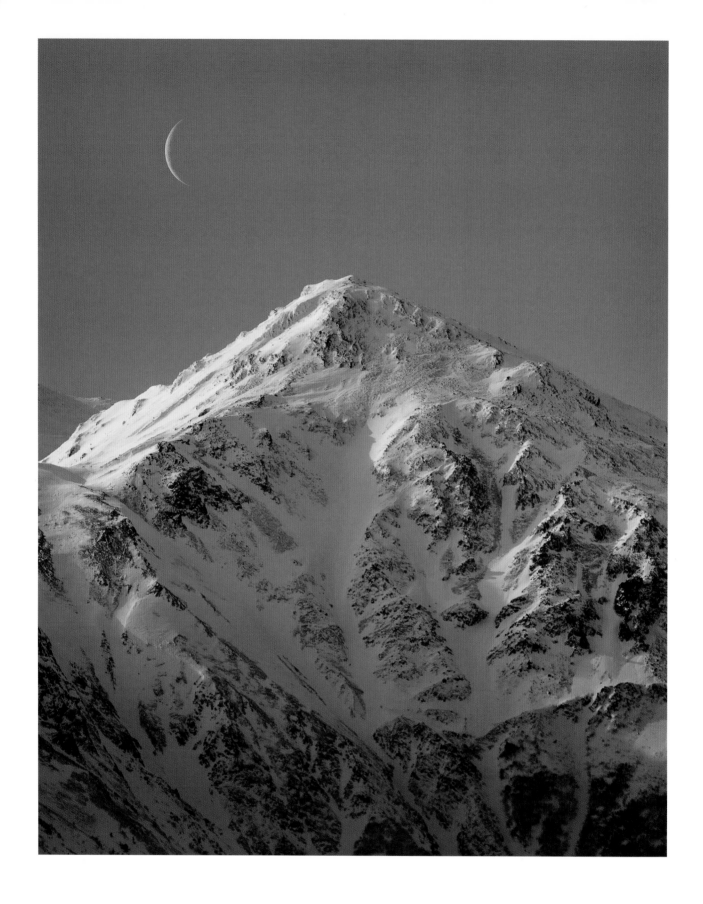

∧ Moonrise over the Chugach Mountains.
⟩ Water jewels dripping off of a fishing bear.

BEHIND THE LENS

For most situations, I prefer to keep my shutter speed fast and my aperture wide. Whether you're documenting wildlife or landscape in Alaska, the weather should always be a concern. Always make sure you have the right layers to stay warm and dry and in the colder months, gloves are a must. Always keep an eye out for wildlife, because they can pop up anywhere at any moment. You might see a moose casually strolling through the city or wake up to a bear in your garden! Also remember to look up, as the aurora borealis frequently makes an appearance.

ALASKA FORCES YOU TO LIVE IN HARMONY WITH THE SEASONS...

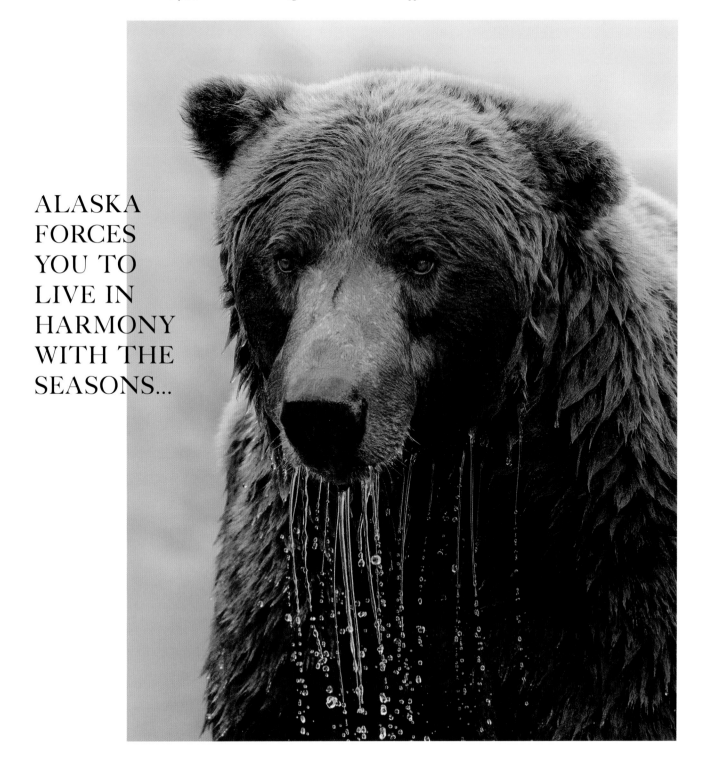

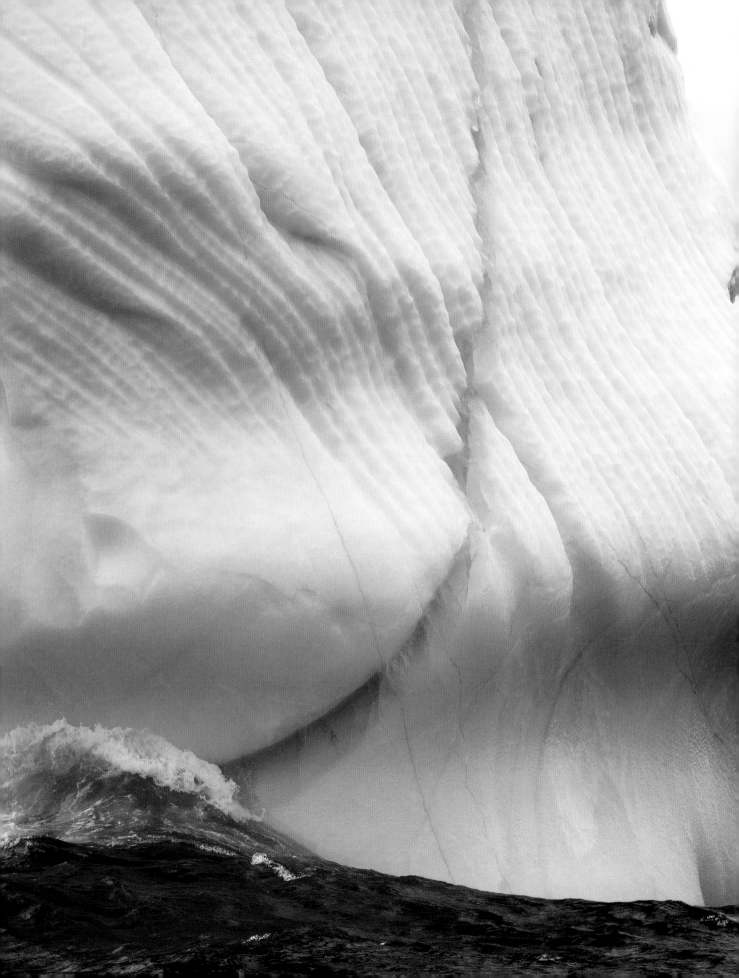

FINN BEALES

JÖKULSÁRLÓN, ICELAND

coordinates
64.0784°N, 16.2306°W

Jökulsárlón is a glacial lagoon on the south coast of
Iceland and part of the Vatnajökull National Park.
Accessible via the ring road that loops the island,
Jökulsárlón is tucked just inland and is largely
separated from the rough and tumble of the ocean
a mere few metres away. Its sheltered blue waters
are mirror-calm and offer a marked contrast to the
black sand coastline beyond. It's an ever-changing
landscape comprised of craggy, jagged icebergs
constantly jostling for position as they slowly
proceed towards the sea.

‹ Icebergs and meltwater meet in the
Jökulsárlón lagoon.

...ICELAND IS A STUNNING COLLECTION OF BLACK SAND BEACHES, CASCADING WATERFALLS, GLACIERS, GEYSERS AND BLEAK VOLCANIC PLAINS.

It was 7.30am and -3°C (-27°F) inside our converted minivan. My nose was frozen. I exhaled and laughed at the vapour that billowed from my mouth. I was wedged tight into the upper bunk, my friend and fellow photographer, Dan Rubin, in the one below. 'Teatime mate?' I suggested, 'bottom bunk is closest to the kettle!' Dan acknowledged my request with a murmur from deep inside his sleeping bag, and not long after the sound of a teakettle whistle signalled the beginning of another day in Iceland.

We were parked next to Jökulsárlón, a glacial lagoon that borders Vatnajökull National Park in southeastern Iceland. We had been on the road for a week – part of a convoy of three vans and six photographers. No client, no destination, but one very definite aim: the aurora borealis.

Iceland is an island in the middle of the Atlantic Ocean between North America and mainland Europe. It sits right atop the Mid-Atlantic Ridge, an active geological plate boundary, which accounts for the numerous volcanoes that influence the makeup of this small country. Outside the capital city of Reykjavík, Iceland is a stunning collection of black sand beaches, cascading waterfalls, glaciers, geysers and bleak volcanic plains. It's an uninterrupted wilderness interspersed with tiny villages, remote farms and the occasional hot spring. Small communities cluster along the coastline and are physically linked by the ring road that loops the island over a distance of around 1,300 kilometres (808 miles). This epic highway was to be our guide for the week, and our primary goal was to track down the elusive aurora borealis and commit it to memory (ahem…) card.

ﬖ My friend, Dan Rubin, photographing icebergs on a black sand beach near the lagoon.

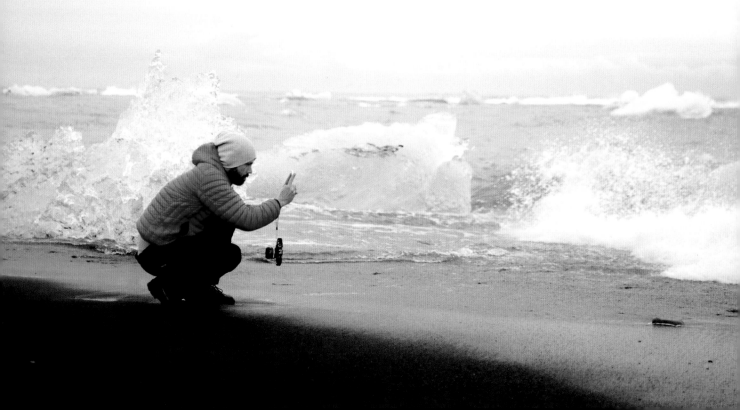

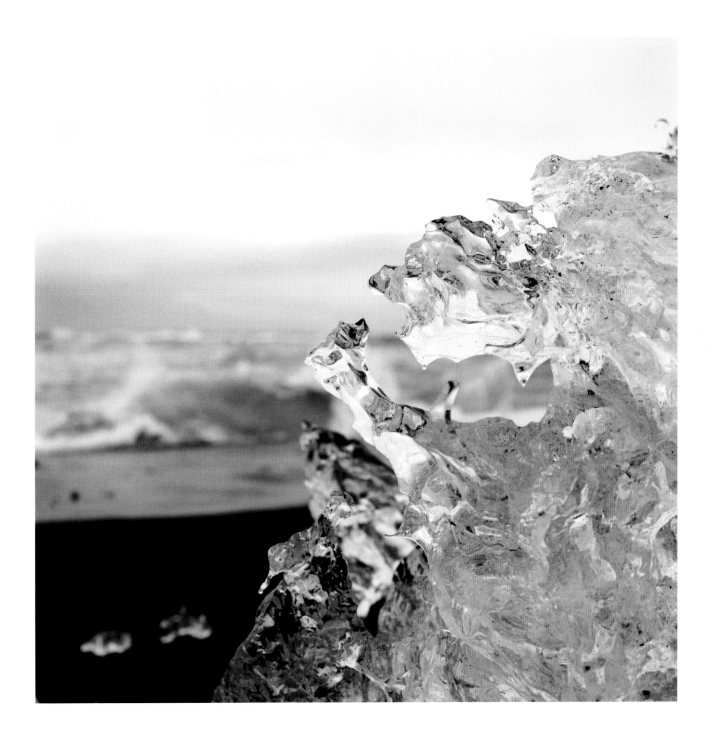

∧ Up close and personal. Shot on film,
with my trusty Hasselblad 500c/m.

ICE & SNOW

❄ 157

I had landed in the capital a week earlier and hooked up with Dan and the others in a small coffee shop tucked between a line of brightly coloured tin houses. I had worked with Dan in the past, and I knew the rest of the crew from Instagram. We had all been chatting online over the last few months and were ready to hit the ground running. We left Reykjavík, and its coffee shops, bars and art galleries, the following morning. I remember looking back at the towering spire of the city's Hallgrímskirkja Cathedral, which

was keeping watch like Sauron's all-seeing eye. It was raining hard – something you should entirely expect on any visit here. Unpredictable weather conditions are par for the course in Iceland. 'There's no such thing as bad weather, just badly dressed people,' is a typical turn of phrase around these parts. Foot to the floor, it was an excellent time to get some miles under our belt.

There are so many pit stops along Iceland's southern coast road that are worth making: the mighty Skógafoss Waterfall, the

⌃ The breathtaking Stokksnes peninsula, in south eastern Iceland.

abandoned DC plane, hot springs, boiling lagoons, the list goes on. We stopped at every one, marvelling at the dramatic scenery. But, this being my second trip to Iceland, I was only really here to witness, and capture, the magic of the northern lights; that mesmeric, celestial ballet that begins after dark, high up in the earth's atmosphere.

We had timed our visit to coincide with a new moon, the first lunar phase when the moon and sun have the same longitude,

THERE'S NO SUCH THING AS BAD WEATHER, JUST BADLY DRESSED PEOPLE.

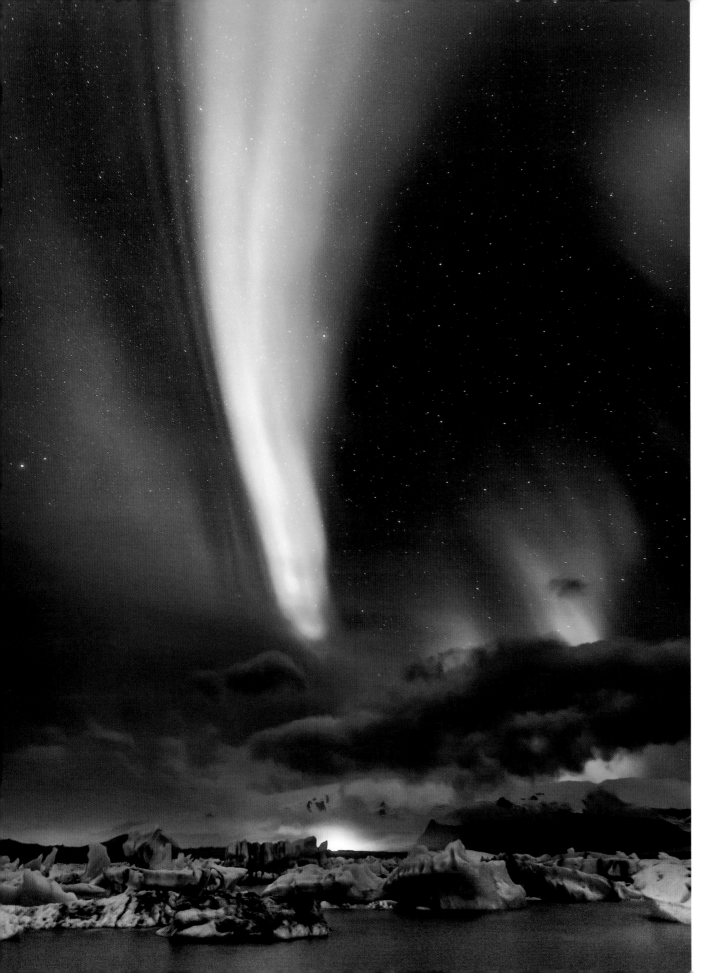

‹ The spectacular aurora borealis.

⌄ Iceberg details; the closer you look, the more you see.

BEHIND THE LENS

Shooting the northern lights requires the right conditions, equipment and plenty of patience:

+ Dark skies will make spotting the aurora easier. Coincide your shoot with a new moon and aim for clear skies.

+ Use an app to monitor aurora activity, such as My Aurora Forecast.

+ You'll need a sturdy tripod, a wide-angle lens (14–24mm) with a fast aperture and extra batteries. Long exposures and cold temperatures drain juice.

+ Think about your frame. What can you use in the surrounding landscape that will help your composition?

which masks the moon in the night sky. Because there is less light above, there is more chance of seeing the aurora from down below. Activity is measured on a scale of 0–9, and we checked the forecast hourly throughout each evening. It's an unpredictable phenomenon and can be short-lived, which means it's easy to miss if you're indoors. Our vans didn't offer the most comfortable sleeping arrangements, but they were chosen for a reason, and that was flexibility. Van life allowed us to keep mobile and move quickly from location to location, depending on where the aurora was most active. The inside-outside nature of life on the road also played in our favour when it came to keeping watch.

We cooked under the stars, always with an eye to the sky. Throughout that first week, we only saw fleeting glimpses of our quarry – a quick flash of green between a gap in the clouds and it was gone. I'll be honest, we were feeling a little dejected that cold-nose morning in Jökulsárlón. However, we woke to clear skies, and a promising forecast persuaded us to stay put for a couple of days. It was a good location, even without the aurora. We spent the day shooting the surrounding black sand beaches, peppered with the washed-up carcasses of soon-to-be-gone icebergs. I made some good pictures, but, in truth, I wished away those daylight hours.

That night, we ate a dinner of vegetable curry cooked on a Primus stove and waited for the light to fade. 'There!' cried Dan. Across the lagoon, the first curtains of colour were clearly drawing across the night sky. I scrambled to realign my tripod and adjust my settings. I took my first shot at 21.43am with a wide 16mm lens to capture as much of the night sky as I could. One 30-second exposure and the wait was over – there it was in the frame in all its ethereal glory. I kept shooting in an almost blind fury, frame after frame after frame, always unsatisfied by the last. I had to remind myself to stop. Think. Make a picture, don't just take one. It's a phrase I often say to myself when working. I looked around and noticed a highway in the distance to my left, lit up with the intermittent glow from passing trucks. Could I use that? I swung my tripod around and switched to a vertical composition. Wait... wait... wait... click.

I haven't photographed the aurora since, and I'm not even sure I want to. The northern lights are set quite apart from anything I have witnessed before. They are a bewilderingly foreign, supernatural formation in the sky, appearing like a shapeless alien intelligent life form attempting to communicate with earth. I looked at the picture on the back of my camera. The dance of light falling from the sky and intersecting with the low glow from the highway. The connection was there. I had my frame. I spent the rest of that evening with my head back, watching the show with my eyes. My nose was still cold.

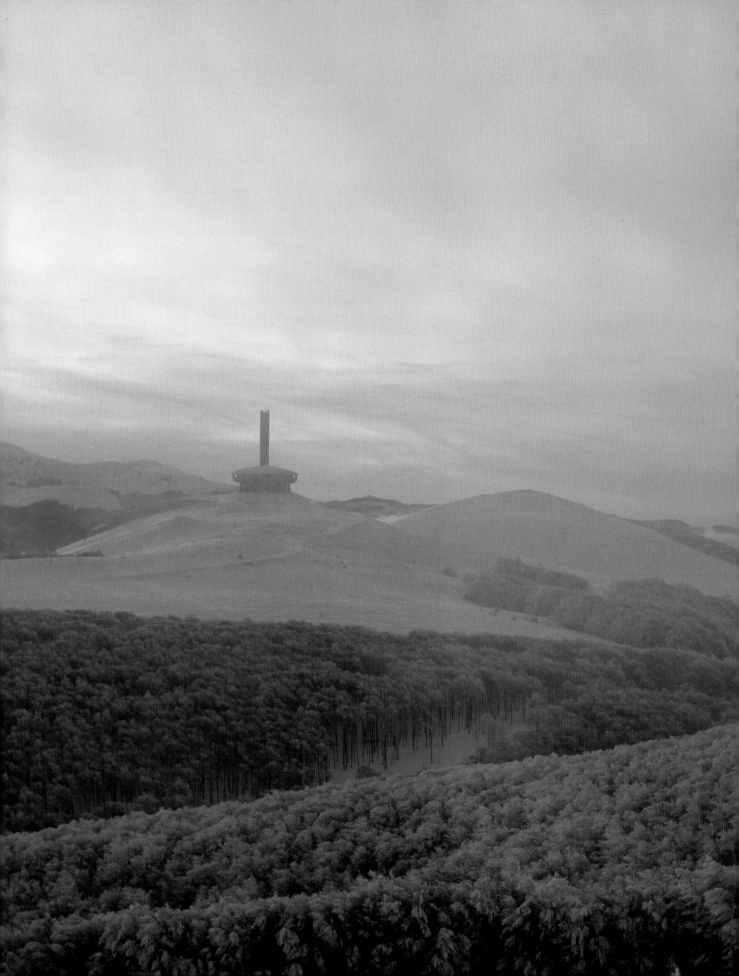

TIMOTHY ALLEN

BUZLUDZHA, BULGARIA

coordinates
42.7333°N, 25.4000°E

Designed by architect Georgi Stoilov, the Buzludzha monument took over seven years to construct and involved more than 6,000 workers. Bulgaria's largest monument to Communist ideology, the decor was an exquisite mixture of marble and glass, including a magnificent central hall with a giant fresco depicting Bulgarian and Soviet communist themes. It was unveiled in 1981 on the 1,300th anniversary of the foundation of the Bulgarian state amid much fanfare, yet was left to ruin only a decade later, following the disbandment of the Bulgarian Communist Party. Today, this incredible building stands as an iconic relic to that abandoned ideology.

❮ The Buzludzha monument sits on top of the Buzludzha peak, surrounded by the snow-covered Balkan mountains.

...CRUMBLING FACADES OFFER THE PERFECT BLANK CANVAS FOR AN INTROVERTED IMAGINATION LIKE MINE.

I first heard about the abandoned Buzludzha Monument (pronounced buz'ol'ja) from a Bulgarian photographer, Alexander Ivanov, way back in 2011 when I attended a photo festival in his home country. He showed me pictures of what looked like a cross between a flying saucer and a Bond villain's secret lair perched atop a striking mountain range.

Six months after looking at Alexander's photographs, I was back in Bulgaria. With the help of a friend, Kaloyan Petrov, and during record low temperatures, we drove the 250 kilometres (155 miles) from Sofia to the edge of the Balkan Mountains. A ferocious snowstorm blitzed the monument for the first four days we spent there, and it was all but invisible when viewed from afar. Striding through deep banks of snow, it would only finally emerge from dense white fog when were just a few steps away.

It was always my plan to get a shot of the Buzludzha monument from the air, and the idea was to fly a microlight over the Balkan Mountains. The drones we take for granted today did not exist back then. On our first attempt, we had to ascend 457 metres (1,500 feet) to escape low cloud cover – snowstorms and a

⌄ The internationally adopted symbol of communism, the hammer and sickle, forms the centrepiece of the dome ceiling.

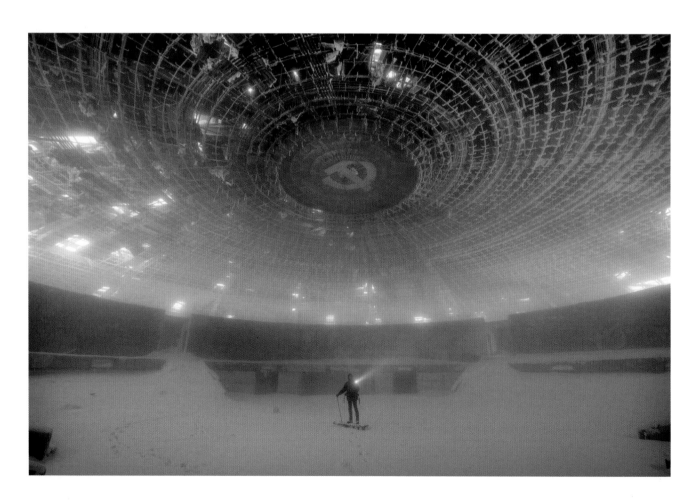

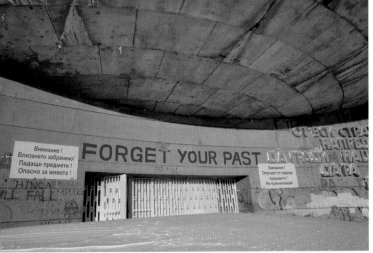

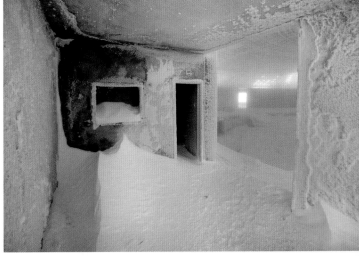

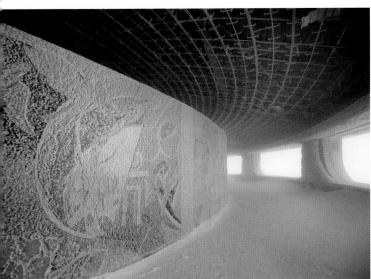

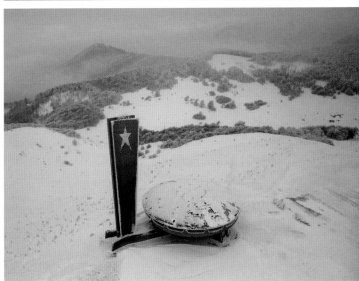

BEHIND THE LENS

If you are planning a trip to shoot a subject that somebody else has already photographed, think about ways you can evolve or expand upon the imagery that you have already seen. Study those photos closely and formulate a plan to help make your body of work something new and original.

⌃ Reminders of the building's Communist past are visible throughout its interior.

⌐ We travelled to the monument amidst a raging blizzard that pounded the building with snow.

⌃ Remains of mosaics commemorating the Bulgarian Communist Party line the interior walls.

⌐ Aerial view of the Buzludzha monument taken by microlight.

microlight are not a good mix. We were in the air for over an hour but returned with nothing more than a frostbitten focusing finger.

We waited a few more hours, but the cloud would not shift. I begged the pilot to take me up one last time, and we flew low and fast, underneath the cloud. It was a quick flight, all of half an hour, with two dangerously windy circumnavigations of the building, but despite frozen digits and eyelids, I managed to get some shots.

Silent and shrouded in mystery, the mountaintop had eluded me all week, but finally, on our last day, the weather began to change. The snow started to clear, slowly revealing the peak, along with the true magnificence of the location. I rose at dawn the following morning and trekked to the monument in the most glorious weather. It was a completely different place; so calm and peaceful, and the building felt at one with itself. Yet, to me, it felt wholly alive.

The dilapidated interior stands as an iconic emblem to an abandoned ideology. The former crowning glory of the building is the main hall containing 500 square metres (5,382 square feet) of mosaic fresco depicting Bulgarian and Soviet communist themes. Accompanied by the sound of the immense roof structure faintly

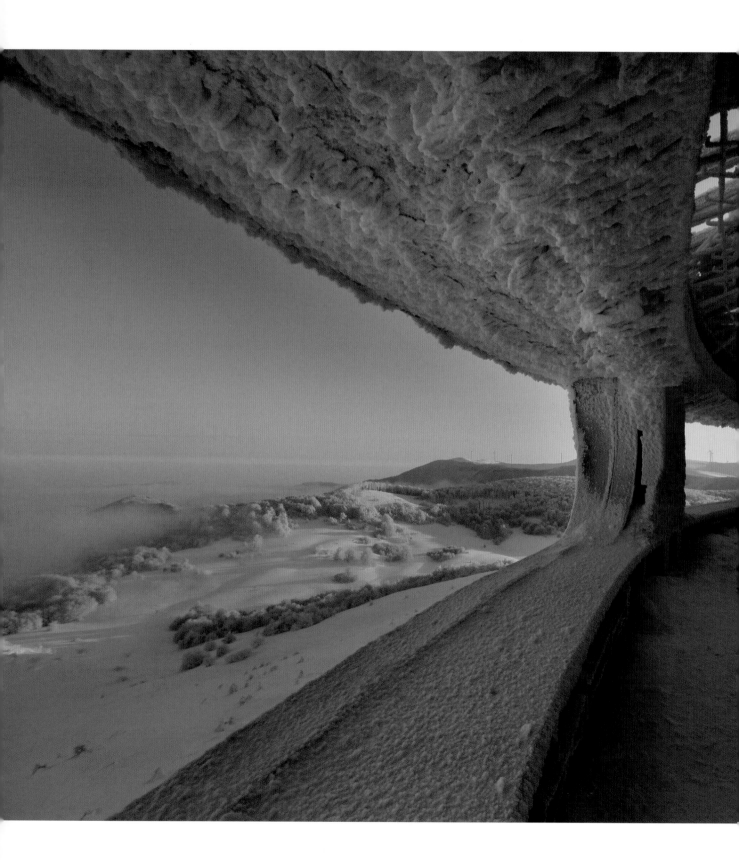

⌃ The natural process of aging is celebrated by the building's crumbling façade.

NOTHING LASTS FOREVER, AND NOR SHOULD IT.

creaking in the wind, I sat alone in the middle of this palatial space observing the decaying walls all around me. I thought of the 6,000 workers who participated in constructing the building over seven years, and of the artists who toiled for 18 months on the decorations.

I've made pilgrimages to many abandoned buildings over the years. Somehow, their crumbling facades offer the perfect blank canvas for an introverted imagination like mine. I find it's a way of experiencing what it would be like to time-travel, allowing me to vividly conjure up images from the past. The argument for preserving old buildings is a strong one. However, on the rare occasion I visit a forgotten building as magnificent as the Buzludzha relic, I can't help but reflect on some of the incredible monuments back home and silently wish that more were left to age and erode naturally. Instead, they are automatically subject to a cycle of restoration and refurbishment, simply to meet the expectations of modern tourism.

Abandoned structures, such as the Buzludzha monument, operate on a different timescale to our fast-paced selves. They are involved in a beautiful natural process of ageing, slowly decaying over the decades. Often, the well-meaning act of 'preservation' can remove their dignity, disrupting that natural erosion and destroying the very essence of what makes them special in the first place.

Nothing lasts forever, and nor should it.

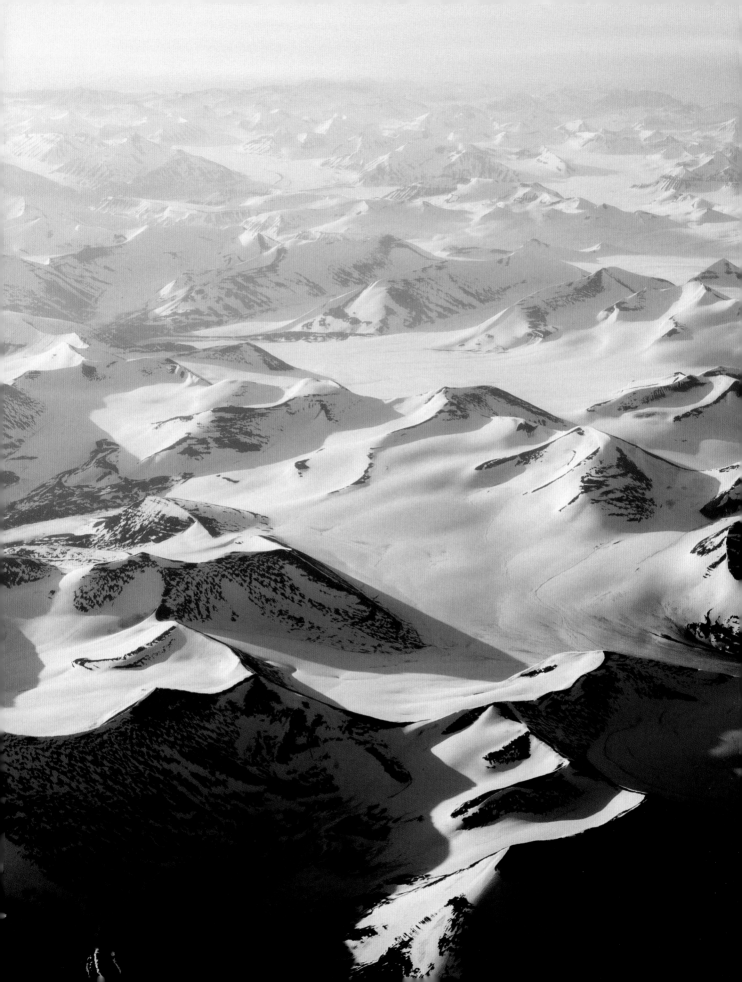

HANNES BECKER

SVALBARD, NORWAY

coordinates
78.2246°N, 15.6540°E

Svalbard, or Spitsbergen, is a Norwegian archipelago in the Arctic Ocean roughly halfway between mainland Norway and the North Pole. The ice-covered islands are characterized by endless unspoiled wilderness. Before its discovery in 1596 during a Dutch expedition, Svalbard had not been touched by man. Even today, only around 2,000 people live in one town of Longyearbyen. This frozen land is home to scientists, adventures and many, many polar bears.

AS THE GLACIERS MELT, RED SEDIMENT MIXES WITH THE OCEAN WATER, CREATING SURREAL APOCALYPTIC SCENES.

Svalbard's appearance changes dramatically with the seasons. The long days of summer are fast replaced by the almost unbearable darkness of winter. Cold and covered in a thick layer of snow and ice, it's a harsh, unforgiving environment. But come spring, the sun appears back on the horizon and the colours change from white and blue to a golden palette. Broad valleys appear, and rushing rivers and enormous glaciers carve their way through fjords to the ocean.

My home for the trip was a sailboat – a tiny, dark cabin with very little room to move between my luggage and camera equipment. I lost count of the times I hit my head getting out of bed; it hurt, but it was an effective jolt from my slumber! I soon established a routine: a hot cup of coffee to ease in the day before braving the cold in search of polar bears and whales. I listened to the waves lapping at the bow and considered the Arctic breeze on my face. No phone service. Nothing. So far from everybody else on the planet, and so pure and pristine.

As a result of climate change, Svalbard's glaciers have receded significantly over the past 100 years. Some by as much as 15 kilometres (9 miles). Their disappearance unveils a hidden landscape that has long been held in an icy grip. As the glaciers melt, red sediment mixes with the ocean water, creating surreal apocalyptic scenes. A warning perhaps?

⌄ Ghost town at the end of the world.

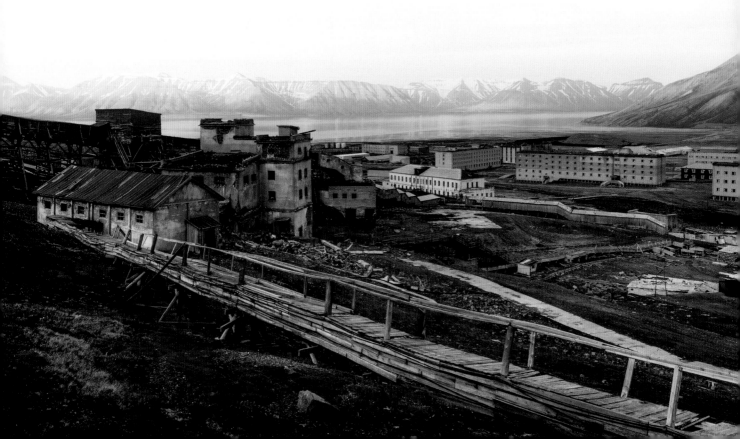

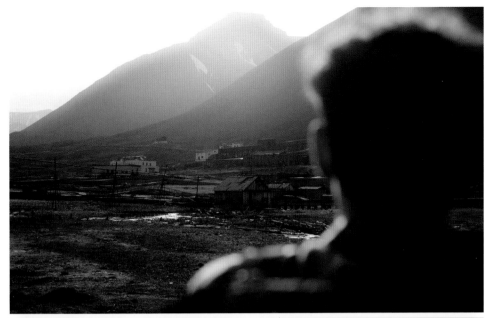

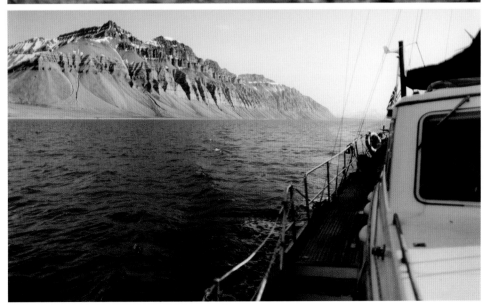

� Where it takes me.

⌐ On the prowl.

❭ Sailing between the fjords.

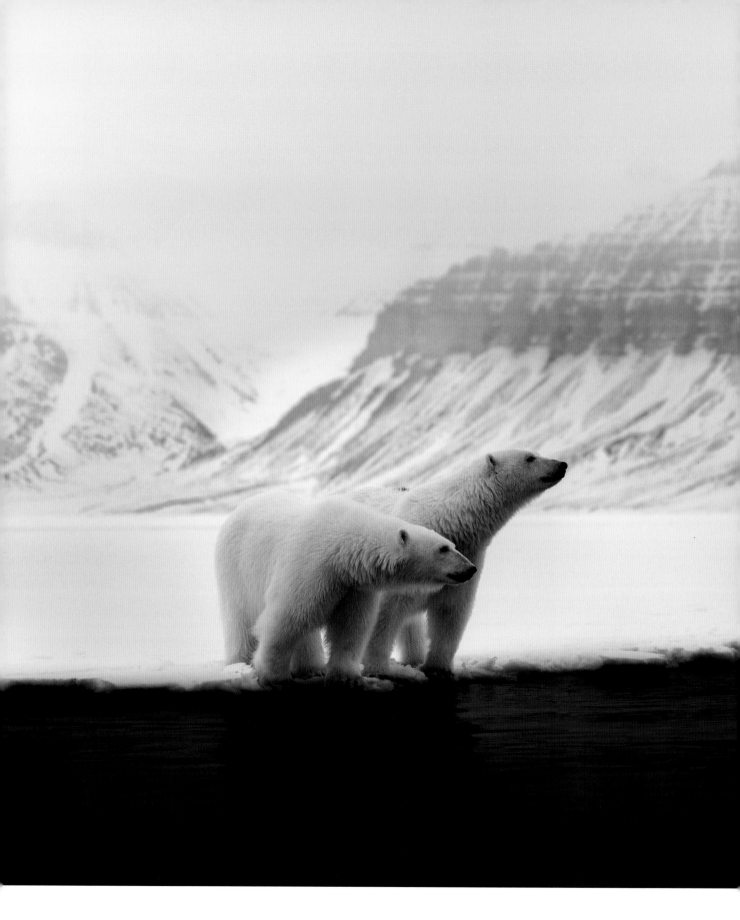

∧ Eye to eye.

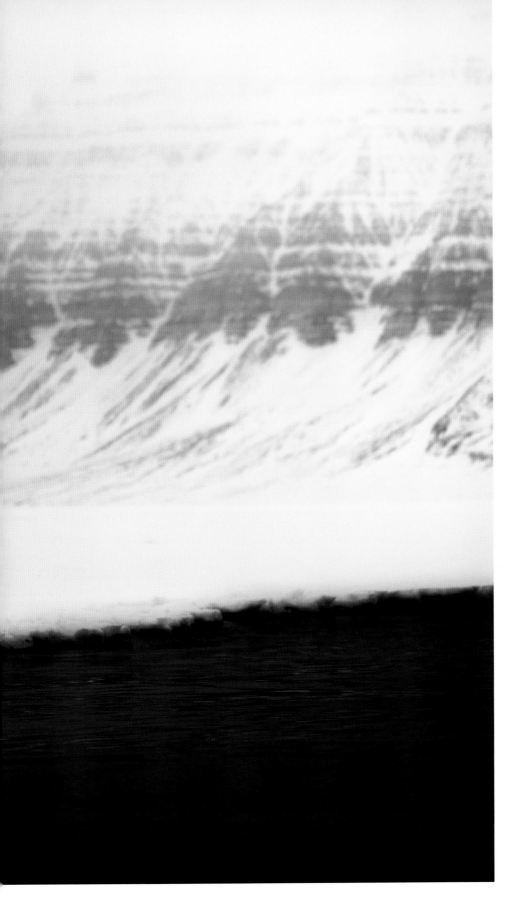

...IN
SVALBARD,
THERE IS
ALWAYS A
POLAR BEAR
CLOSER
THAN YOU
THINK; AND
BELIEVE ME,
THEY WILL
FIND YOU.

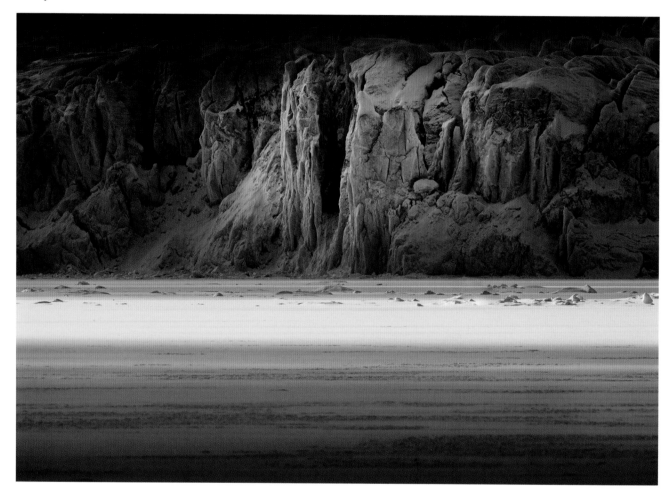

In summer, Svalbard is home to a wild variety of life: foxes, whales, walruses and an abundance of seabirds. We would occasionally take to a smaller vessel to photograph icebergs up close or stretch our legs on land. A thrill, because in Svalbard, there is always a polar bear closer than you think; and believe me, they will find you. As they slowly advanced over the frozen sheets of ice, we spent our days observing their habits and documenting their behaviour. I was in a constant state of anxious excitement, and I felt my heart was pumping a little faster than usual.

Sailing from fjord to fjord, we discovered peak after peak, each more rugged than the last – stark, alone and defiant against the elements. Gradually, after a few months, the evenings began to darken and the daylight diminished with each passing day. Winter was coming, freezing the island in time once more.

BEHIND THE LENS

A telephoto lens is your friend in Svalbard. The distances are great and access is difficult, with a constant threat of polar bears. Telephoto lenses also compress the landscape, making elements appear much closer than they really are. You will stumble upon different shapes and textures in the viewfinder. However, to really appreciate this place's scale and majesty, take a drone and view it from the sky.

˥ Bleeding glaciers.
〉 Upon entering Svalbard.

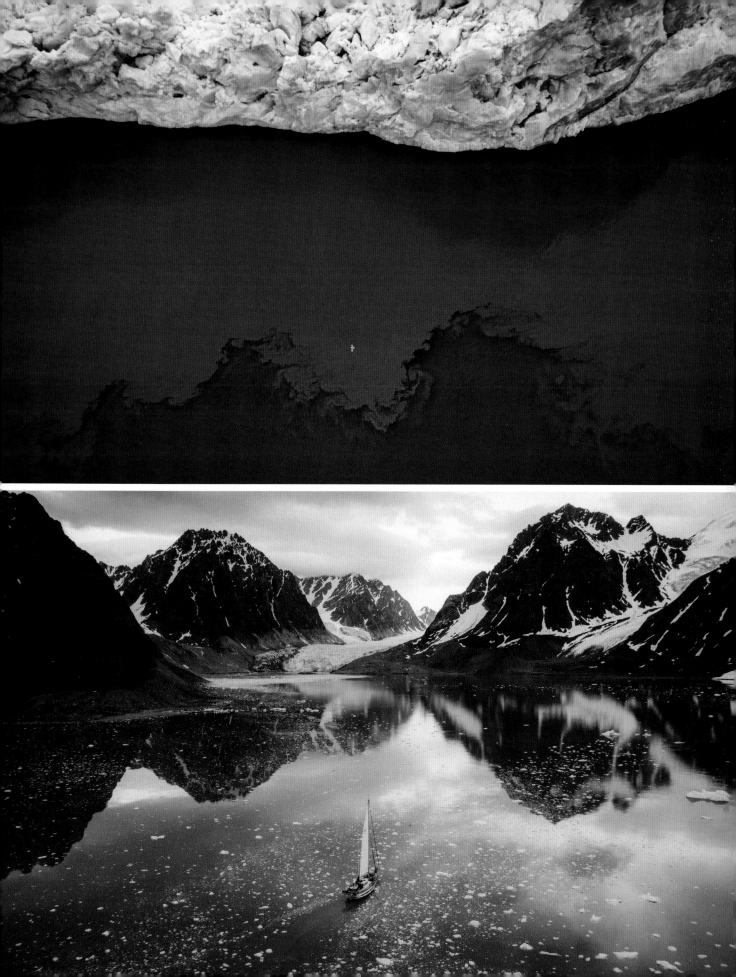

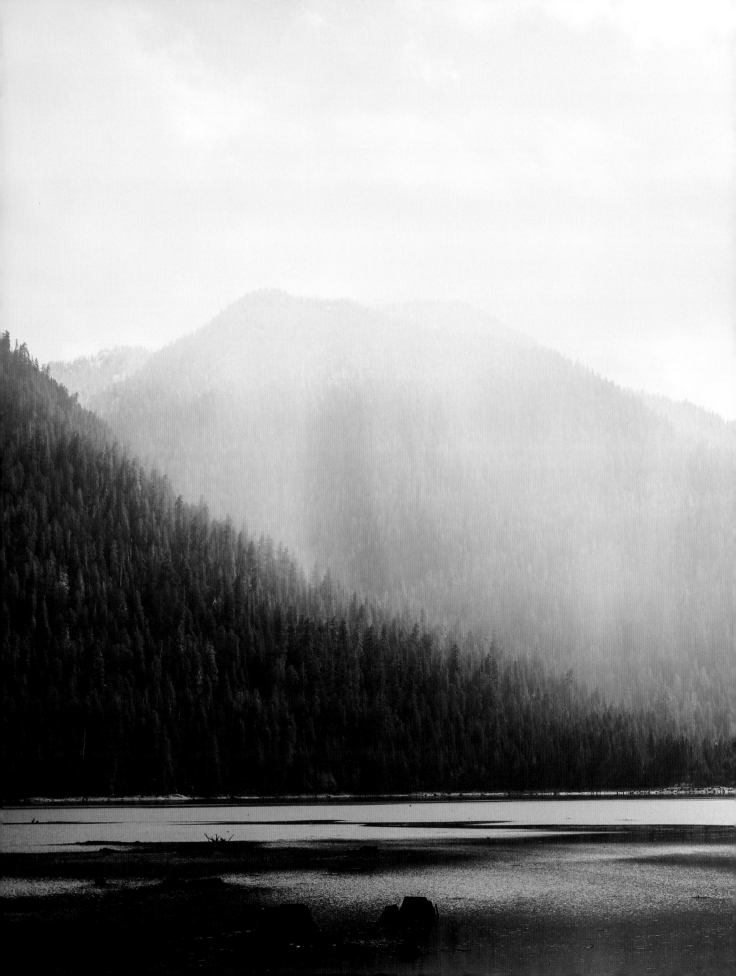

LAKES & RIVERS

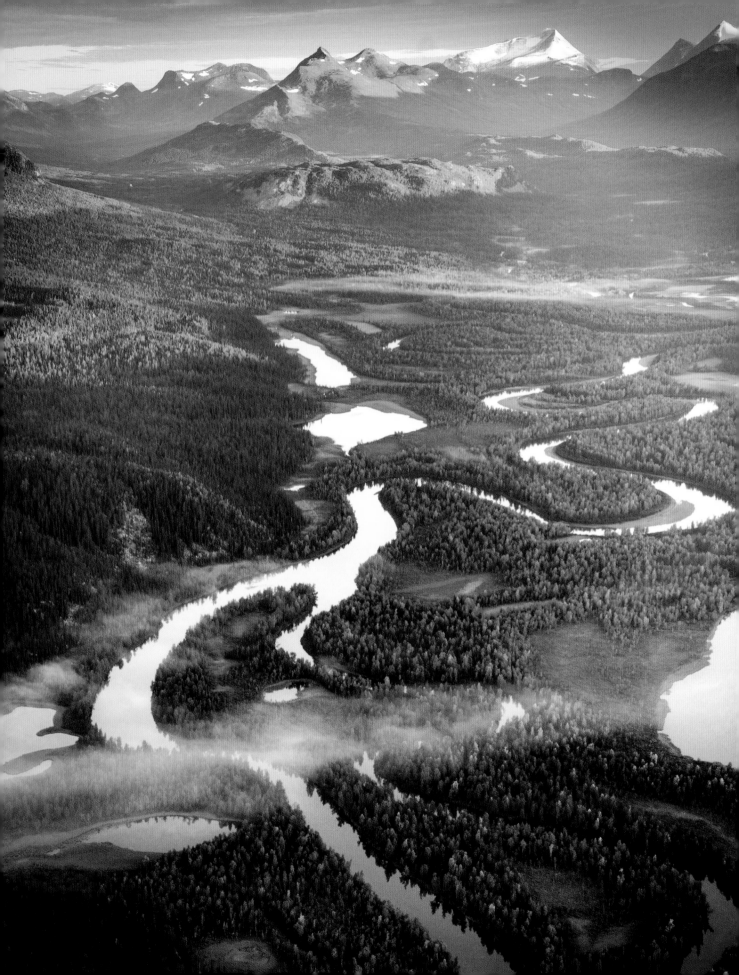

TOBIAS HÄGG
LAPLAND, SWEDEN

coordinates
66.952°N 17.720°E

Kvikkjokk is a mountain village in the municipality of Jokkmokk, located in the north of Sweden. Traditionally a Sámi area, it is one of the oldest Swedish settlements in Lapland, known for a constantly changing delta where the rivers Kamajokk and Tarraälven meet Lake Saggat. The Swedish name comes from the old Sámi name for the Gamájåhkå river, Kuoihkajohko, meaning 'rapids river'. In the late seventeenth century, silver was discovered in the mountains, but when the mines proved unprofitable, most of the prospectors left the area, leaving it to the wilds and a tiny population that numbers just 16 today. Sweden's longest hiking trail, the Kungsleden, or 'King's Trail', passes through Kvikkjokk on its route to Abisko and provides the entrance to Sarek, Europe's oldest national park.

‹ A golden morning spent capturing the landscape of Swedish Lapland by helicopter.

THE RIVERS STRETCH OUT LIKE LONG, OPEN ARMS, EMBRACING AND BINDING THE OLD-GROWTH FOREST TOGETHER.

It was autumn and I was hiking the long, loose roads in Swedish Lapland. A dense yellow-brown canopy of pine and birch fell away either side of me. The terrain is challenging. When I say roads, I am being generous; they are not perfectly crafted nature trails that lead you politely to a viewing spot. Swedish Lapland is a wild place, and to tackle it effectively, you need to respond to the landscape, as well as the life which resides within. I kept my ear to the ground, conscious of the near-inevitable likelihood of encounters with reindeer, moose, bears, wolves and lynx.

The river deltas in this part of Swedish Lapland are almost too beautiful to comprehend. Pastel blue glacial water winds its way through the rugged terrain. The rivers stretch out like long, open arms, embracing and binding the old-growth forest together.

When I finally reached Kvikkjokk, a small village deep in the middle of Norrbotten County, I noted a small church ahead. I had read before my visit that only the priest and sexton remained when the silver mining industry collapsed. The rest of the population deserted the area in 1702. The church was erected by missionaries to the Sámi using Kvikkjokk as a base. Subsequent settlers arrived in the nineteenth century, subsisting off hunting and fishing, but otherwise nothing has changed for hundreds of years. You can feel the slow pace of the place, at the edge of Europe's last wilderness.

⌄ Canoeing downstream through the Terradalen delta.

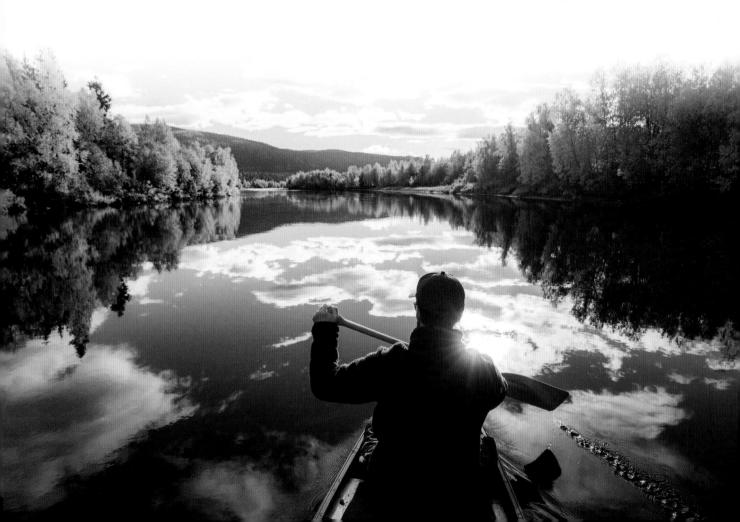

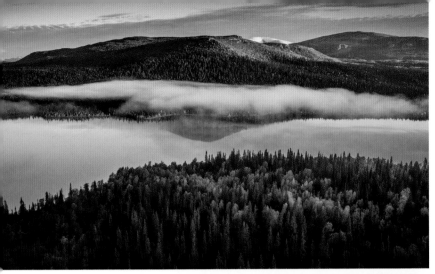

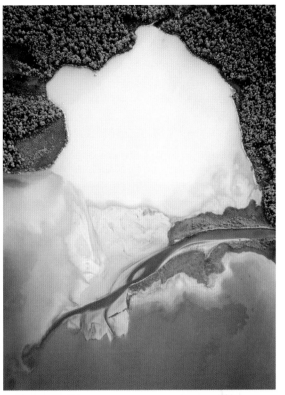

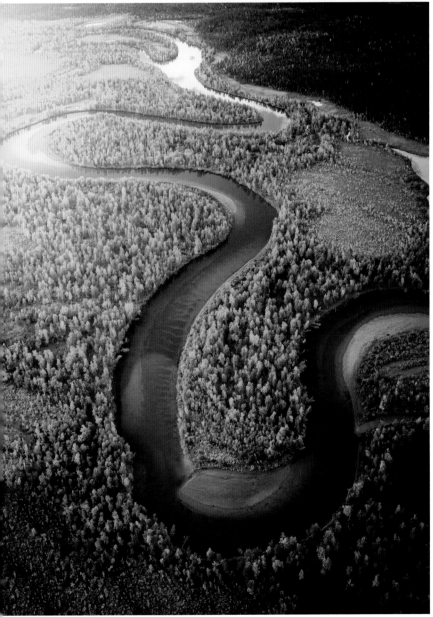

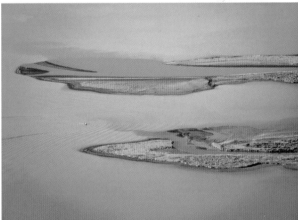

⌐ Above the treetops of Swedish lapland,
 covered in an early morning mist.

≫ Vast and inaccessible areas surrounded by water
 makes Lapland pristine, untouched and unspoiled.

∧ Pastel blue glacial river.

‹ Rivers of Swedish Lapland.

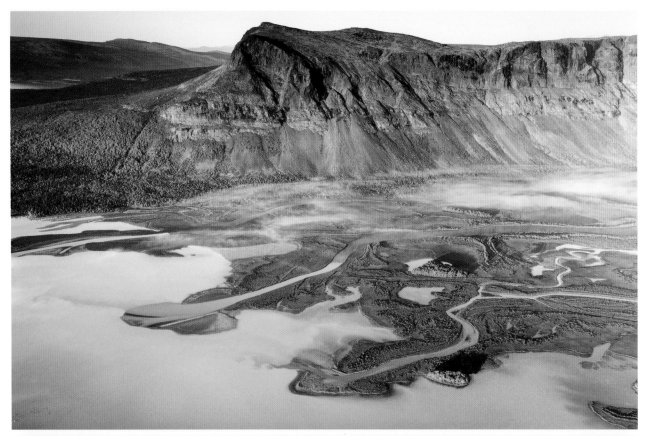

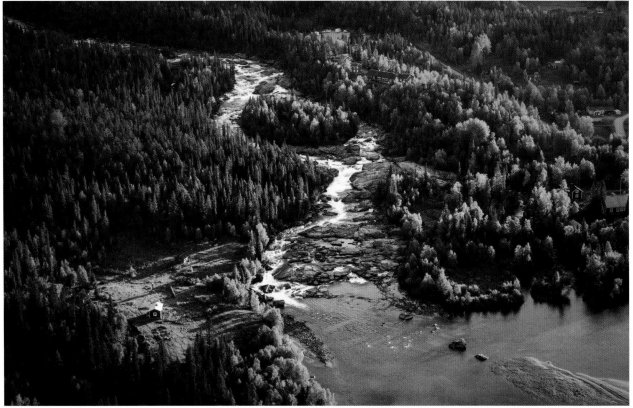

⌃ The Swedish Wilderness.

⌃ The Kamajokk river in Northern Sweden.

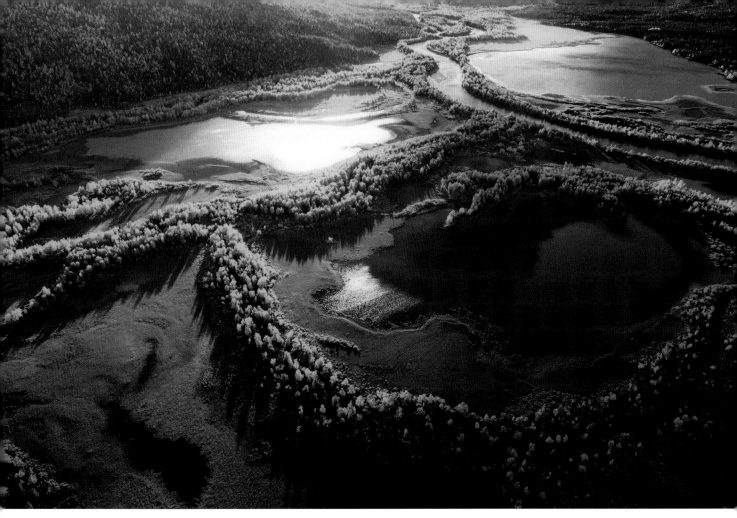

BEHIND THE LENS

I don't think there is a right or wrong way to capture this place on camera. You should simply capture things as you feel them. Photography is a personal art form; only you know what memories you want to take home with you. Sunrise is an excellent time to shoot wherever you are in the world, but here in particular. When the sun rises above the mountains, the water takes on an almost translucent quality, and the surrounding landscape appears to float above it. It's magical.

I hiked onwards and upwards; the air felt thinner as I progressed. I was treading an easy path towards Prinskullen, The Prince Hill, built by the mineworkers in the middle of the 1600s. It was a two-hour hike to the summit along the ridge of Vallevárreit, passing through an area scattered with ancient remains from the first structures built around Kvikkjokk.

When I finally reached the summit, the views were magnificent. The surrounding mountains were dressed in a soft white cloak of snow and made a perfect foil to the skirt of trees burnished red by the change in season lower down in the valley. It was a fantastic viewpoint over the Tarradalen delta.

The roar of the Kamajokk River speeding rapidly through the land below was inescapable, and its call was strong. I descended the way I had come, eager to get to the water. I hired a canoe and paddled downstream through the delta. I watched the fantastic swirls of colour where the blue and green glacial melt mixed with fresh rainwater.

This area never fails to surprise me. The photographic possibilities are endless, and I love shooting the ever-changing beauty of a landscape in constant transition, unmarred by human activity. The natural world provides me with all the inspiration I will ever need.

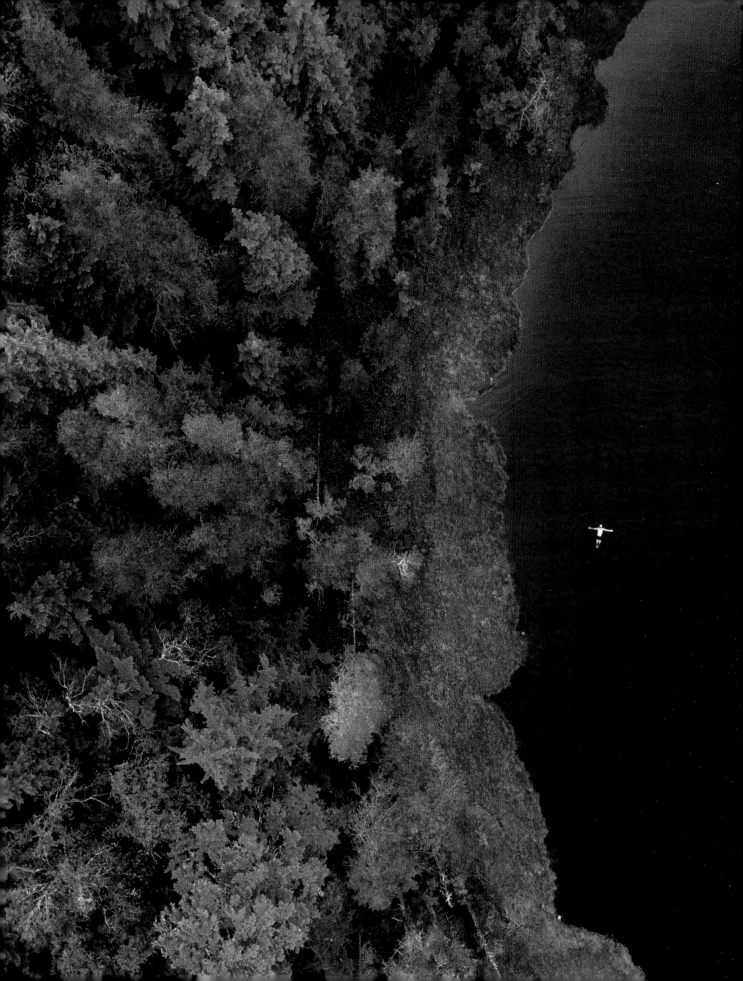

CALLUM SNAPE

THE SKEENA RIVER, BRITISH COLUMBIA, CANADA

coordinates
54.2351°N, 129.0325°W

The Skeena River originates in northwestern British Columbia in Canada. It flows through remarkable wilderness areas down to the small town of Terrace before making its way out to the Pacific Ocean. The watershed basin is still home to the Tsimshian, Gitxsan and Wet'suwet'en indigenous people, and archaeological evidence suggests they have continuously inhabited this area for over 10,000 years. The river plays a vital role across the broader ecosystem, supporting five different Pacific salmon species, the rare Kermode bear, grizzlies, black bears and countless other animals.

‹ Patrick swimming in Findlay Lake, a place he used to spend lots of time at as a child.

...THICK LAYERS
OF LUSH GREEN
LICHEN HANG
FROM OLD-
GROWTH TREES,
MIST DANCES
ACROSS THE
RIVER, AND THE
FAINT SCENT
OF WOOD-FIRED
STOVES LINGERS
IN THE AIR.

There's a slow clash of identity in these parts of British Columbia, where indigenous tradition meets modern western Canadian culture. Both cultures are working hard to strike a balance, and this is reflected in the architecture, food, lifestyle and people. The locals are welcoming, the type that will cook up a storm and relay their life story over a meal long into the night, and they have a deep and passionate connection with the Skeena River. It provides water for their homes and puts food on their plates. Every morning, men, women and children spread out along the river banks wearing waders, waiting for their fishing lines to tighten.

Outside the towns, thick layers of lush green lichen hang from old-growth trees, mist dances across the river, and the faint scent of wood-fired stoves and lingers in the air. I still dream about the fruity, sweet scent of salmon smoking over woodchips.

The two quaint towns of Terrace and Smithers are home to most residents in this region, and since my partner was raised in Terrace, we still have strong connections with the town and visit once or twice each year. I spent a week navigating the Skeena River with Patrick. My dream is to photograph a spirit bear, a rare all-white subspecies of black bear, and they are found only in this region of British Columbia.

⌄ Our guide and owner of Northern BC Jet Boat Tours, Rob, navigates us up the Exchamsiks River.

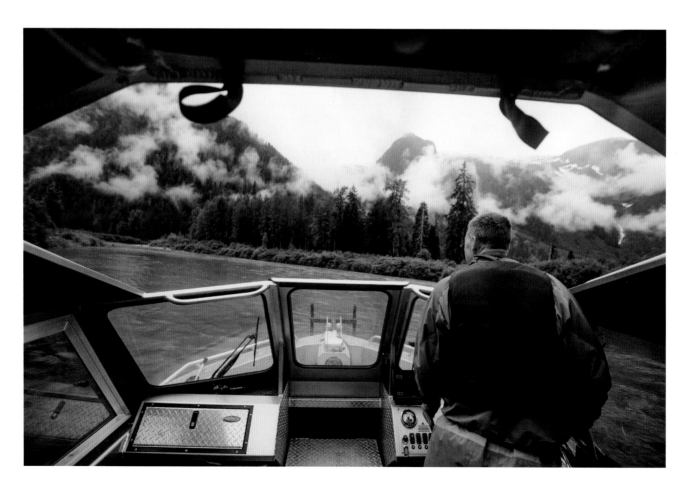

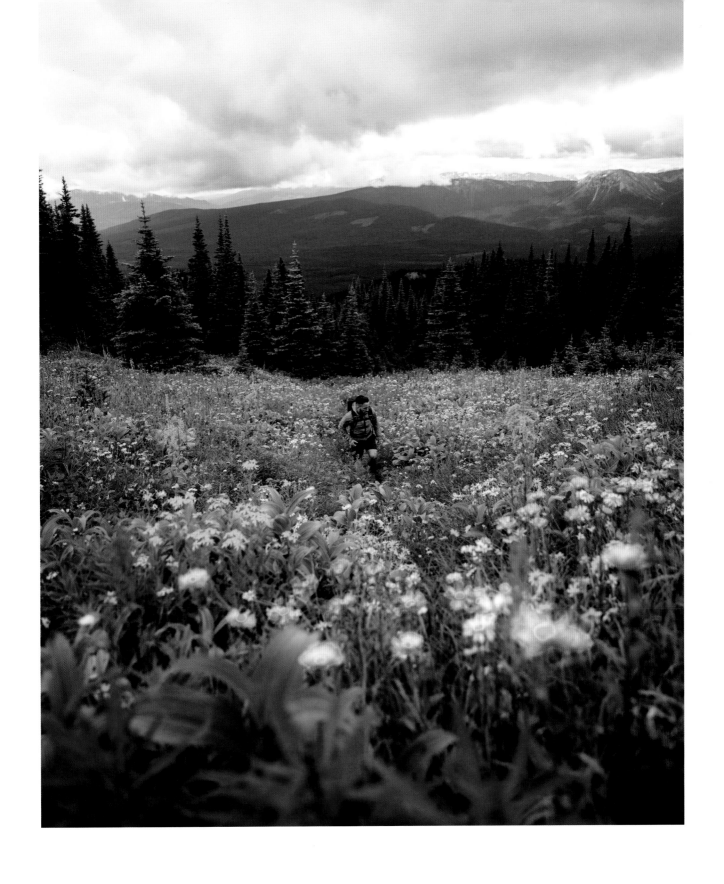

^ Hiking through meadows full of wildflowers on the
Crater Lake trail in Smithers. The smell was incredible.

LAKES & RIVERS

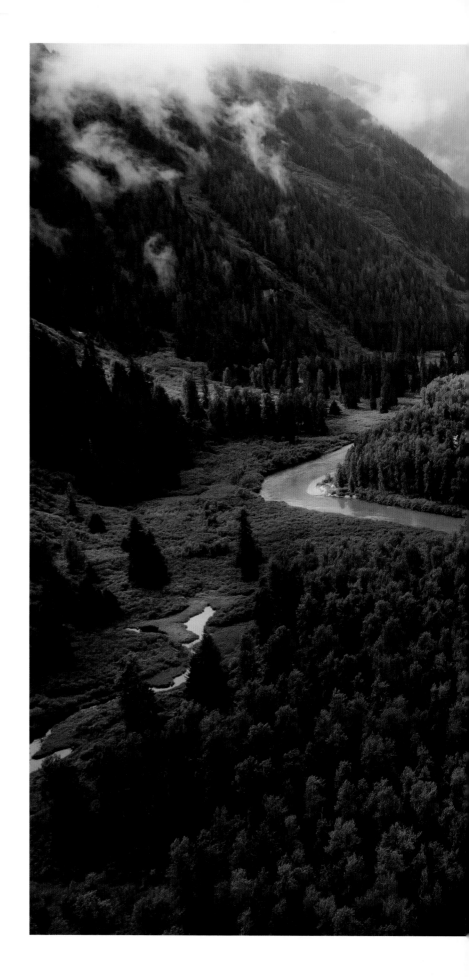

THERE'S
SOMETHING
MAGICAL
ABOUT
REVISITING
THE PLACE
YOU GREW UP,
RECOGNIZING
IT WITH
MATURE EYES...

> The Exchamsiks River feeds into the Skeena River
before making its way out to the Pacific Ocean.

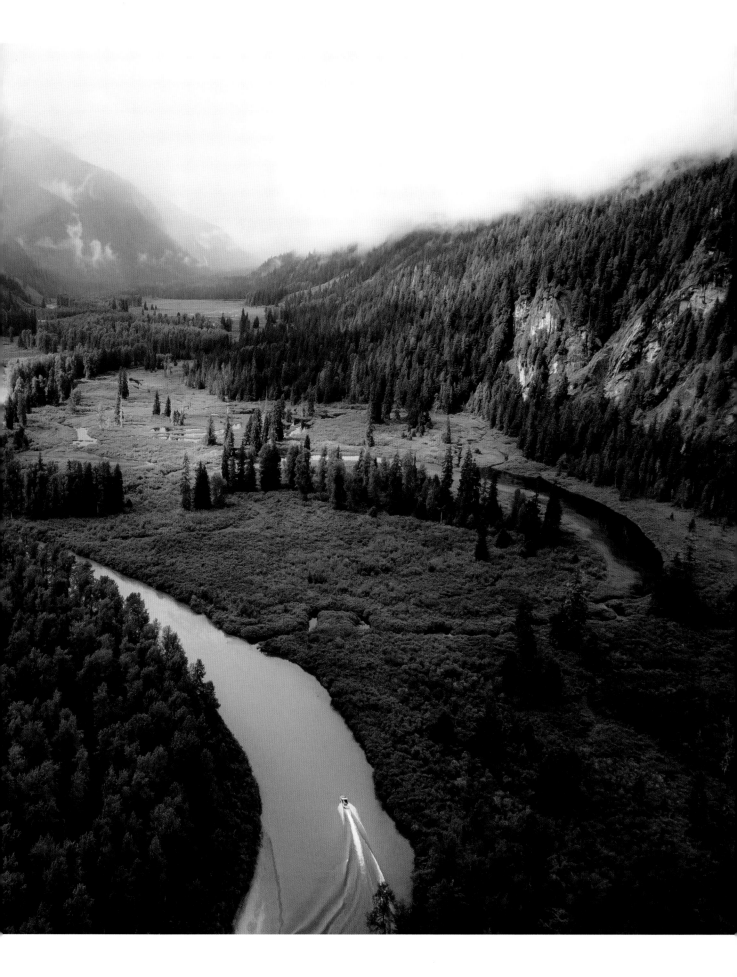

MORE OFTEN THAN NOT, THERE WAS A MIST OF RAIN AND LOW CLOUD IN THE VALLEY, GENTLY CARESSING THE CLIFFS ABOVE.

Waterfalls plummeted from mountaintops as we made our way upstream, our jet boat fighting the ceaseless flow of the river. Black bears and bald eagles are commonplace and the weather notoriously unpredictable. More often than not, there was a mist of rain and low cloud in the valley, gently caressing the cliffs above. Yet it was warm enough to swim in some of the surrounding spring-fed lakes, which was pure joy.

There's something magical about revisiting the place you grew up, recognizing it with mature eyes or, indeed, seeing it through someone else's. On our adventures, Patrick saw a side of his hometown that he didn't notice during the eighteen years he lived there. There was a childlike wonder in his eyes as he guided me down dirt roads, waded through streams and roamed wildflower meadows.

I moved to the heart of Vancouver a few years ago, and city life is inevitably hectic. Each visit to northern British Columbia leaves me feeling refreshed and relaxed, and this extended stay helped me connect more deeply with the landscape. It made me yearn for a slower-paced life. We will, of course, return. Besides the attractive lifestyle, I am yet to see and photograph the mythical Skeena spirit bear.

BEHIND THE LENS

This part of Canada can get a lot of rainfall, which means plenty of reflective surfaces that can make photos look busy. Be sure to pack a circular polarizer to help remove reflections from the water surface, wet rocks and waxy leaves. Rise early to spot wildlife, but remember not to approach animals. Use a telephoto lens and carry bear spray when hiking, though making noise is the best way to prevent an encounter.

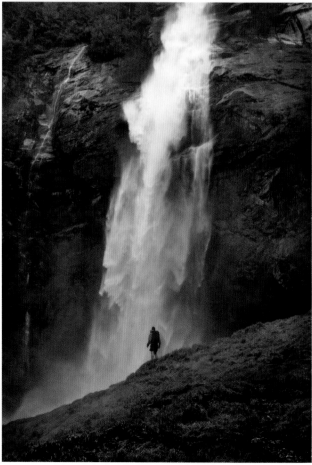

∧ Spotting countless bald eagles as we make our way upstream.

⌐ Completely soaked from hiking to Rooster Tail Falls we
 find a river bank to cook up some fresh shrimp over a fire.

‹ Hiking up to the upper section of Exstew Falls. Patrick
 grew up in this area and it was his first time here!.

LAKES & RIVERS

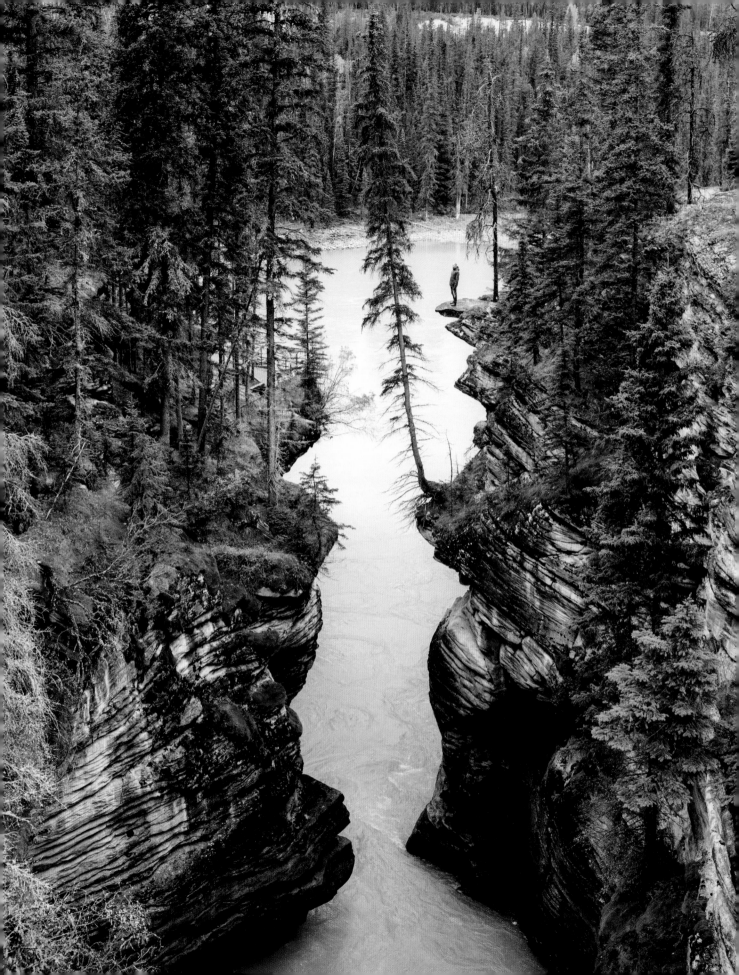

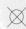

FINN BEALES
BANFF, ALBERTA, CANADA

coordinates
51.4254°N, 116.1773°W

Banff is Canada's oldest national park in the province of Alberta. Established in 1885 after three railway workers found a natural hot spring on the Rocky Mountains slopes, it is now a UNESCO World Heritage Site covering 6,641 square kilometres (2,564 square miles). Unparalleled when it comes to accessible mountain landscapes, it's a vast area to explore, with a heady mix of majestic peaks cloaked in sweet-smelling spruce and super-massive glaciers that give way to the phantasmagorical lakes they create.

〈 My friend, Eelco Roos, standing proud above
fast flowing glacial melt water.

IT'S LIKE LOOKING THROUGH THE HAZY LENS OF A WORLD BUILT BY THE DIRECTOR WES ANDERSON, YET THIS VIEW IS QUITE REAL.

'Dear Finn, I'm planning a trip with tourism Canada for Alberta. Wanted to include you in the team. Sept 29–Oct 4. Interested? Dates OK?'

I knew little about Alberta way back in 2013 when this Twitter DM landed in my inbox. Instagram was in its infancy, and the overwhelming volume of travel photography that we now have at our fingertips did not exist. However, I did 'know' the five other photographers on the trip, although I had never actually met them. Alex Strohl was from France, Rishad Daroowala from Vancouver, Jared Chambers from LA, Eelco Roos from Amsterdam, and Hiroaki Fukuda from Tokyo. We had all connected via the emerging photo-sharing app, finding a common thread of interest through the photographs we were making. Of course, I said yes to the invitation.

Thirty-one days later, I found myself high on a mountain looking out through the boughs of an evergreen tree on to Lake Louise. A small red canoe, bedecked with a proud Canadian flag, was gliding fast across the fantastical blue-green waters and I could just hear the laughter of its occupants over a blanket of silence that otherwise surrounded me. It was an overwhelming welcome to a spectacular landscape of pin-drop-quiet forests, iridescent lakes, grizzly bears, elk and thousands and thousands of majestic snow-capped peaks.

I had arrived in Calgary, Alberta's most populous city, before meeting up with others and pushing north. We quickly left the man-made skyscrapers behind and replaced them with a more

⌄ Miles of majestic snow capped peaks frame countless water bodies in Alberta.

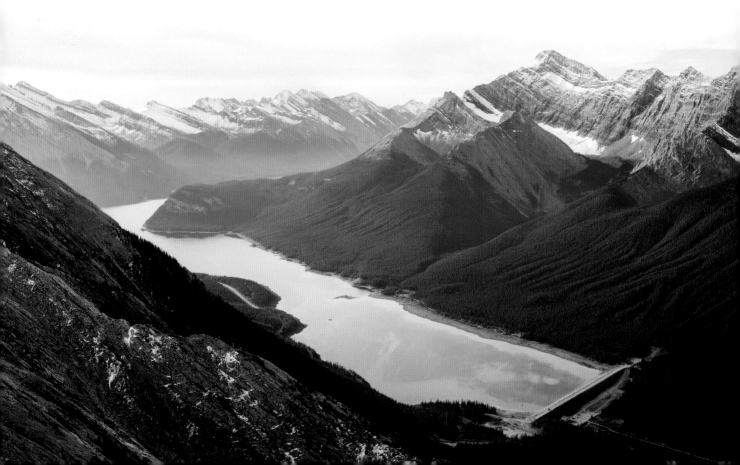

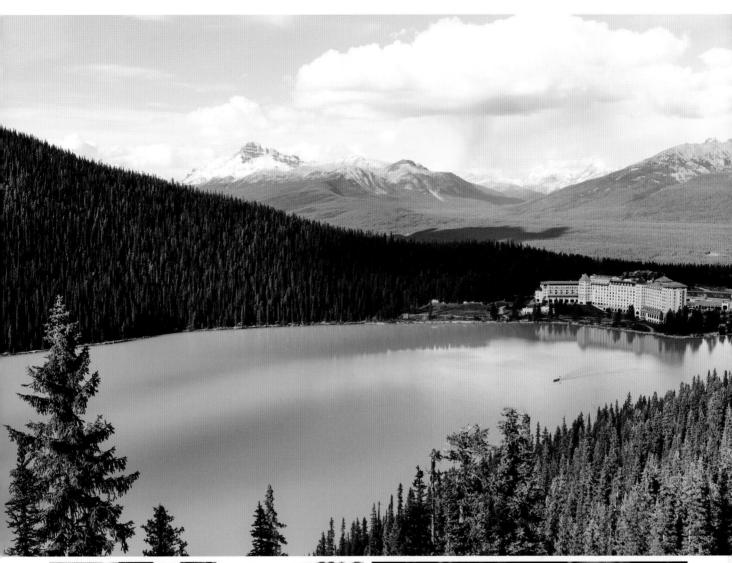

⌃ Lake Louise as seen from the Fairview Lookout trail.

⌃ Looking towards Spirit Island in Maligne Lake
 in Jasper National Park.

⌐ Mountain goats grazing along the roadside verges.

LAKES & RIVERS

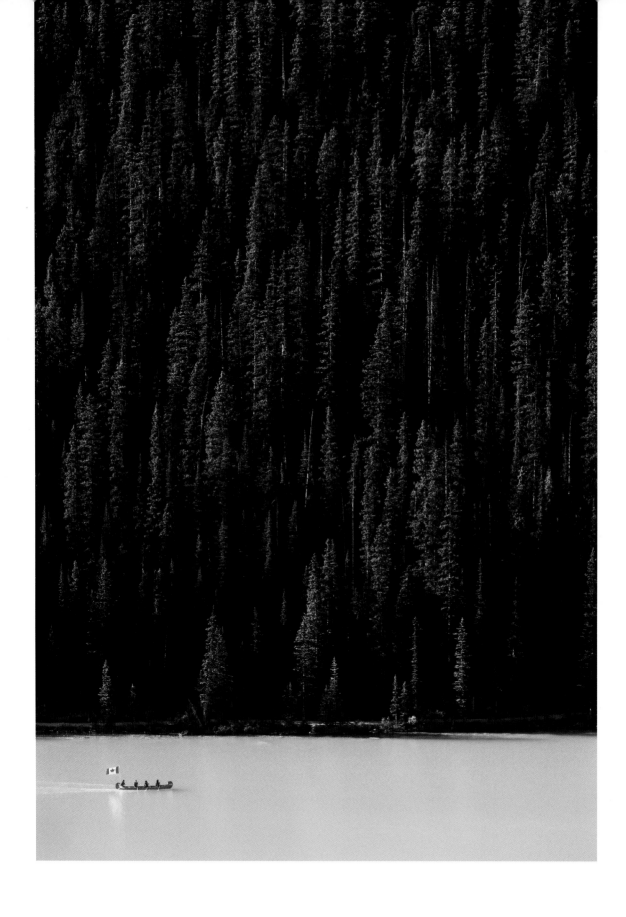

⌃ Paddling at speed across Lake Louise.

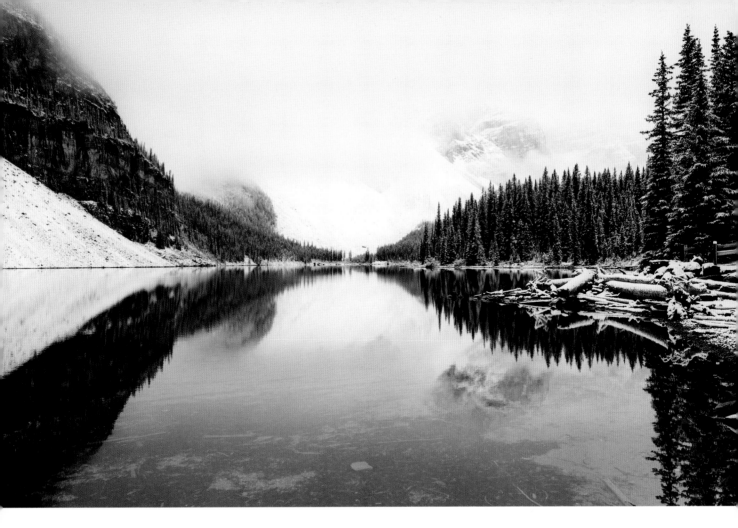

natural alternative. Alberta is famous for its mountain ranges, many of which were formed during the last ice age, about 12,000 years ago. Unlike the Rockies, which begin their climb to the sky from an elevated valley bottom at around 1,500 metres (5,000 feet), Alberta's mountains rise from something much closer to sea level. They shoot straight up from grassy brown plains, crisscrossed by migrating elk and moose. The effect is incredibly dramatic and multiplied two-fold when paired with surreally coloured, mirror-calm lakes lapping at their feet.

Lake Louise is no secret, it is a world-class destination, so I'd recommend timing a visit to avoid the summer crowd (early morning/late evenings) if you are passing through. The emerald green waters aligned against a pastel-coloured sky feel nostalgic and almost dreamlike. It's like looking through the hazy lens of a world built by the director Wes Anderson, yet this view is quite real. The water receives its distinctive colour from light refracting off fine particles of rock (called rock flour) found in the run-off that flows from the mountain and glaciers high above. It's a place you need to witness with your own eyes in order to believe what you are seeing.

We arrived at lunchtime and spent much of the day waiting for the few tourists that had braved the cold to disappear and the good light to take their place. We used the time well, scouting for locations and hiking the Fairview Lookout trail, which was an easy 45-minute round trip. It offered commanding views across Lake Louise, perfect for capturing the turquoise water against the precipitous pine forest that meets its shores. Scouting ahead of shooting is incredibly valuable, giving you time to find your compositions so you know exactly where to return when the light is right.

Moraine Lake in the adjacent valley is only half the size of Louise, but it's surrounded by a bowl of grand peaks, and is arguably even more dramatic than its near neighbour. It's a little higher, sitting at around 1,883 metres (6,178 feet), which means it is frozen for much of the year. Indeed, the first snows of the season started to fall while we were there – feather-soft flakes, coating the trees in time for Christmas, a gift-wrapping that only spring could open.

This is a land of escape and adventure where nature rules supreme – breathtaking, towering scenery, elegantly lit and cinematically coloured. It was pure eye candy for a group of landscape photographers from all four corners of the world, and a perfect place to forge deeper friendships that first began online. Memories were made on this trip. Thank you, Canada.

⌃ Moraine Lake, after the first snow fall of the season.

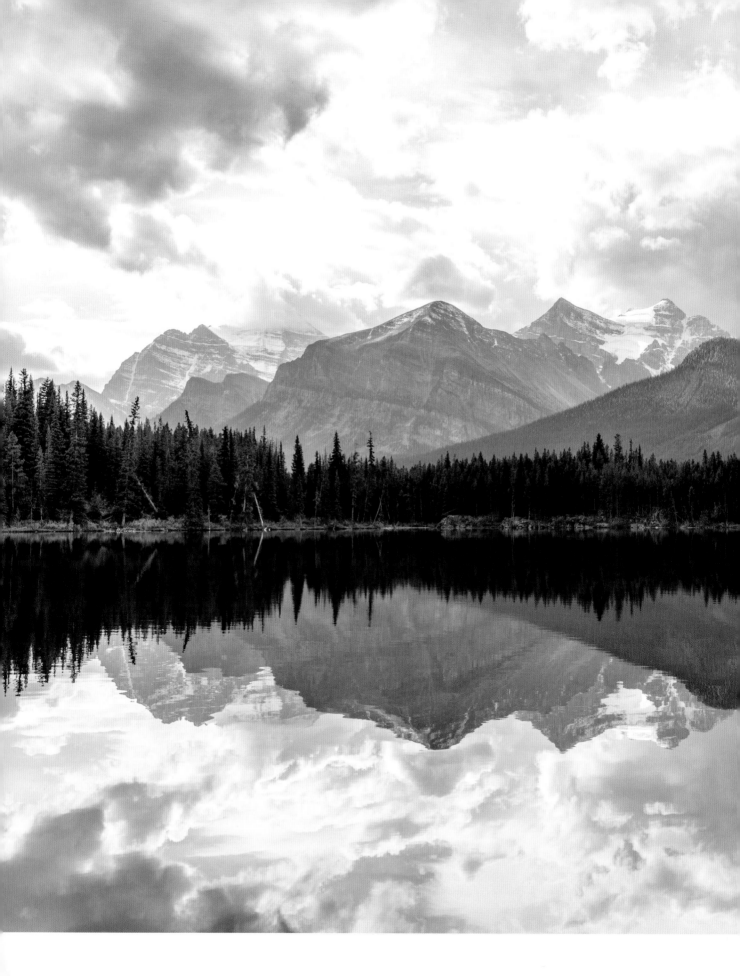

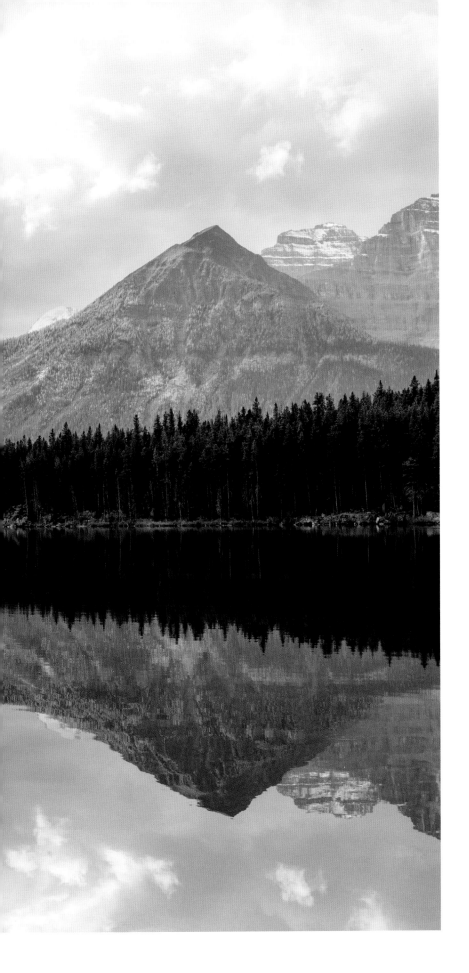

REFLECTIONS CAPTURED IN A BODY OF WATER INCREASE THE FEELING OF SPACE AND GRANDEUR...

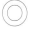

BEHIND THE LENS

It can be difficult to convey the might of a landscape in a photograph, and we can sometimes feel disappointed when a photo doesn't match a real-world experience. Using reflections to increase the scale and majesty of a scene is a great way to counter the problem. Reflections captured in a body of water increase the feeling of space and grandeur, plus they can lend a photograph a degree of atmosphere, as well as compositional balance and depth. For pin-sharp reflections and dreamy light, shoot in the hour before dawn. Use a tripod for stability and close down your aperture to keep the entire scene in focus.

‹ Reflecting the majesty of Banff National Park.

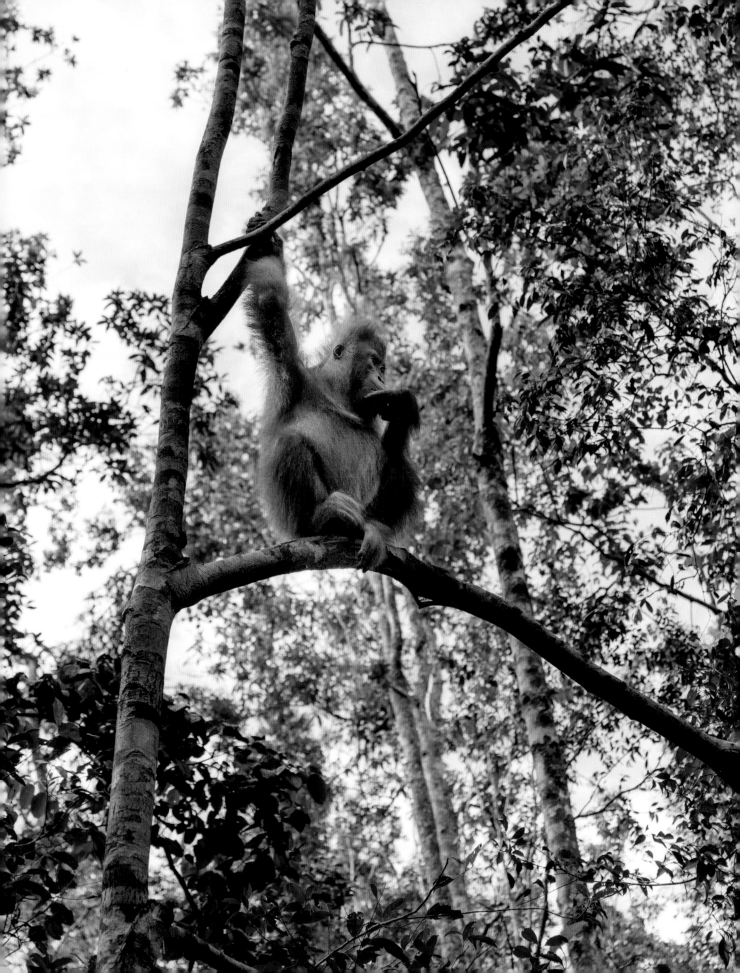

NICOLEE DRAKE
BORNEO, INDONESIA

coordinates
2.7938°S, 111.8415°E

Indonesia is a chain of over 17,000 islands scattered between the Asian mainland and Australia in the Indian and Pacific oceans. It is the largest archipelago in the world and sprawls along the equator for over 5,000 kilometres (3,100 miles). Indonesia's expansive landscape ranges from dense tropical rainforests and majestic mountain ranges to endless white, sandy beaches.

DEEP IN THE JUNGLES OF BORNEO, WE WERE SURROUNDED BY UNTAMED NATURE.

As our *klotok*, a traditional wooden double-decker riverboat, cruised the winding waterways and mangroves, passing stilted houses and villages, crocodiles gliding through coal-black water made for an ominous sight, but they were quickly countered by a red-brown orangutan swinging through the trees above. What a magical place. These great apes were joined by spotted proboscis monkeys and all manner of colourful birds. Deep in the jungles of Borneo, we were surrounded by untamed nature.

I was in Tanjung Puting National Park on behalf of the Indonesian government, with a commission to document the Bornean orangutan. I was on a storybook journey through the jungle via the meandering Sekonyer River, a wetland paradise of mangroves, peat swamps and nipa palm groves.

We moored up under the jungle canopy where we would have dinner by lantern light, gaze at the stars and marvel at thousands of fireflies. That night we slept under mosquito tents and awoke to a pre-dawn symphony of nocturnal animals: birds, insects and the sound of the early morning call to prayer from a distant mosque. It was 5am and pitch black – so much noise for so early on. An unknown creature rustling through the vegetation roused my imagination well before the rest of my body was ready for the day. We ate a breakfast of coconut rice, scrambled eggs, roti and jam, banana fritters, fresh mango, coffee, tea and juice, and set out in search of the elusive orangutan.

Photographing wild Bornean orangutans as they peek at you from behind tree branches along the riverbanks is a delightful and unique experience. From the moving *klotok*, spotting wildlife was a matter of luck, but once tied ashore, the birds were perched above us and some of our primate friends weren't shy about boarding the boat and stealing bananas.

⌄ Island hopping in Komodo National Park.

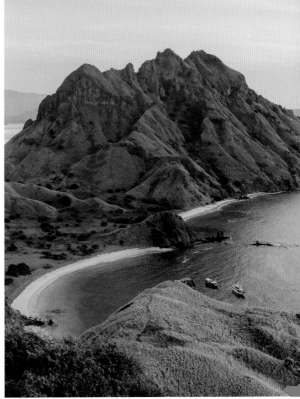

But to see the Bornean orangutan up close, we had to venture with our local guides to Camp Leakey, the leading orangutan research and conservation centre in Tanjung Puting National Park, which serves as a rehabilitation centre for displaced and orphaned orangutans. Indonesia is the world's largest producer of palm oil and the demand for palm oil plantations is the biggest threat to the survival of the orangutan population in Borneo. Slash-and-burn fires, although illegal in Indonesia, are a common practice to clear land for the plantations. This destroys the orangutans' natural habitat and limits their food supply, often pushing them into starvation.

Camp Leakey and other rehabilitation centres provide feeding programmes for both semi-wild and wild orangutans where the animals are free to come and go as they please. There are no fences, just bunches of bananas on an elevated wooden platform in the jungle. Here you can get a close look at these magnificent apes before they head back to the treetops.

We continued our trip to Labuan Bajo and the Komodo National Park. For centuries, the *phinisi* boat, a traditional Indonesian wooden schooner, has been sailing the Indonesian archipelago. Originally used to transport cargo, such as exotic spices, sandalwood and textiles along the trade route, the *phinisi* is used nowadays for sailing charters. We hitched a ride on one and sailed to the spectacular Pink Beach, or Pantai Merah, where a spotless stretch of pale pink sand blends into the bright turquoise of the sea.

⌃ Winding through the jungle on the Sekonyer River.

⌐ View from the top of Padar Island overlooking the Phinisi boats and white sand beach.

⌐ Stilted houses on the Sekonyer River.

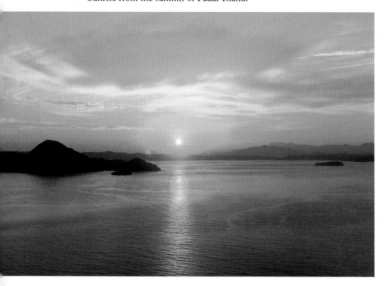

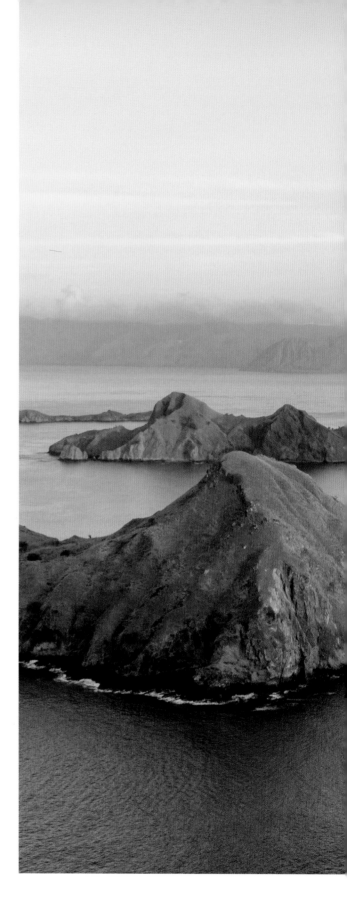

Located between the islands of Sumbawa and Flores, it is one of the few pink beaches on the planet. Beneath the surface of the calm waters you will find colourful fish swimming among coral reefs.

We anchored for the night in Padar Island Bay. The next morning, we rolled out of our bunks before dawn and piled off the schooner into our transport boats in the water below. We were taken ashore to the foot of a trail to begin the steep, 30 minute ascent to the island's summit, torches in hand. The beginning of the trail is a wooden planked pathway, which makes the trek a little easier, but we were thankful to have our knowledgeable guides leading the way in this unfamiliar terrain in the dark.

The summit of Padar Island revealed a dreamscape: perfect light and golden peaks connected by three crystal-clear turquoise bays. Standing on the top of this uninhabited island at daybreak, we watched colour gradients form in the sky. It was magical experience and made for some breathtaking photographs. There's something to be said for being present at the moment when the sun appears across the horizon, casting the first light of day across the landscape.

Travel is an ongoing exercise in humility. This remote corner of the world inspires a sense of wonder and discovery and is a reminder of just how small we are on this planet.

BEHIND THE LENS

If staying on a schooner overnight at Padar Island, as I did, a rowboat or a motorized dinghy will escort you ashore in the morning for your trek. Bring a waterproof backpack or drybag for your shoes and camera gear. The view from the top is 360°, and there is a fair amount of distance between peaks, so bring a variety of lenses. This is also a perfect place for a drone, although note there is a fee to fly one.

View of Padar Island's black and pink sand beaches.

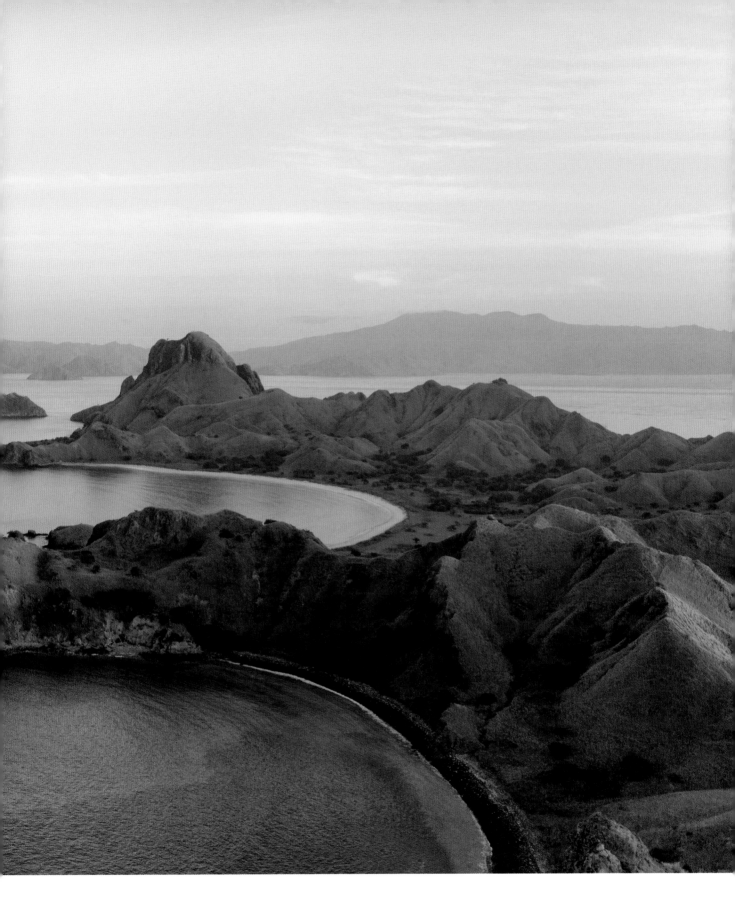

FORESTS

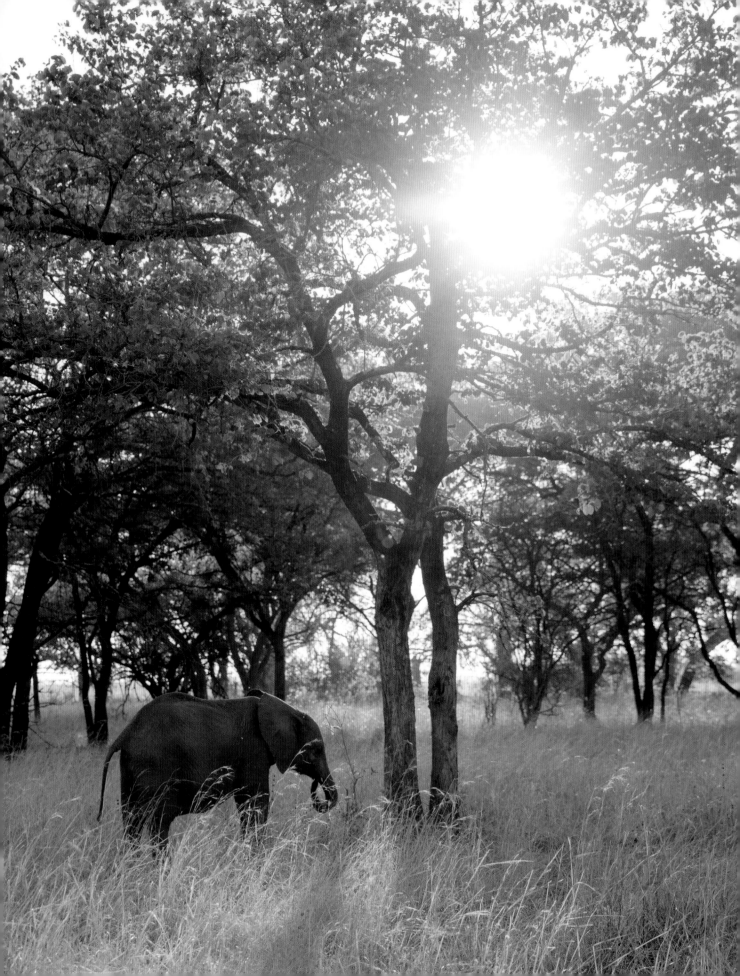

HOLLY-MARIE CATO
ZAMBIA

coordinates
15.3200°S, 28.1926°E

Zambia is a rich and vibrant country, landlocked between eight other countries in southern Africa. It's known for its wildlife and safari industry, as well as being the Copperbelt of Central Africa. Sixty percent of the country (458,000 square kilometres; 176,800 square miles) is covered in forest. Although deforestation is a growing problem, many local officials are working to reduce this plight.

‹ The elephant nursery is situated amongst the forest and grasslands of South Luangwa National Park.

On the first leg of this adventure, I travelled southeast from the capital city of Lusaka to the Lilayi Elephant Nursery. The journey is a few hours by car. My friend and conservation photographer Melanie Mahoney and I drove against the dry bright red earth with which I'd soon became familiar. It ushered our wheel between endless rows of green trees that lined the landscape and we passed elephants taking dust baths to protect themselves from the sun.

Outside the city, Zambia felt quiet, lulled only by the hum of our engine and the sound of crunching gravel as we finally exited the public road into the Lilayi Elephant Nursery. Visitors can either volunteer and camp on the nursery grounds, which takes a lot of prior planning, or opt for a more luxurious stay in Lilayi Lodge nearby. However, this trip wasn't about rest, and there would be little sleep with 45°C (113°F) heat dictating our nocturnal schedule. Most days we woke before the sun in order for the team to rescue and relocate vulnerable elephants during the coolest part of the day. I visited in October, which is at the end of Zambia's long, dry season that runs from mid-May to mid-October.

During one of these early starts, the team got an emergency call about an adult elephant who had escaped poachers in Mozambique

and crossed the Zambezi River in distress. Although we were in between our second attempt at trying to relocate Mulisani, a robustious three-year-old, 3-ton elephant, everyone mobilized quickly. There was a great deal of urgency, as local villagers were cautious of the wounded elephant causing harm to their settlements and there was the potential threat of poachers finding the vulnerable animal first.

The journey to the area of the reported sighting took the better part of the day. We stopped at a nondescript guesthouse, the only one for miles I was told, and placed so deep in the bush I couldn't relocate it on a map even if I wanted to. We hunkered down, barely resting for three hours before rising again while the sky was still dark. The air was crisp with cold, disturbed only by the sounds of crickets and the low whisper of our voices as we loaded up the vehicles for the rescue mission. With the expert help of local government veterinarians who knew the land, this small team and one large flatbed truck ventured deeper into the bush.

We finally found the elephant a few hours after the sun had risen. At first I saw nothing, his body hidden against the sparse foliage waiting for the rain. I was glad to have a team of well-seasoned conservationists around me.

∧ A crane lowers the elephant while the veterinarian directs the bull's decent on to the truck.

A SINGLE ELEPHANT
HAS THE CAPACITY TO
PLANT 300 TREES A DAY.

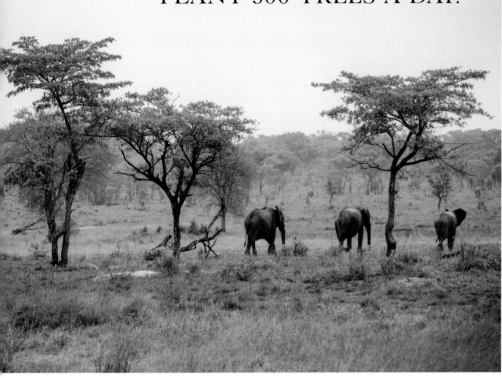

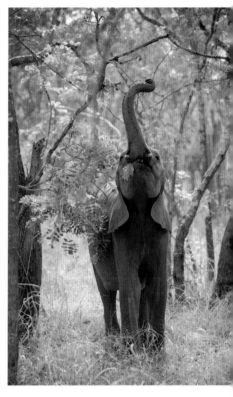

BEHIND THE LENS

In challenging lighting environments, I've found working in black and white helpful. In the image above, I was photographing in harsh direct sunlight. Removing the distraction of unwanted colours helps to focus the narrative by emphasizing shape and form within the image.

∧ The forest provides most of the resources the elephants need whilst the elephants contribute to the forest's growth and renewal.

The biggest obstacle to rescuing an elephant is its size. Most people have never seen a 5-ton elephant being lifted upside down, and I certainly hadn't. Once the creature was sedated, recorded and treated for its wounds, then came the moving. Within moments, the largest existing land animal, a mass of rough, wrinkly Jurassic skin, was up in the air, floating, then resting back down again, and strapped to a truck. Minutes later we all clambered back into our convoys in hot pursuit of the flatbed truck en route to safer, greener land for this elephant to inhabit.

Being inside a national forest meant that most of the resources an elephant needs, from shade to food, could be found around us. When we had Mulisani, the young bull elephant, in transit, we stopped to cut down vegetation for him to eat. During the adult bull's relocation, we cut down thick branch leaves to use as shade from the sun. This was important to do, as elephant's don't have sweat glands. Their body temperature is regulated by flapping their large ears; so when sedated, it was the team's job to ensure the elephant kept cool.

One of the most treasured inhabitants of Zambia's forests is the baobab tree. These trees grow in isolation from each other, rising dominantly against the mostly flat terrain. October marked the

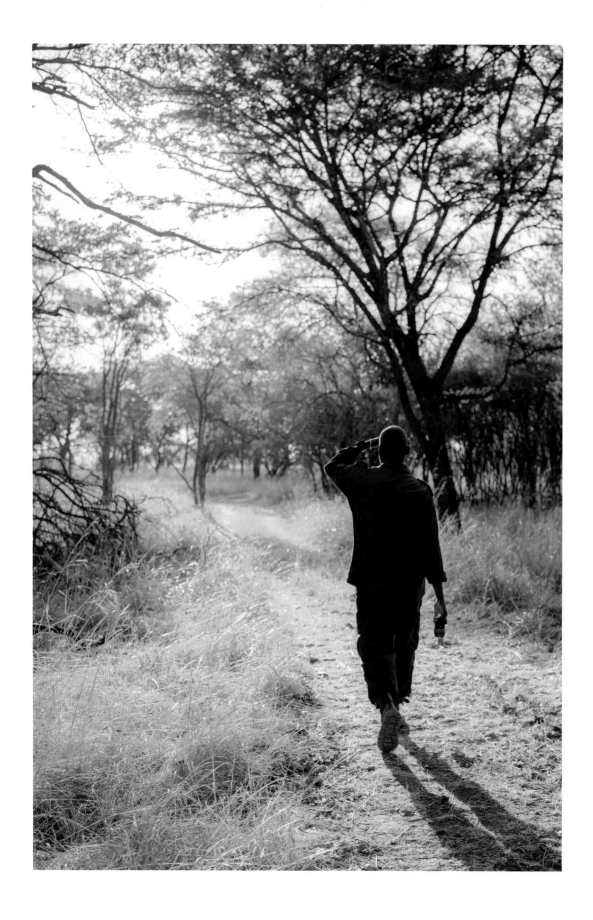

⌃ Trained keepers nurture and support the orphaned elephants.

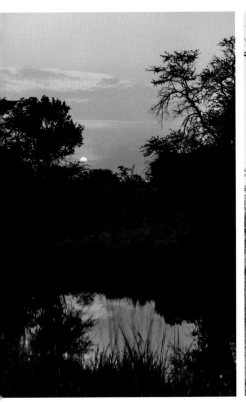

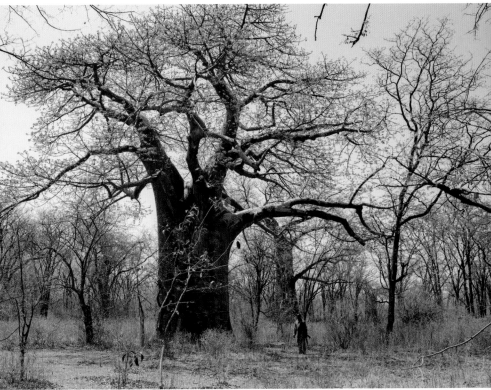

end of the growing season and most of the fruit had been picked, consumed and preserved by the locals already, but I was fortunate enough to meet a farmer who took us across his land to collect them. The fruit is a sweet treat and citrus-like in flavour. Some consider the trees sacred, others shared memories of nomadic entertainers who would tell stories from the hollowed bases of the baobab. Most know the baobab as the tree of life, as it provides shelter, food and water for people and animals across the African savannah. Many of the oldest and largest baobab trees have died in the past decade or so due to an unexplained tree virus, but their rich history suggests they can live as long as 5,000 years under the right circumstances. Being my favourite tree, I stood mostly in awe and wonder when seeing them for the first time.

We ended our trip back at the Lilayi Elephant Nursery and stayed in the lodge overnight. It gave us the perfect opportunity to wake up early and observe the elephant's first walk of the day with the keepers. There's a stillness and calm on the grounds that only breaks when the elephants realize their morning forage is over and they'll be welcomed back to the nursery with warm milk. It's important that we humans have minimal contact with elephants directly and keep our distance. This is because the elephants need to get used to living in the world independent of humans to aid their successful rehabilitation back in to the wild.

Elephants can eat up to 169kg (373lb) of food a day. They have the power to tear down trees and stomp through vast areas of forests. However, their movement and consumption aren't solely destructive: both are a part of a restorative process of regeneration of the forest too. Elephant dung acts as a natural fertilizer, carrying and planting the seeds from the foliage they eat as well as feeding insets. As they move through the forest eating plants and upheaving soil, they till the earth – a single elephant has the capacity to plant 300 trees a day. Elephants contribute to much of the forest's growth and renewal; they are essential to keeping the balance of their environment and ecology of the area.

⌐ The sun sets over the elephant nursery.

⌃ The baobab tree is known as the 'tree of life' and is one of the most treasured species in Zambia's forests.

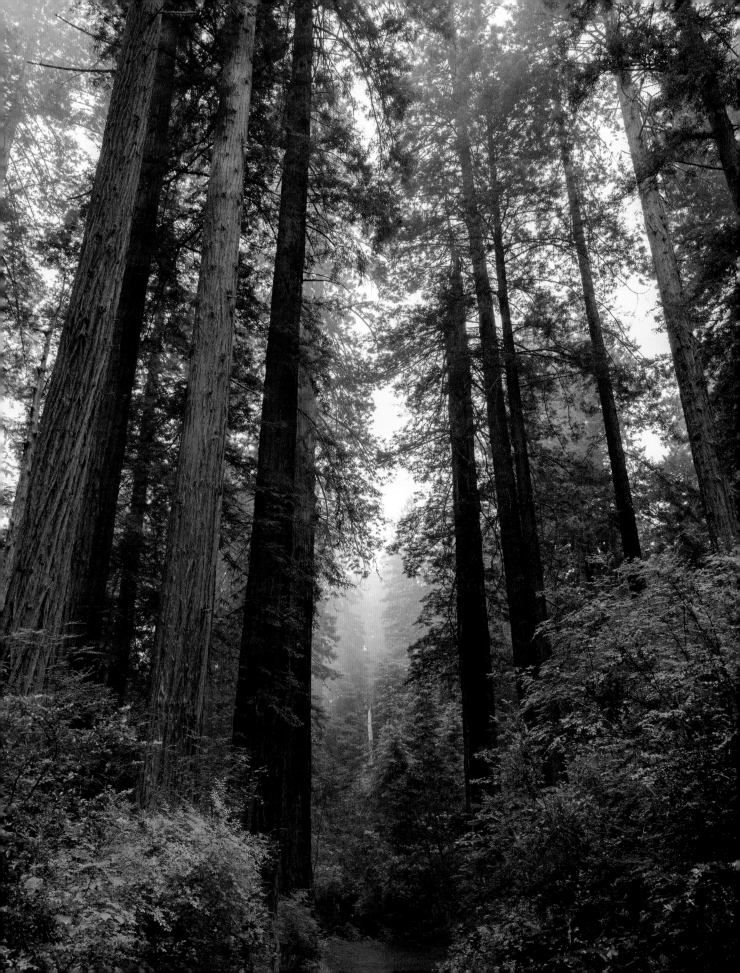

FINN
BEALES

REDWOOD NATIONAL
AND STATE PARKS,
CALIFORNIA, USA

coordinates
41.2132°N, 124.0046°W

Established in October 1968, Redwood National and State Parks form a string of interconnected forests and grasslands stretching along 60 kilometres (37 miles) of northern California's coast. It is the last refuge of the ancient coastal redwood forest. Although only a fraction of the original old-growth forest remains, the park is enormous. As well as accommodating the tallest trees in the world, it is also home to elk, bears and a forest floor blooming with ferns, mosses and, somewhat surprisingly, flowering rhododendron. The park is one of the least visited in the US and entry is free.

‹ Redwood National and State Parks are home to the world's tallest trees.

FORESTS

215

...NOTHING PREPARED ME FOR THE SOARING, NATURAL SKYSCRAPERS... MOST VISITORS DON'T STRAY FAR FROM THE CITIES, AND THEY ARE MISSING OUT.

Located entirely within California's Del Norte and Humboldt Counties, the parks protect 45 percent of all remaining old-growth redwood forests, totalling at least 158 square kilometres (61 square miles). These trees are the tallest and largest species on earth and grow only on this stretch of the Pacific Coast. The four park areas are vast and impossible to cover in one visit, so we focused our attention on two specific areas: the Lady Bird Johnson Grove and the Avenue of the Giants, home to some of the biggest trees in the parks.

With our compass bearing west, my wife and I tracked across the state of California towards The Redwood National and State Parks. It was a long drive from our origin in the town of McCloud (around five hours), but we were rewarded with a landscape almost too spectacular for words. I've long had a fascination with 'big nature', and always research an area before my visit, but nothing prepared me for the soaring, natural skyscrapers of Northern California, some as high as 30-storey buildings. I was here on behalf of the California Tourist Board, with a brief to photograph some of the state's more secret spots. Most visitors don't stray far from the cities, and they are missing out.

Redwood terrain is rugged and mountainous, with deep narrow valleys cut by streams heading west towards the ocean. The trees grow in a humid region running along a coastal strip around 800 kilometres (500 miles) long, but their distribution seems to be determined more by their exposure to summer fog than the amount of rainfall they receive. Moisture and low cloud condenses on their towering crowns and slowly drip, drip, drips down to the roots during the dry summer months.

⌄ Native to the pacific coast, from southern Oregon to central California, the coastal Redwood does not extend more than 50 miles inland.

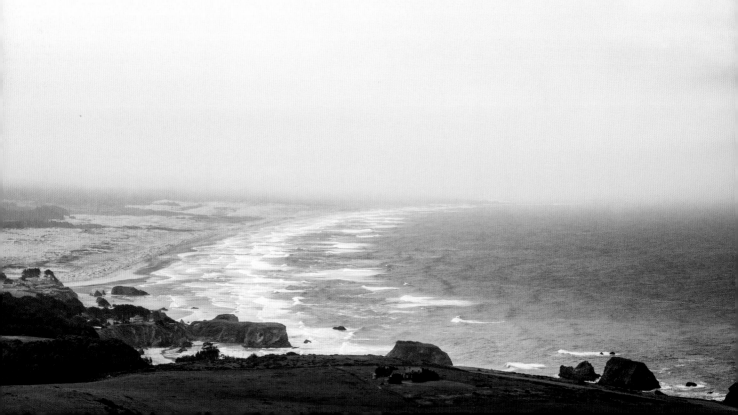

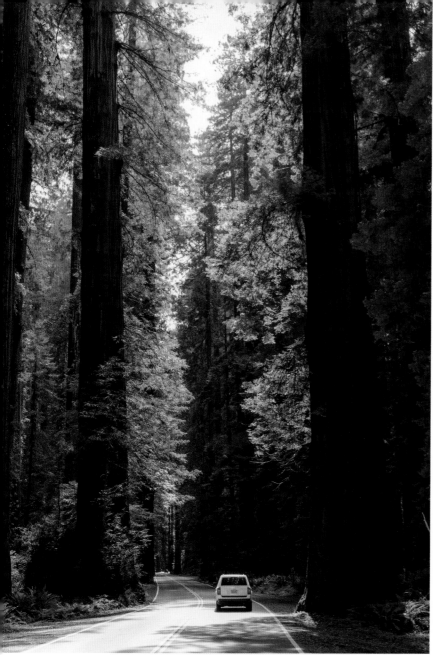

⌐ Passing through the Avenue of the Giants.

≫ This World Heritage site protects nearly half of the world's old growth redwoods.

∧ No phone signal means we resort to a more full proof method of navigation.

‹ Tree monitoring by park rangers.

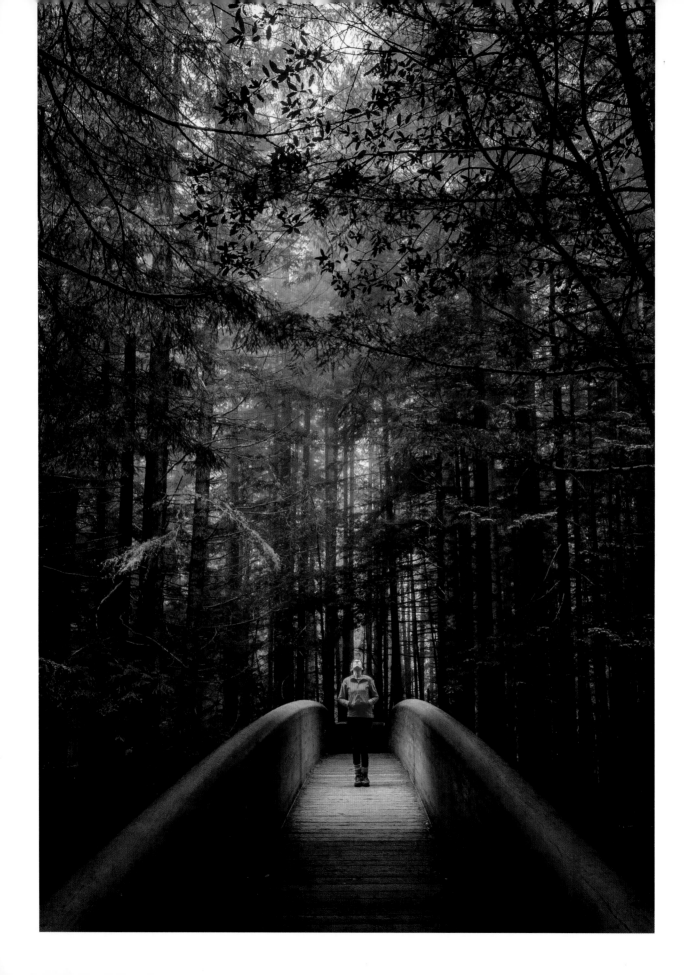

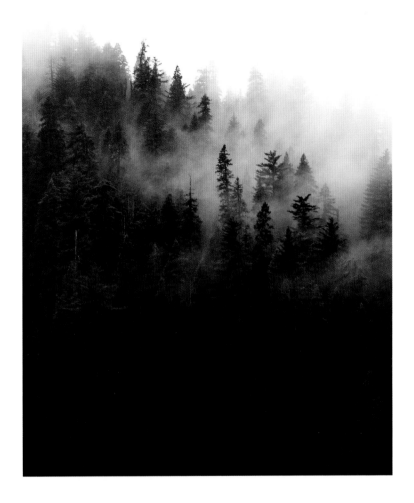

TECHNICAL TIP

The Lady Bird Johnson Grove is 366 metres (1,200 feet) above sea level and classed as a redwood upland environment. This means it's often in the clouds and receives a lot more fog than lowland groves. Fog and trees are the perfect ingredients for an atmospheric frame, so it's worth a trip up here to shoot the footpath bridge that leads into the grove from the car park. I'm always looking for leading lines within a landscape, and as the bridge passes through the trees, it helps to make a straightforward composition. It also lends a degree of perspective to the photograph, which allows a viewer to size the trees against something they can relate to.

We saw very few people on our hikes through the forest; and that afforded ample quiet time for contemplation. It's a strange feeling, walking among these supermassive giants. You are enveloped in a fairy tale; ancient trees tower so high above you can barely see the sky. I began to imagine other worlds sitting atop their branches. It's tricky to describe how big these trees actually are. Photographs can help, but only when providing a familiar reference point for the viewer. Earlier in the trip, I bought a new jacket for Clare (my muse); it was bright pink, a perfect contrast against the green foliage. By including a person or everyday object in the scene, the viewer can more easily appreciate the size of other elements within the frame.

The forest floor is cast in deep shade, and the obstructed views are in sharp contrast to the wide-open coastline just a few miles west. It's a quiet place: sounds are muffled and soft. Underfoot, each step along the needle-covered paths gifts the smell of Christmas.

Logging during the last century decimated these ancient groves, and they once covered over 8,100 square kilometres (3,130 square miles). Only 4 percent of the original old-growth forest remains. It would have continued apace had the state of California and Save the Redwoods League not combined forces to create the state parks in a mission to protect and restore the coastal redwood (*Sequoia sempervirens*) and giant sequoia (*Sequoiadendron giganteum*). These parks now shelter the largest concentration of living material, or biomass, in the world in just one grove of trees.

Humans have evolved to think within our own lifespans, which means we inhabit a very short-term world, especially today, with most of us focusing on what is directly in front of us. Social media, news headlines and gone-tomorrow trends: it's all about the now. I'm as guilty as anyone, but my aim was to consciously step outside that world by visiting the oldest living matter on our planet. Redwood National and State Parks is the very antithesis of short-termism and, as a result, these trees are nothing short of magnificent. A visit is humbling physically (they are just so big!), but also mentally, when you think some of these trees are over 3,000 years old. They are epic in every sense and stretch our capacity to think long term, which helps us escape the 'now' and begin to take responsibility for the future. They are a gift to us today and, all being well, many generations to come.

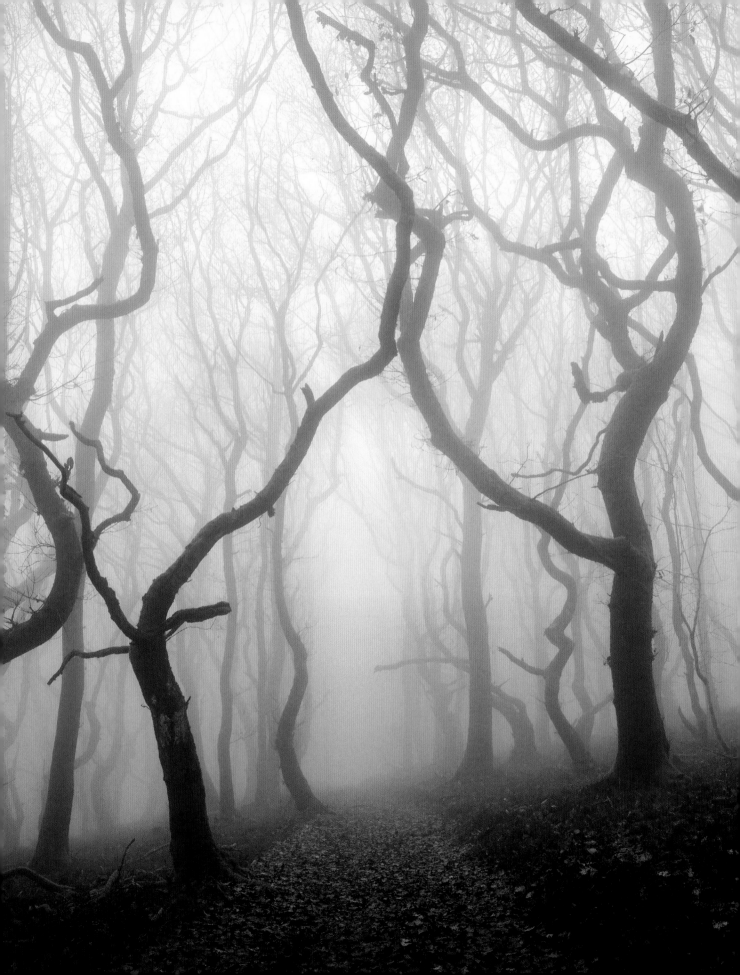

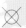

FINN BEALES
ST MARY'S VALE, WALES

coordinates
51.8627°N, 3.0579°W

St Mary's Vale is a wooded valley tucked beneath the Sugar Loaf Mountain in Wales, around 3 kilometres (2 miles) north of Abergavenny in Monmouthshire, within the Brecon Beacons National Park. The slopes are thickly forested, with a mix of deciduous woodland bracken, heathers and whinberry found on the upper slopes. Towering oak trees form a dense canopy overhead, depositing a deep carpet of leaves every winter. It's an ethereal place, but to experience its otherworldly glory properly, you should embrace the grey and visit on a foggy day.

❮ The ghostly forms of Sessile Oak, the
unofficial emblem of Wales.

PEERING OUT, I COULD SEE THAT THICK FOG HELD THE MORNING IN A DAMP EMBRACE

I woke early and opened the curtains. It was cold, and condensation had formed on the windows of the seventeenth-century longhouse I call home. Peering out, I could see that thick fog held the morning in a damp embrace – the signal of a shift in seasons along the border between Wales and England. Some refer to these days as 'pea-soupers', a reference to the notorious polluted smog London experienced during the Industrial Revolution. However, Welsh atmospherics are quite different from the dirty smog found in cities.

A change in wind direction revealed a line of leafless trees etched on the horizon; the skeletal shapes another reminder that winter was coming. I wait all year for days like these. I crept downstairs, grabbed a pre-packed camera bag and closed the front door quietly behind me – the rest of the house was still asleep.

I was heading for St Mary's Vale, nestled beneath the distinctive peak of the Sugar Loaf Mountain. It's a special place at any time of year. In spring, sunlight pours through the emerald green canopy, bouncing off the waters of the Nant Iago stream as it chuckles downslope towards the town of Abergavenny. In the winter, the same trees take on an altogether different form. Stripped of their leaves, and a ghost of their summer selves, these twisted forms hold the fog close, performing a slow, haunting dance. To lose yourself in this cathedral of trees is pure therapy for the soul.

The marked change in seasons affects how I approach my photography. The winter sun is soft and low in the sky, and colours

⌄ My trusty companion Otto.

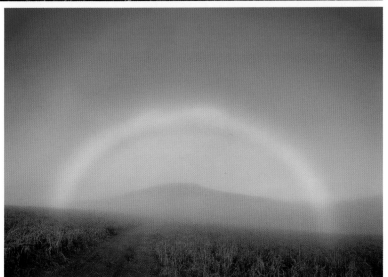

⟨ A farm house enveloped in a sea of mist.
⌄ Spider webs catching dew drops.
⩔ Oak leaves litter the forest floor.

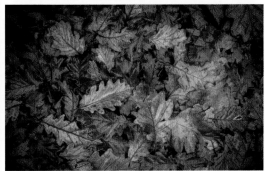

BEHIND THE LENS

To capture the scale and majesty of a fogbow (or a ghost rainbow) try using the panorama mode on your phone. Tap the shutter button to begin the panorama, starting on the left-hand side of the bow. Slowly move the camera towards the right along the horizontal plane. The route is handily displayed on the screen. Move slowly to prevent motion blur and try not to move the phone up and down while panning. The phone is smart and will smooth edges automatically, but if there is too much vertical movement, you will see some ugly 'joins' in the final image.

TO LOSE YOURSELF IN THIS CATHEDRAL OF TREES IS PURE THERAPY FOR THE SOUL.

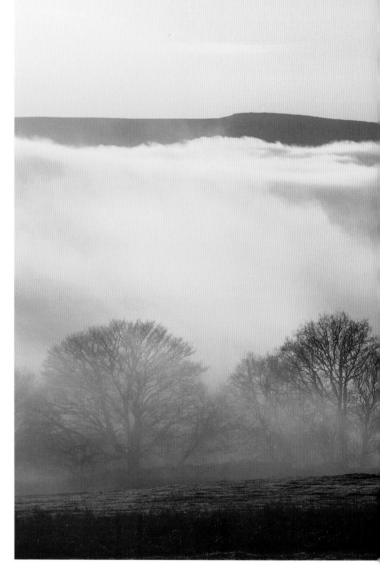

 Skeletal shapes of long spent plants.

❭ Sun set as seen from The Sugar Loaf.

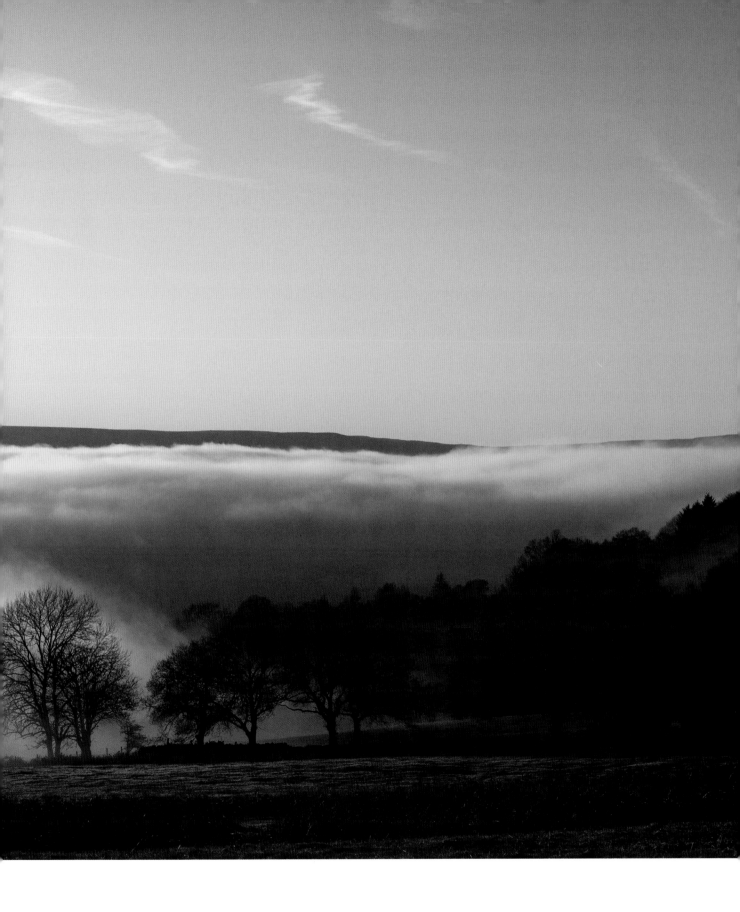

﹀ Miles of wonderful oak and beech cling to the sides of this ancient valley.

are more muted. I find I can shoot for longer and the restrained palette is easier to work with. The summer brings more predictable weather but the sun is much higher in the sky, and the light is harsh; super-early starts (4am!) are the only option.

Otto, our beloved sprocker spaniel, makes a trusty companion on days like this. He loves these woods and barrels around, nose to the ground in search of birds he will never be able to catch. Visibility was low, perhaps 20 metres (66 feet), and the trees cast a dark silhouette against the grey. I moved slowly, looking at the shapes before tracking left and right, trying to improve the balance of the composition through my camera's viewfinder.

I rested against a knotted tree for a while and breathed in my surroundings – they are ancient and spiritual. This was somewhere druids once practised their rituals, a place for nymphs and elves to hide from the world, and where the old kings came in search of answers. Lost in thought, my daydreams were interrupted by the rustle of Otto's escapades and the occasional peel of laughter; distant chatter was emanating from the soaring summit of the Sugar Loaf. I pushed on towards these sounds, and the trees began

to thin, opening on to the shoulders of the mountain.

Otto was well camouflaged against the bracken-clad moorland and he flushed a hare from the cover. I made him halt with a whistle and we both watched as the master of the quick-turn switched back and forth across the hill, before disappearing into a whisper of mist. Onwards up the slope we climbed, eventually emerging into the welcome winter sun. The warmth buoyed my pace and I marvelled at the landscape that I'm lucky enough to call home. I have lived here for most of my life, I have walked these hills numerous times, yet I always experience something new.

A glance to the peak revealed an arc in the sky overhead: a rare ghost rainbow, formed by the low-slung winter sun shining through the fast-evaporating fog. I smiled and reached for my camera before quickly realizing the scale of the phenomenon I was attempting to capture. I moved downhill in an attempt to create some distance so I could fit it within my frame but, of course, it followed, just like its more colourful cousin. A bow isn't fixed like the old oak trees in the vale below; it's fluid like the hare, on the run, from here to there, and then gone.

⌃ Otto, on the lookout for animals he will
never be able to catch!

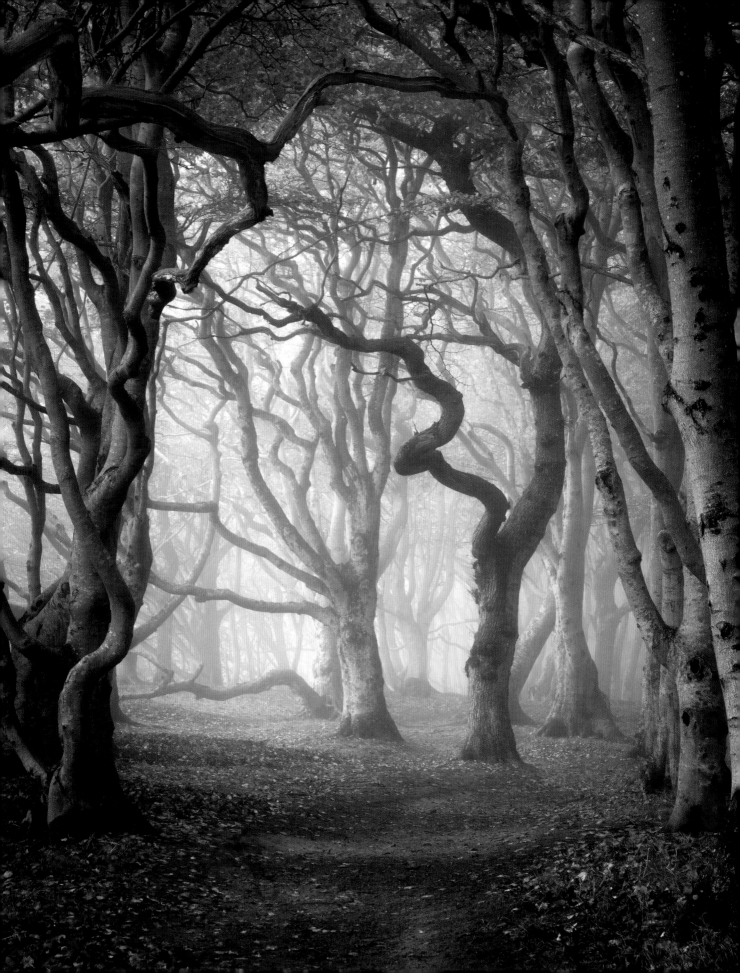

MADS PETER IVERSEN

HESTEHAVE FOREST, DENMARK

coordinates
56.2807°N, 10.4683°E

Squirrelled away in the Hestehave Forest, north of Kalø Castle ruin, is a trail leading westwards through a landscape formed at the end of the last ice age. The route is part of the Mols Mountains Trail (or Mols Bjerge-stien), which sounds (and looks) like a film location from *Lord of the Rings*. The Mols Bjerge National Park, through which the trail leads, contains everything from old forests, fjords, rural countryside and towns to hilly landscapes with fabulous panoramic views. The entire area is typically Danish. It is a calm landscape without dramatic mountains, waterfalls or glaciers, where you have almost uninterrupted views towards the horizon.

〈 An uninterrupted view of the Hestehave Forest engulfed in an icy mist.

Officially created in 2009, the Mols Bjerge National Park covers 180 square kilometres (69 square miles) and contains many ancient dolmens and graves from the Bronze Age. The fjord and forests provide a haven for a wide variety of wildlife, and the smell of nature – of seaweed and salt – and the dampness of the surrounding forest is sublime.

I think getting a little bit lost is often the key to discovering new places. I stumbled upon Hestehave Forest purely by chance while scouting a range of different locations for a personal photo project. After a short time exploring the Mols Mountains Trail, I knew instantly that this type of forest would benefit significantly from a thick layer of fog. It would separate the trees from each other and create the atmosphere I am so fond of when it comes to forest photography. However, due to its location, such atmospherics are rare, so when the forecast promised fog a good six months later, I knew I had to jump at the chance.

It was towards the end of October, which meant a late sunrise. The length of the day differs by 10 hours between summer and winter in Denmark, so this was somewhat of a relief; an hour more in bed is never a bad thing. This time of year also meant I could capture the last of the autumn colour in the leaves – a double win.

Fog can be somewhat elusive, but the mist lingered for a few hours that morning, giving me plenty of time to find and photograph various compositions. It was a calming experience, especially once I knew I had captured what I came for, so I

...GETTING A LITTLE BIT LOST IS OFTEN THE KEY TO DISCOVERING NEW PLACES.

⌄ Aerial view of the Mols Bjerge National Park. Home to a variety of wildlife and many ancient dolmens.

❯ The Hestehave Forest in a rare atmospheric state caused by a cloudy thick fog.

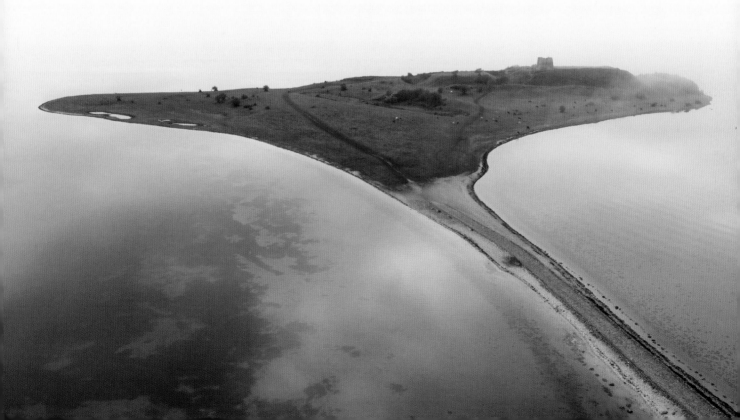

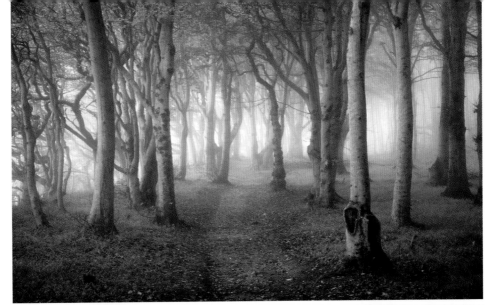

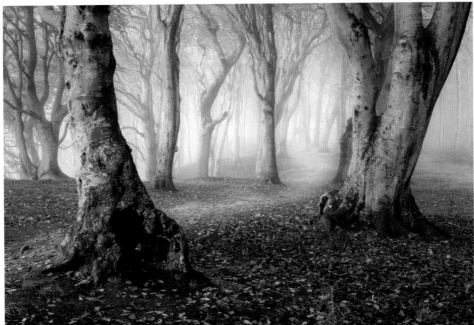

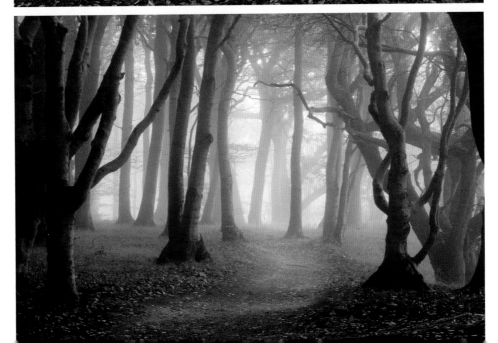

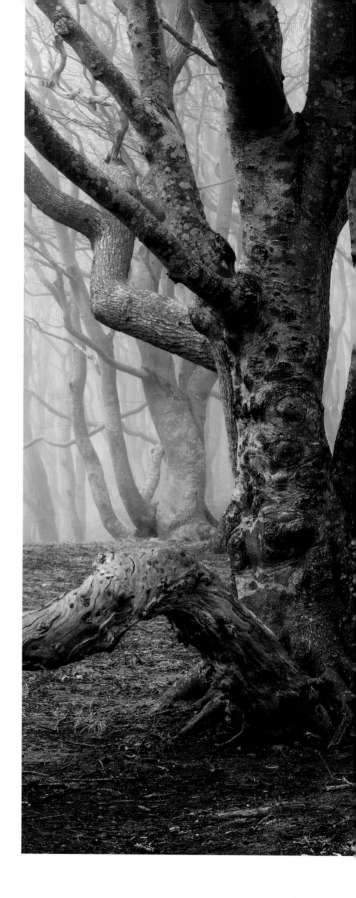

FOG CAN BE SOMEWHAT ELUSIVE BUT THE MIST LINGERED FOR A FEW HOURS THAT MORNING...

continued to explore for the rest of the morning. Sometimes the pressure to capture a photograph can break the 'flow' and override the experience of being in a place. I try to overcome such feelings as much as possible within the confines of my job as a photographer.

Different weather conditions combined with post-processing techniques allowed me to shape my vision. Although the trees are moody and crooked, I went with an airy, bright and atmospheric edit for this series to avoid making the photos feel too gloomy and ominous.

I love the look of this forest; it's like something from a fairy tale. The trees grow very close to one another; in fact, many trunks originate from the same stump. This, combined with the effects of sea salt and wind, cripple the growth into crooked forms. In Denmark, we refer to them as 'troll forests', and many such forests are scattered across the country. As the fog began to evaporate that morning, the sun broke through and lit up this particular troll forest, changing the atmosphere dramatically. I raced to capture a few final photos, placing emphasis on the gnarly silhouettes of the trees. I looked at the back of my camera. I had caught the trolls themselves.

BEHIND THE LENS

I personally like to photograph forests with the addition of mist and fog. Pack a tripod as woods can be rather dark, meaning you will need to shoot with longer shutter speeds. The stability a tripod gives your camera makes for sharper photographs and more flexibility when it comes to shooting at a greater depth of field.

∧ The crooked forms of the trees in the Hestehave Forest as a result of sea salt and wind.

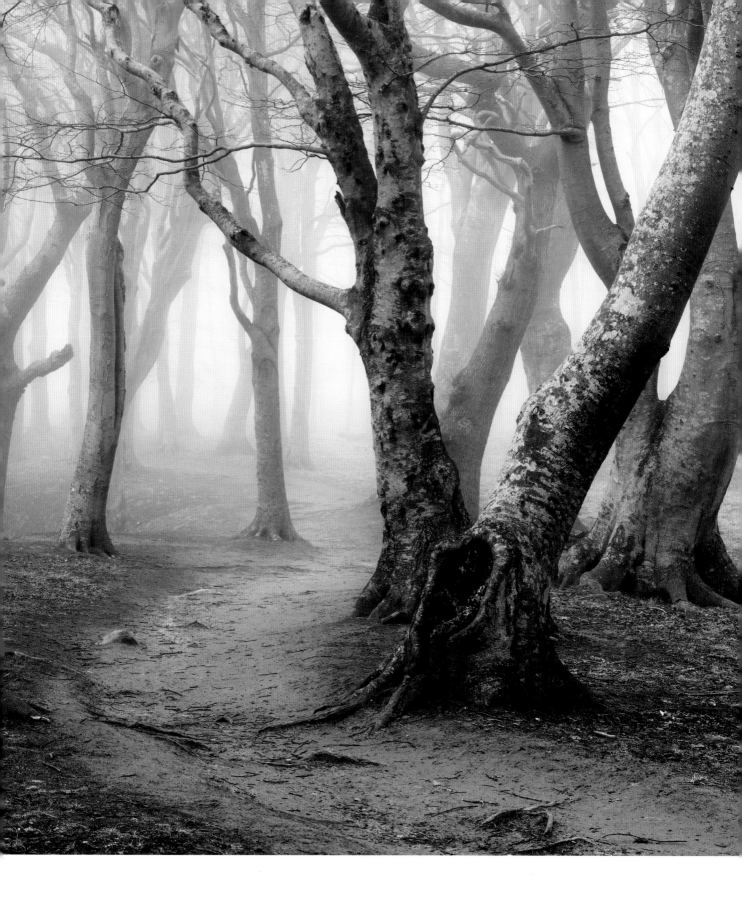

PHOTOGRAPHER BIOGRAPHIES

FINN BEALES

Finn Beales is an award-winning photographer and director, celebrated for his cinematic landscape and lifestyle photography. He travels the world to capture the raw power of nature. His epic shots, that immortalize spellbinding moments in wild, off-grid locations, have earned him a loyal following of over half a million on Instagram, as well as major clients such as Apple, Cartier, Land Rover and Omega. Finn is based in Wales, where he lives with his wife and two children.

madebyfinn.com
@finn

TIMOTHY ALLEN

Award-winning photographer Timothy Allen has worked for *The Guardian*, the *Sunday Telegraph* and *The Independent*, as well as being in charge of photography for Human Planet for the BBC. In addition to being a photographer, Timothy also specialised in multimedia production and is now a regular commentator in the media as well as producing and directing his own films. Timothy remains passionate about indigenous cultures and remote locations and travels as much as possible.

humanplanet.com/timothyallen/
@timothy_allen

HANNES BECKER

Hannes Becker is a German-based freelance photographer and a licensed drone operator specializing in outdoor, adventure and landscape photography. Passionate about travelling, he has used Instagram for the last seven years to share his impressions of new places and has become one of the world's most-followed travel photographers. His photography aims to inspire the viewer and portray his experiences realistically, not only documenting his travels, but also incorporating his personal interpretations, with a particular focus on composition, mood and lighting.

hannesbecker.com
@hannes_becker

CHRIS BURKARD

Chris Burkard is an accomplished photographer, creative director and author. He travels throughout the year to the farthest expanses of the earth to capture stories that inspire humans to consider their relationship with nature. Chris is known for his images of untamed, powerful landscapes. His visionary perspective has seen him work on prominent global campaigns with Fortune 500 clients, speak on the TED stage, design product lines and publish a growing collection of books. Based in California, he is happiest with his wife Breanne, raising their two sons Jeremiah and Forrest in his hometown of Pismo Beach.

chrisburkard.com
@chrisburkard

HOLLY-MARIE CATO

Combining travel and street photography, Holly-Marie Cato seeks out authentic stories across the world, always leading from a human perspective. Her work has seen her travel the globe, from Nicaragua to Mumbai, forging connections with grassroots-based charities and partnering with international brands. Holly-Marie wields her camera like a third arm, seamlessly switching from film to photography with a distinct bold aesthetic. Her work is gracious and honest, and portrays her subjects with dignity. Holly-Marie's ability to connect with people extends beyond the camera to hosting sold-out workshops and talks on the art of storytelling and photography. When she's not travelling, you can find Holly-Marie on the streets of London documenting the city.

hollycato.com
@h_cato

NICOLEE DRAKE

Nicolee Drake is a travel, lifestyle and commercial photographer based in Rome, Italy. Originally from Southern California, she has been living and working in Rome since 2009. A love of photography and a background in design led Nicolee to a full-time career travelling the world and shooting for clients such as Apple, Veuve Clicquot, Cloudy Bay and other global brands. She's drawn to golden light, a cinematic style, precise composition and the subtleties of everyday life. As an early adopter of Instagram, she also works with brands using her platform to help bring their stories to life.

cucinadigitale.com
@cucinadigale

RICHARD GASTON

Richard Gaston is a Scottish travel and lifestyle photographer residing in Glasgow, Scotland. With his clean style, free of noise, and considered compositions, he clearly distinguishes his subjects. Richard has shot for clients such as Arc'teryx, *Cereal* magazine and British Airways. He is also a published author and co-wrote the award-winning travel guide book, *Wild Guide Scotland*.

richardgaston.com
@richardgaston

JONATHAN GREGSON

Jonathan Gregson is an award-winning photographer with almost 20 years' experience in the genres of travel, food and still life. He started his career as a travel photographer but food quickly became a regular feature of his work as he took on commissions to photograph wine regions and gastronomic destinations. Studio-based food and still life now make up a large portion of his commercial work and Jonathan counts some of the biggest global brands among his clients. However, travel remains central to his portfolio and editorial commissions. In 2018, he received a Fellowship Award from the British Institute of Professional Photography. He lives in London with his wife and two daughters.

jonathangregson.co.uk
@jonathangregsonphotography

TOBIAS HÄGG

Tobias Hägg, also known as Airpixels, is a photographer and videographer based in Stockholm, Sweden. Passionate about exploring the great outdoors, he is known for his powerful landscapes and eye for detail, pattern and simplicity. Tobias was featured in *Masters of Drone Photography* and judges the CEWE Photo Award. He has worked for clients such as Apple, Google and Volvo, and his work has been published and exhibited all around the globe, including *National Geographic*, the *Telegraph* and *Daily Mail*, together with exhibitions of his work at the Swedish Museum of Photography, Fotografiska. Tobias is happiest at home in the Swedish forests with his two sons, Henry and Lorents, and his girlfriend, Maria.

airpixelsmedia.com
@airpixels

BENJAMIN HARDMAN

Benjamin Hardman is a photographer and cinematographer based in Iceland. After moving from Australia in 2015, the fragile, barren and isolated landscapes of the frozen north have become the core focus of his work. With more than 10 years in the creative sphere, multiple solo exhibitions and over 30 assignments as a polar expedition photography specialist, Benjamin has developed an intricate knowledge of the lands of Iceland, Greenland and Svalbard, and a passion for documenting them. He utilizes social media to share his imagery and first-hand experiences of glacial retreat, sea ice changes and the culture and wildlife of the north to help raise awareness of our rapidly changing global climate.

benjaminhardman.com
@benjaminhardman

MADS PETER IVERSEN

Mads Peter Iversen is an award-winning fine art landscape photographer and YouTuber from Denmark. His style is probably best described as 'romantically stylized realism' and is influenced by fantasy tales and raw Nordic nature. Mads has more than 10,000 subscribers on YouTube and more than 750,000 followers on Instagram, making him one of the big players in contemporary landscape photography (according to some; Mads disagrees, as he has only been a photographer for a little more than 10 years).

mpiphoto.dk
@madspeteriversen

LUCY LAUCHT

Lucy Laucht is a travel, fashion and lifestyle photographer based in Cornwall, UK. Imbued with a strong sense of story, her transportive photographs capture the essence of the destinations she visits and each scene sheds light on the soul of a place and the people who live within it. A Leica ambassador, Lucy's work appears regularly in *Elle* France, *Condé Nast Traveller*, *Grazia*, *Vogue* Australia and Goop. Select clients include American Airlines, Qantas, Topshop, Madewell, Desmond & Dempsey and Relais & Châteaux.

lucylaucht.com
@lucylaucht

GREG LECOEUR

Originally from Nice, France, and a lifelong lover of the Mediterranean Sea, Greg Lecoeur became interested in marine biology and diving at a very young age. After studying business and becoming an entrepreneur, he sold his company to pursue his dream: a year backpacking around the world with his camera. Since then, his photographs have received numerous international awards, including National Geographic Photographer of the Year 2016 and Underwater Photographer of the Year 2020. Today, Greg devotes all his time to his passion: capturing the emotions of the living marine world in order to tell the oceans' stories and raise awareness about the preservation of underwater ecosystems.

greglecoeur.com
@greg.lecoeur

LAURA PRITCHETT

Laura Pritchett first picked up a camera as a tool to study motion and light for her paintings and never put it down. Photography quickly developed into a new creative outlet and has grown in harmony with her painting career. Laura has been named one of the top 50 American photographers on Instagram by *TIME*. She has photographed for clients such as Google, Coach, Kiehl's, Van Cleef & Arpels, *Condé Nast Traveller*, GAP, Audi, Travel Alberta, Mitsukoshi (Japan) and GE. She lives with her husband and daughter in a house in Delaware, USA, and in an Airstream, anywhere.

lauraepritchett.com
@bythebrush

EMILIE RISTEVSKI

Emilie Ristevski is an Australian photographer whose work focuses on natural light and bringing beautiful moments to life through meaningful storytelling. With nearly 10 years' experience working in the creative arts industry, Emilie has partnered with some of the world's leading travel and lifestyle brands, including Adobe and *Lonely Planet*. Her dream-like imagery has led her to all corners of the planet, from remote villages in South America to the wild landscapes of Iceland, Namibia and everywhere in between. Emilie's work aims to encourage her audience to seek a deeper connection with nature and themselves, in the hope of discovering a newfound love for the beautiful planet we call home.

@helloemilie

CHARLY SAVELY

Charly Savely was born and raised in Bristol, England, but has lived the majority of her life on the west coast of the USA. She currently resides in the beautiful state of Alaska. She has moved around and travelled her whole life with a camera in hand. A jack-of-all-trades, Charly has a bachelor's degree in Photography, Graphic Design and Scientific Illustration from the University of California, Santa Cruz. She is a full-time freelance photographer who specializes in adventure, wildlife and commercial photography. Currently, her focus is on capturing the disappearing Arctic, as well as minimalist moments.

charlysavely.com
@charlysavely

CATH SIMARD

Cath Simard is a Canadian-born digital artist and a self-taught travel and landscape photographer with a passion for the outdoors and the wilderness. After quitting her job as a fashion stylist and model, Cath now travels the world full time, creating unique images and teaching photography workshops. Her main sponsors are Sony and The North Face. For her, photography is like a therapy that offers a sense of purpose and an outlet for self-expression. Through her work, she hopes to encourage people to spend more alone time in nature for self-improvement and healing.

cathsimard.com
@cathsimard

CALLUM SNAPE

Callum Snape is a freelance travel and adventure photographer from Vancouver, Canada. His work is a reflection of his passions and is layered with landscape, lifestyle, adventure and sports subjects, along with the personalities that find meaning from the same sources. In addition to capturing beautiful images, Callum has amassed over one million followers – one of the largest digital audiences in the travel and outdoor industries within Canada. He travels around the world capturing photos for brands such as Tourism Switzerland, Air Canada, Samsung, Panerai and more.

callumsnapephoto.com
@calsnape

MOLLY STEELE

Molly Steele is a Los Angeles-based analogue reportage photographer and writer. Her work evokes an emotive quality from the minutiae of everyday life and captures the magic of lived experience. Molly celebrates time spent outdoors and a life lived beyond the commercial status quo. Known for her sun-bleached and natural palette within her photography, she seeks out rugged coastlines, freight trains and the cracks between spaces where life finds a way.

molly-steele.com
@moristeele

ALEX STROHL

Alex Strohl is a photographer, filmmaker and author. Best known for his immersive landscape photography, he has unrivalled influence on outdoor media, having worked with *National Geographic*, *Outside* magazine and *Gentleman's Journal* and producing critically-acclaimed marketing campaigns. Strohl also runs photography workshops that have inspired tens of thousands of participants. When not traveling the globe with his wife Andrea Dabene, Alex is based in Montana.

alexstrohl.com/
@alexstrohl

REUBEN WU

Reuben Wu is a fine art and commercial photographer. By experimenting with lighting and technology, he aims to show familiar places in an unfamiliar light. His photography has enabled him to travel the world and shoot for clients such as Apple, Samsung, Audi and Snap Inc. Reuben's images have been published in *National Geographic* and *TIME* magazine, and he was a speaker at the National Geographic Storytellers Summit in 2020. Reuben is a global ambassador for Phase One and lives in Chicago with his wife and two children.

reubenwu.com
@itsreuben

INDEX

Dedicated to my Dad. I hope we meet again someday.

ACKNOWLEDGEMENTS

A massive thank you to everyone who helped me bring this book to life. In particular, the immensely talented group of photographers who kindly agreed to join me on this journey. I really enjoyed our conversations and am thrilled at how they evolved into the travel stories that accompany your fantastic images.

Huge thanks to all the team at my publishers White Lion. In particular, Zara Anvari, whose constant encouragement helped me hold the course, my ever-patient editors Charlotte Frost and Ellie Wilson, for putting up with my continuous chopping and changing, and the immensely talented Isabel Eeles, whose design skills are second to none.

Thank you to my Mum and Dad, for packing my two sisters and me aboard a boat as kids and heading out to sea. Your enduring stability and sense of adventure remain the benchmark I strive for in my own life.

Thank you to my family, Clare, Harlan, Seren and Otto. I often say that life is a homecoming: a return to something, someplace, or feeling. You are all of these things – my homeland.

Thanks too, to all of you who follow my work online and, now, in print! The past decade has been quite a journey. Long may it continue.

First published in 2021 by White Lion Publishing
an imprint of The Quarto Group.
1 Triptych Place, 2nd Floor,
London, SE1 9SH,
United Kingdom
T (0)20 7700 6700
www.Quarto.com

Design © 2021 White Lion Publishing
Text and photography © 2021 Finn Beales with the exception of

pp.10–17 © 2021 Jonathan Gregson; pp.18–25 © 2021 Alex Strohl; pp.26–33 © 2021 Richard Gaston; pp.48–55 © 2021 Catherine Simard; pp.58–63 © 2021 Emilie Ristevski; pp.64–71 © 2021 Reuben Wu; pp.56–57, 86–93 © 2021 Laura Pritchett; pp.96–101 © 2021 Lucy Laucht; pp.102–107 © 2021 Chris Burkard; pp.108–113 © 2021 Molly Steele; pp.132–139 © 2021 Benjamin Hardman; pp.140–147 © 2021 Greg Lecoeur; pp.148–153 © 2021 Charly Savely; pp.162–167 © 2021 Timothy Allen; pp.168–175 © 2021 Hannes Becker; pp.178–183 © 2021 Tobias Hägg; pp.184–191 © 2021 Callum Snape; pp.200–205 © 2021 Nicolee Drake; pp.208–213 © 2021 Holly-Marie Cato; pp.228–233 © 2021 Mads Peter Iversen.

ISBN 978-0-7112-5610-1
Ebook ISBN 978-0-7112-5611-8

10 9 8 7 6

Publisher Jessica Axe
Commissioning Editors Zara Anvari and Pete Jorgensen
Designer Isabel Eeles
Editor Charlotte Frost

Printed in China